Contents

List of Illustrations

Foreword

The publication of this *Finders' Guide to Prints and Drawings in the Smithsonian Institution* begins what I hope will be a series developed to make the National Collections more easily accessible to students and scholars everywhere. It is the result of an effort by an institution-wide curatorial committee formed to think about, among other things, ways to foster increased exchanges of knowledge about various Smithsonian collections.

Stimulated by discussions of the Smithsonian Council at its fall 1976 meetings, the Institution formed four committees which are broadly representative of disciplines and organizational units throughout the Smithsonian. In addition to prints and drawings, these committees are focusing on decorative arts, photography, and folklife materials.

Great credit is due the Council for its thoughtful observation that there was a need ". . . for an information network relative to (similar) collections within various branches of the Smithsonian. . . ." The Council, established in 1966 to study and advise on institutional concerns and opportunities for advancing public understanding and knowledge in the fields of art, history, and science, recommended regarding our collections that there be "communication and coordination on a more active and specific basis" among our museums than seemed to be occurring. We are well along the way to such increased communication, and are most grateful to the twenty-five members of the Council for their guidance.

Publication of this *Finders' Guide to Prints and Drawings* is intended to assist researchers in locating works of art on paper in all the many varied collections of the Smithsonian. Further, the process of producing it has been immensely instructive to the Institution, and the information gathered will form a basis on which other deliberations regarding the collections can occur. Finally, it is our hope that the *Guide* will also serve to increase research and to spark additional publication and diffusion of knowledge.

S. Dillon Ripley
Secretary, Smithsonian Institution

9

Acknowledgments

Many staff members of the Smithsonian Institution have contributed to this project. They have discussed their collections, located prints and drawings tucked away in storage areas, read and revised collection descriptions, typed, ordered photographs, punched names into computers, and cooperated in every possible way.

Some people have made special contributions to this publication. The Curatorial Committee on Prints and Drawings acted as liaison between the author and various bureaus, read the complete manuscript, and, in general, were always available for advice and counsel: James D. Dean and William A. Good, National Air and Space Museum; Elaine Evans Dee, Cooper-Hewitt Museum; Janet A. Flint, National Museum of American Art; Frank B. Gettings, Hirshhorn Museum and Sculpture Garden; Elizabeth M. Harris, National Museum of American History, Francis M. Hueber, National Museum of Natural History; Wendy C. Wick, National Portrait Gallery; Ann Yonemura, Freer Gallery of Art. James J. Crockett, Deputy Director of the Office of Computer Services, supervised the computerization of the Location Guide to Artists. Ruth W. Spiegel, a senior editor at the Smithsonian Institution Press, brought a sense of balance to the format of the publication and ensured that the publication process was one of consistency and ease. Susan A. Hamilton, Special Assistant to the Assistant Secretary for History and Art, guided the efforts of all with her gracious intelligence, patience, and good humor.

Introduction

The *Finders' Guide to Prints and Drawings* has been compiled to assist researchers in locating works of art on paper in the collections of the Smithsonian Institution. A collection level survey rather than an itemized listing, the *Finders' Guide* establishes directional signposts for researchers attempting to chart their way through the vast and administratively complex holdings of the Institution.

Many of the Smithsonian's print and drawing collections, of course, are already well known to researchers and well documented in a wealth of scholarly and popular publications. Oriental art at the Freer Gallery of Art, for example, or the modern European works at the Hirshhorn Museum and Sculpture Garden, or the American holdings of the National Museum of American Art (formerly National Collection of Fine Arts) are recognized worldwide and heavily utilized as research resources. But there are numerous Smithsonian bureaus or divisions whose collections of prints and drawings are relatively untapped resources, such as the National Air and Space Museum, the Smithsonian Institution Archives, or the Division of Military History in the National Museum of American History (formerly National Museum of History and Technology). This guide describes, for the first time, all of the Smithsonian collections of works of art on paper that are available for historical and scientific research.

For purposes of this guide, the terms *print* and *drawing* are rather broadly interpreted. In addition to works traditionally defined as prints and drawings, the *Finders' Guide* contains information about collections of watercolors, pastels, sketches and unfinished drawings, posters, scientific illustrations, engineering drawings, and books illustrated with original works of art. Manuscript and archival collections that incorporate sketches or drawings are also described.

Each museum and bureau of the Smithsonian independently pursues its own research and/or collecting interests. This decentralization means that prints and drawings are collected for a variety of reasons—as art, as historical objects, as the products of technology, or as documentary evidence about a particular subject or activity. The *Finders' Guide to Prints and Drawings* draws together these various points of view for the researcher needing to locate the full range of graphic materials about a particular artist, subject, period, or place.

Preparation of the Guide

The *Finders' Guide to Prints and Drawings* is the result of information gathered between January 1979 and January 1981. Information about the collections was first gleaned from conversations with curators, specialists, librarians, archivists, or historians in each of the custodial units. In each case, general questions were asked

about the scope and contents of the collections, and about policies and procedures affecting acquisitions, collection development, organization, processing, conservation, and accessibility. Existing finding aids and publications about the collections were examined. In some units, particularly those without finding aids, all of the works of art on paper were examined; in other departments, selections from the collection were examined.

Organization of the Guide

The *Finders' Guide to Prints and Drawings* is organized alphabetically by name of bureau; within each bureau, the departments or divisions are arranged alphabetically. Each bureau is designated by a number, and each unit within that bureau is assigned an identifying alphanumeric. For example, the Cooper-Hewitt Museum is designated as 2; its Department of Drawings and Prints is 2A. These locator numbers and letters establish the indexing principal throughout this volume; page numbers are not used.

Each collection description is composed of an essay followed by some or all of these "ready reference" categories: finding aids, publications, photoduplication service, exhibition program, loan policy, and public access. In all cases, reference categories refer only to the works of art on paper held by each unit.

Essay The essay is a general descriptive statement about the primary research and collecting missions of each bureau, department, or division, and how the collection of prints and drawings is central to or complementary to those missions. The essay outlines the collection of graphic arts in terms of scope and content, numbers of items, dates encompassed, items of extraordinary quality and/or quantity, and subject strengths. When appropriate, a brief historical note about the bureau or collection is also provided.

Finding Aids All card catalogues, special files, registers, indexes, and other listings that provide information about graphic arts in each collection have been enumerated. These finding aids are available in the specific bureau, department, or division in which the works of art are housed. Most of the art and history collections have numerous finding aids, permitting a variety of access routes to graphic arts— by artist, by medium, by subject. But many of the scientific and technological collections lack any finding aids for prints and drawings. The lack of finding aids has been stated in this reference category by the words "none available."

Selected Publications Selected books, exhibition catalogues, periodicals, and journal articles that describe and/or illustrate a significant number of works of art on paper are listed. These publications generally provide more detailed descriptions of individual collections or objects than was possible in the essay.

Photoduplication Service Unless restricted by condition of the object or copyright, photographic copies of prints and drawings in the Smithsonian collections are available to researchers. Photoreproduction costs are determined by the Institution;

prepayment is generally requested. Researchers must have permission of the appropriate bureau to reproduce these photographic copies.

Exhibition Program Any regular exhibition schedule of graphic arts by individual bureaus, departments, or divisions is described. If no regular program of exhibition for works of art on paper exists, this reference category has been excluded from the collection description.

Loan Policy Procedures in effect for institutional borrowing from the national collections are delineated. In some cases, restrictions prohibit lending. In all cases, requests must be made as far in advance as possible. The Smithsonian Institution does not loan works of art to individuals.

Public Access Appointments are required to visit any collections not on public exhibition. The times available for research appointments are stated, as is the appropriate office to which one may write for information about the collection.

Location Guide to Graphic Artists

The Location Guide to Graphic Artists is a computer-generated alphabetical listing of all graphic artists represented in the eight major art collections of the Smithsonian Institution: Cooper-Hewitt Museum, Freer Gallery of Art, Hirshhorn Museum and Sculpture Garden, Museum of African Art, Art Department of National Air and Space Museum, National Museum of American Art, Division of Graphic Arts in National Museum of American History, and National Portrait Gallery. These collections contain the majority of works of art on paper in the Institution and, in standard art museum practice, provide researchers with access to these works by name of artist. The Location Guide was devised in lieu of attaching lengthy lists of names to the brief descriptive essay about each collection. The Location Guide is a finding list directly for the collections themselves, and does not function as an index to material in this volume. For consistency's sake, however, the same numbering system is used for both Location Guide and Index.

Artist names in the Location Guide were compiled from the internal files of the eight major art collections. Every effort has been made to stabilize the spelling of these names and the alphabetical ordering of names with particles (e.g., De La Marcade) where there was orthographic variation from collection to collection. Because of limitations imposed by the computer, diacritics do not appear.

Index

The Index to this volume is a single alphabetical list that includes the following terms drawn from the essays: all personal names, including names of authors in the bibliographic entries; geographic and corporate names; titles of works of art; titles of publications; selected format terms (e.g., maps, posters, scientific illustrations); and subjects (e.g., aeronautics, mathematics).

The Index does not include titles of publications listed in the bibliographic entries. Media and techniques (e.g., charcoal, watercolor, woodcut, engraving) have not been indexed unless they appear as subject specialities of a custodial unit; lithography, for example, is discussed as a subject interest of the Harry T. Peters *America On Stone* Lithography Collection (8E1) and as such is indexed.

The Location Guide should be used in conjunction with the Index. While the Location Guide lists by name all graphic artists represented in the eight major art collections, the Index may provide additional locations by directing the reader to collection descriptions that mention the particular artist. For example, a researcher wishing to know which art collections of the Smithsonian contain works on paper by Currier & Ives may quickly consult only the Location Guide; the locations listed are **2**, **7**, **8H**, and **10**. The Index, however, directs readers to two additional locations, **8E1** and **8T**, and also specifies the context in which these prints are held by the custodial unit (**7C**). The Index also includes artist names culled from the collection descriptions of the non-art collections of the Smithsonian Institution.

THE COLLECTIONS

College St. Servaise, Rue St. Gilles.
Liege, Belgium,
October 7th 90,

[handwritten letter] My dear, dear old Al!

1

2

3

1 | Archives of American Art

1. Lyonel Feininger, illustrated letter to Alfred Churchill. Ink on paper, 1890 (Lyonel Feininger Papers)

2. Peggy Bacon, untitled drawing. Pen and ink on paper, undated (Charles Sheeler Papers)

3. Oscar Bluemner, sketch. Pencil on paper, undated (Oscar Bluemner Papers)

The Archives of American Art is the nation's largest repository of primary source materials documenting the history of American visual arts. Founded in 1954 and affiliated with the Smithsonian since 1970, this bureau gathers, preserves, and microfilms the original records of American artists, craftsmen, collectors, dealers, critics, museums, and art societies. These records may include letters, scrapbooks, diaries, business records, slides, photographs, writings, sketches, and catalogues. Materials date from the 18th century to the present and now number some 3,000 individual collections, or approximately 6 million documents. To protect the documents and make them more readily accessible to qualified researchers, all materials are microfilmed and copies distributed to the Archives' five regional offices, in Boston, New York, Detroit, San Francisco, and Washington. Original records are housed in the Washington office which is located in the Old Patent Office Building, location also of the National Museum of American Art and the National Portrait Gallery.

More than 400 of the archival collections contain prints, drawings, or sketches; these may be by the person for whom the collection is named, or by that person's colleagues or correspondents. Collections particularly rich in material of this description are the papers of Peggy Bacon, Saul Baizerman, Maurice Becker, Isabel Bishop, Oscar Bluemner, Francis Bradford, James Brooks, Federico Castellon, Samuel Colman, Konrad and Florence Cramer, Philip Evergood, Lyonel Feininger, Karl Knaths, Walt Kuhn, Willard Metcalf, Gladys Mock, Fairfield Porter, William Page, J. Francis Murphy, Abraham Rattner, Charles G. Shaw, Everett Shinn, Russel and Xanthus Smith, John Storrs, Elihu Vedder, and Worthington Whittredge. A project to identify by artist and medium all prints and drawings in the Archives' holdings is currently in progress.

Finding Aids

• Card Catalogue, arranged alphabetically by personal or institutional name. Identifies and cross-indexes major correspondents within a particular collection. Card catalogue available in each regional center.

• Checklist of the collection, arranged alphabetically by collection name. Provides information on quantity of material, inclusive dates, gift or loan status, microfilm roll number, and type of material, such as drawings, sketches, letters, photographs. Does not indicate subject matter or correspondents.

Selected Publications

Archives of American Art: A Checklist of the Collection. Arthur J. Breton and Nancy Zembala, comps. 2d ed. rev. Washington, D.C.: Smithsonian Institution, 1977.

All collections and interviews owned, recorded, or borrowed and microfilmed as of September 1977 are listed. Entries indicate form of documents, such as diaries, letters, photographs, sketches and drawings, interviews. Inclusive dates, quantity of material, and microfilm roll number are also indicated. A supplement to the checklist is available, listing those collections added through October 1978.

Archives of American Art: A Directory of Resources. Garnett McCoy. New York: R. R. Bowker, 1972.
This volume briefly describes 555 collections as to form of documents, inclusive dates, approximate quantity, and selected correspondents. An index provides access through personal, institutional, or publication name.
Archives of American Art Journal. Detroit and New York. 1960—.
This illustrated quarterly contains reports on acquisitions along with articles and notes based on the collections.

Photoduplication Service
Available at prevailing rates, subject to rules and procedures of Archives of American Art.

Loan Policy
Microfilms of collections are available through interlibrary loan, for use in borrowing library only. Original documents are occasionally loaned to institutions for exhibitions, with approval of the Director and the Archivist of Archives of American Art.

Public Access
By appointment; Monday–Friday, 10–5. For reference service, write to regional offices or: Archives of American Art, Smithsonian Institution, Washington, D.C. 20560.

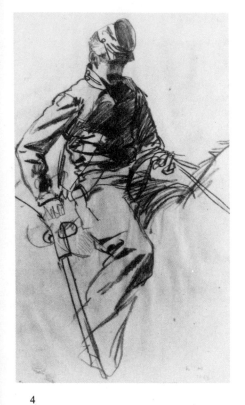

4

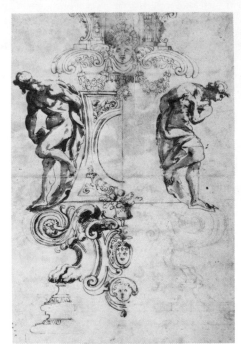

5

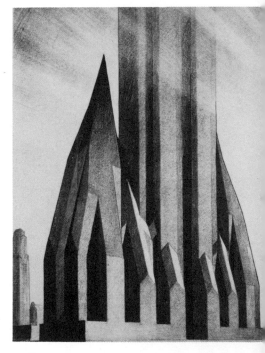

6

2 | Cooper-Hewitt Museum

4. Winslow Homer, *Cavalry Soldier*. Black chalk on paper, 1863

5. Antonio Gentili, design for the base of the silver crucifix for the high altar of Saint Peter's, Rome. Pen and brown ink, brown wash, and black chalk on paper, 1578

6. Hugh Ferriss, study for the *Maximum Mass Permitted by the 1916 New York Zoning Law*, stage 2, 1922

The Cooper Union for the Advancement of Science and Art was founded in New York in 1859 by Peter Cooper—inventor, manufacturer, and philanthropist—with the aim of providing free education in science, engineering, and art. In 1897 Cooper's granddaughters Sarah, Amy, and Eleanor Hewitt established the Cooper Union Museum in the school to provide visual information for the study of design and decoration. Through gift and purchase, the museum successfully created a facility comparable in scope and quality to Europe's great design and decorative arts collections. During the 1960s, when the Cooper Union was faced with closing the museum because of lack of funds, the collections were transferred to the custody of the Smithsonian Institution. The museum became the Smithsonian's national museum of design in 1968 and the name was changed to the Cooper-Hewitt Museum. Now elegantly housed in the former Andrew Carnegie Mansion in New York, the Cooper-Hewitt offers a collection of nearly 300,000 items spanning 3,000 years and illustrating changes in taste and fashion through the fields of textiles, wallpapers, ceramics, glass, furniture, woodwork, metalwork, jewelry, architecture, painting, drawings, and prints.

2A | DEPARTMENT OF DRAWINGS AND PRINTS

The Department of Drawings and Prints, located in the Drue Heinz Study Center for Drawings and Prints, houses approximately 50,000 drawings and 25,000 prints which date from the 15th century to the present. The collections are oriented, for the most part, toward architecture, ornament, the decorative arts, and design. The drawing collection is the largest and one of the most distinguished in America; strengths are in 18th and early 19th-century European works and late 19th-century American works. The collection of textile designs is without rival in the United States. Highlights of the print collection include a significant group of northern European Old Master prints, a series of etchings by the Tiepolos, and important holdings of 18th-century French ornament prints. There are notable collections of American prints and 19th-century Japanese woodblock prints. Examples of calligraphy, greeting cards, paper toys and games, decorated book papers, cut papers, silhouettes, puppets, peep shows and peep show prints, and package labels are collected for their design and decorative value. Additions to the collection are primarily through gift; presently the most active collecting sphere is drawings by architects and contemporary designers, especially those drawings done in conjunction with objects acquired for other departments of the museum.

The collection of Old Master prints was one of the earliest collections acquired by the museum and is significant both for the number of prints by individual artists and for the quality of the impressions. Among the prints by northern European Old

Masters are nearly 200 woodcuts and engravings by Albrecht Dürer; more than 100 etchings by Rembrandt; 28 engravings and a woodcut by Lucas van Leyden; numerous prints by Martin Schongauer, Hans Sebald Beham, Albrecht Altdorfer, Israhel van Meckenem, Lucas Cranach, and Heinrich Aldegrever. Highlights of the Italian Old Masters include 4 engravings by Andrea Mantegna, 19 engravings by Marcantonio Raimondi, 70 etchings by Salvator Rosa, and numerous etchings by Stefano della Bella.

French and Italian architectural and ornament drawings of the 17th, 18th, and 19th centuries constitute one of the most important elements of the Cooper-Hewitt Museum collection. The majority of these drawings were acquired from two of Europe's outstanding private collections in the early years of this century. In 1901, the museum purchased more than 5,000 drawings of Italian architectural and decorative designs from Cavaliere Giovanni Piancastelli, curator of the Borghese Collection in Rome. In 1911, the museum added approximately 500 drawings and 400 volumes of French ornament prints from the collection of the French interior designer Léon Decloux. Another 8,000 drawings from the Piancastelli Collection were added in 1938, supplementing those works which the Hewitt sisters continued to acquire as they traveled through Europe. Among French drawings in the Cooper-Hewitt collection are architectural designs by François de Cuvilliès, Hubert Robert, and Charles De Wailly; architectural fantasies by Charles Michel-Ange Challe; designs for interior decoration by François Boucher, Gilles-Marie Oppenort, Richard de Lalonde, Jean-Baptiste Pillement, Jean-Charles Delafosse, Leonard Chailleat, François-Joseph Bélanger, and Gilles-Paul Cauvet. One of the earliest French drawings is a perspective rendering of the Chateau de Verneuil by Jacques Androuet Ducerceau, c1565. The drawings are complemented by some 400 volumes of prints, published works which made possible the spread of particular styles. The decorative designs of François Boucher, for example, were engraved and the prints distributed, as were the architectural fantasies of Jean-Laurent Legeay. Oppenort's designs as published by Huquier and Ducerceau's *Les Plus Excellents Bastiments de France* (1576) are also part of the Decloux Collection.

Italian works are as significant as the French holdings. Italian drawings include designs for metalwork (e.g., lamps, silver tableware) by Luigi Righetti and Pietro, Giovacchino, and Vincenzo Belli; jewelry designs by Sebastiano Meyandi; stage designs by Antonio Basoli, the Bibiena family, Girolamo Fontana, Romolo Liverani, Alessandro Sanquirico, and Angelo Toselli; architectural designs by Mario Asprucci, Francesco Guardi, Filippo Juvarra, Carlo and Filippo Marchionni, Giovanni Battista Natali, Paolo Posi, and Giacomo Quarenghi; designs for interior decoration by Giuseppe Bernardino Bison, Tommaso Conca, Fortunato Tesi, Flaminio Minozzi, Francesco Solimena, and Luigi Rossini. There are nearly 1,200 designs by Giuseppe Barberi (1746–1809) for palaces, villas, urban spaces, public buildings, monuments, stage settings, fountains, metalwork, and architectural details. Drawings by Felice Giani (1758–1832) number approximately 1,000 and include designs for architectural interiors, furniture, funerary monuments, and theater settings, along with landscapes and figure drawings on classical themes. Architectural and decorative drawings by Giovanni Battista Tiepolo are enriched by a complete series of the etched works of Tiepolo and his sons Domenico and Loren-

zo; the more than 300 prints, many in rare early impressions, are from an album possibly kept by the Tiepolo family as a record of their work. The drawing books of Jan van der Straet (Stradanus) date from the 1570s to the 1590s and contain more than 300 sketches.

English drawings of the 18th and 19th centuries lend additional strength to the Cooper-Hewitt's holdings of architectural and ornamental works. There are approximately 200 designs from the firm of John Crace and Sons representing the firm's activities during its years of greatest success, from the end of the 18th century into the early 19th century. Nearly 90 of the drawings document the decoration of the Royal Pavilion at Brighton, 1815–1823. Additionally, there are furniture designs by Robert Adam, Thomas Chippendale, and Augustus Charles Pugin, and drawings for stained glass by Sir Edward Burne-Jones.

Modern architectural drawings complement the earlier works and constitute one of the developing collections in the museum. Representative French works include drawings by Hector Guimard (1867–1942) and drawings for the Villa Stein by Le Corbusier (1887–1965). American architectural drawings include works by Pietro Belluschi, Arnold William Brunner, Serge Ivan Chermayeff, Hugh Ferriss, Paul Rudolph, and Whitney Warren. A recent acquisition is a 1979 drawing by Michael Graves for the Fargo-Moorehead Cultural Center spanning the Red River between Fargo, North Dakota, and Moorehead, Minnesota. Twentieth-century stage designs are primarily by American artists such as Stewart Chaney, Robert Edmond Jones, Charles LeMaire, Simon Lissim, Donald Oenslager, Oliver Smith, Jose Varona, and John Wenger.

The collection of drawings by late 19th and early 20th-century American artists numbers approximately 7,500 and is composed primarily of gifts to the museum from the artists themselves or from their families and heirs. The Cooper-Hewitt Museum holds the single largest concentration of drawings and watercolors by Winslow Homer, nearly 300 works including landscapes, seascapes, figure studies, Civil War drawings, illustration drawings for *Harper's Weekly,* and sketchbooks. These works are enhanced by 22 early paintings, an etching, and a nearly complete set of Homer's wood engravings. Most of these works were contained in Homer's studio upon his death in 1910 and were donated to the museum by the artist's brother. Drawings and oil sketches by Frederic Edwin Church number more than 1,500 and represent the major portion of his graphic work. The 84 drawings by landscapist Thomas Moran were a gift from the artist in 1917. Other significant American holdings in the collection include more than 90 figure studies by Elihu Vedder, c1885–1890; 135 watercolor sketches by Walter Shirlaw, c1900; drawings, watercolors, and oil sketches by William Trost Richards, including 6 sketchbooks of landscapes; almost 80 drawings, watercolors, and oil sketches by William Stanley Haseltine; 17 sketchbooks and some 400 figure studies and landscapes by Daniel Huntington; more than 80 sketches for mural decorations in the Library of Congress (c1895) and other public buildings in the United States by Kenyon and Allyn Cox; mural studies for New York's Mendelssohn Hall (1895–1898) and 18 sketchbooks of European landscapes (1880–1891) by Robert Frederick Blum; 28 landscapes by Francis Hopkinson Smith. Designs for book illustration, costumes, and stage settings by Edward McKnight Kauffer are complemented by a group of his posters; numbering more than 1,100 items, these works form one of the most complete collections of Kauffer's oeuvre.

Prints by American artists account for a significant segment of the Cooper-Hewitt collection. The Rose Collection of 15,000 wood engravings spans the 18th to 20th centuries and is one of the two largest wood engraving collections in the world. Among other American prints are 25 etchings and lithographs by Childe Hassam; 11 lithographs by Grant Wood; 3 lithographs and a group of woodblocks by Will Barnet; color woodcuts by Antonio Frasconi; etchings by James A. M. Whistler, Robert Conover, and Linda Plotkin; and representative works by, among others, Thomas Cole, Joseph Pennell, Thomas Hart Benton, Gabor Peterdi, Sam Francis, and Andy Warhol.

The Cooper-Hewitt Museum houses more than 500 Japanese woodblock prints which date from the 18th to 20th centuries. The majority are 19th-century *ukiyo-e* prints, those that depict scenes of everyday life. There are a number of prints by Katsushika Hokusai, Katsukawa Shunso, Andō Hiroshige, and Utagawa Kunisada. Approximately 400 Japanese stencils (katagami) date primarily from the 19th and early 20th centuries. These cut-paper stencils were used in the process of dyeing fabrics and are decorative objects in their own right.

The collection of wallpapers consists of approximately 6,000 examples which reflect the entire development of wall coverings from the 17th century to the present day. Precise documentation for the history of taste is provided by the many printed papers from specific, dated American houses. The collection also includes a large number of bandboxes covered with wallpaper. (The wallpaper collection is discussed fully in the forthcoming *Finders' Guide to Decorative Arts in the Smithsonian Institution.*)

Textile designs number approximately 2,000 and date from the 18th century to the present; the majority are French 18th-century embroidery designs. The collection has additional strengths in 19th-century English and 20th-century American works.

Fashion plates, the published prints that served as guides on how to dress, comprise some 9,000 items dating from 1786 to 1930. The majority of the plates were published in French, English, German, and American fashion journals, although the collection does contain small numbers of prints from Spanish and Italian magazines. Those journals represented by significant numbers of plates include *La Belle Assemblée, Le Follet, Illustrierte Frauen-Zeitung, Le Journal des Dames et des Modes, Le Journal des Demoiselles, The Lady's Magazine, Le Moniteur de la Mode, Petit Courier des Dames, La Revue de la Mode,* and *World of Fashion.*

The majority of the Cooper-Hewitt's 18th-century and 19th-century silhouettes are of the cut-paper variety but also include those painted on cardboard, glass, plaster, and ivory. Silhouette artists include Auguste Amant Fidèle Edouart, John Miers, John Field, William Langford Holland, H. Gibbs, and Edmé Quenedey.

Finding Aids

● Card Catalogue for drawings and prints, arranged by accession number. Includes artist, title, date of execution, medium, dimensions, provenance, and description of subject.

● Artist Index for drawings and prints, arranged alphabetically by name of artist. Under name, lists works by medium and accession number.

● Box Listings (Shelf List), classified by drawings and prints. Within each classification: arranged by country, then by period, then by subject. Box listings

kept in individual storage boxes and as complete file in department office.
● Card Catalogue for Decloux Collection books. Cards arranged by artist and by subject (e.g., arabesques, architecture, chinoiserie, metalwork).
● Index to Fashion Plates, arranged by date (decade), by nationality, and by some subjects (e.g., brides, children, menswear). Fashion plates arranged by name of journal and chronologically under journal name.
● Summary Catalogue of Drawings by Identified Italian Architects. Unpublished file compiled in 1964, listing identified Italian architectural drawings of the 16th–20th centuries by name of architect.
● Summary Catalogue of Drawings and Prints Designed for Theater. Unpublished file compiled in 1965, listing many theater designs by name of artist. Also includes architectural fantasies, peep shows, landscape designs, and designs for festivals.
● Slides of Drawings. Transparencies of approximately 8,000 drawings available for viewing. (American drawings dating from 1820 to 1943 have been microfilmed by the Archives of American Art [see 1, above] and are available for viewing at regional offices of the Archives.)

Selected Publications

An American Museum of Decorative Art and Design: Designs from the Cooper-Hewitt Collection. Exhibition catalogue. London: Arts Council of Great Britain, 1973.
Drawings constitute the subject of a major chapter in this illustrated catalogue which accompanied an exhibition at London's Victoria and Albert Museum.
"The Architect's Eye." Richard P. Wunder. In: *The Cooper Union Museum Chronicle* 3 (September 1962): 3–47.
Wunder documents 147 architectural drawings, prints, books, and models drawn primarily from the museum's collections. Works are arranged chronologically and range from the design for a Gothic steeple (c1490–1500) to drawings by Eero Saarinen and Pietro Belluschi (1960s). Twenty-nine of the drawings are illustrated.
Close Observation; Selected Oil Sketches by Frederic Edwin Church. Exhibition catalogue with essay by Theodore E. Stebbins, Jr. Washington, D.C.: Smithsonian Institution Press, 1978.
This catalogue describes an exhibition organized for the Smithsonian Institution Traveling Exhibition Service. More than 100 of Church's oil sketches from the Cooper-Hewitt collection are discussed and illustrated.
The Cooper Union Museum Chronicle. New York. 1934–1963.
Published for 30 years, this journal included articles on various objects in the museum's collections. Articles were usually illustrated.
The Cooper Union Museum for the Arts of Decoration: An Illustrated Survey. New York: Cooper Union Museum, 1957.
This volume is the first picture book issued by the museum, on the occasion of its sixtieth anniversary. The 40 objects discussed and illustrated are intended to serve as an introduction to the scope and variety of the collections; more than a quarter of these items are works on paper.

Crosscurrents: French and Italian Neoclassical Drawings and Prints from the Cooper-Hewitt Museum. Exhibition catalogue with essay by Catherine Bernard. Washington, D.C.: Smithsonian Institution Press, 1978.
More than 100 representative French and Italian drawings of architecture and ornament are described and illustrated.
Drawn from Nature/Drawn from Life. Exhibition catalogue with essay by Jay E. Cantor. New York: American Federation of Arts, 1971.
In the catalogue of an exhibition organized for the Ithaca College Museum of Art, Cantor discusses nearly 50 studies and sketches by Frederic Edwin Church, Winslow Homer, and Daniel Huntington.
L'età Neoclassica a Faenza, 1780–1920. Exhibition catalogue by Anna Ottani Cavina et al. Bologna: Edizioni Alfa, 1979.
The theme of the 1979 Biennale D'Arte Antica was 18th-century art in Emilia and Romagna. The exhibition included 55 Emilian drawings—many of these illustrated—from the Cooper-Hewitt collection.
Etchings by the Tiepolos: Domenico Tiepolo's Collection of the Family Etchings from an Album in the Cooper-Hewitt Museum. Exhibition catalogue by George Knox and Elaine Evans Dee. Ottawa: The National Gallery of Canada, 1976.
This scholarly catalogue documents more than 200 etchings by the Tiepolos. The volume includes a bibliography, an index of titles, and a concordance of DeVesme, Rizzi, and Knox numbers.
Extravagant Drawings of the Eighteenth Century from the Collection of the Cooper Union Museum. Richard P. Wunder. New York: Lambert-Spencer, 1962.
The magnificence and variety of the museum's 18th-century European decorative arts drawings are revealed in the 79 works described and illustrated.
Five Centuries of Drawing: The Cooper Union Centennial Exhibition. Exhibition catalogue by Richard P. Wunder. New York: Cooper Union Museum, 1961.
This catalogue lists 100 drawings by 96 artists; 18 drawings are illustrated.
Frederic Edwin Church. Exhibition catalogue. Washington, D.C.: Smithsonian Institution Press, 1966.
In an exhibition organized by the National Museum of American Art, 85 of the exhibited works were from the Cooper-Hewitt collection.
Idee und Anspruch der Architektur Zeichnungen des 16. bis 20. Jahrhunderts aus dem Cooper-Hewitt Museum, New York. Exhibition catalogue by Elaine Evans Dee. Köln: Museen der Stadt Köln, 1979.
This exhibition provided a survey of architectural drawings and decorative designs, 16th–20th centuries, from the Cooper-Hewitt collection. The drawings, significant for their draftsmanship and imaginative qualities, reflect primarily idealized schemes rather than realized buildings.
Italian Drawings for Jewelry, 1700–1875. Rudolph Berliner. New York: Cooper Union Museum, 1940.
This essay on 18th-century and 19th-century Italian jewelry design and manufacture was intended to serve as an introduction to the Cooper-Hewitt collection. Four drawings are illustrated.

Japanese Woodblock Prints in the Collection of the Cooper-Hewitt Museum. Elaine Evans Dee and Thomas S. Michie. New York: Smithsonian Institution, 1979.

This volume describes the Cooper-Hewitt's collection of more than 500 *ukiyo-e* prints; 31 prints are illustrated.

Kata-gami: Japanese Stencils in the Collection of the Cooper-Hewitt Museum. Elaine Evans Dee and Thomas S. Michie. New York: Smithsonian Institution, 1979.

This volume describes the museum's collection of fabric-dyeing stencils; 31 representative stencils are illustrated.

Master Printmakers from Cooper-Hewitt Museum of Decorative Arts and Design. Exhibition catalogue by Elaine Evans Dee. New York: American Federation of Arts, 1970.

This pamphlet contains a checklist of 50 master prints; 7 prints are illustrated.

Nineteenth-Century Jewelry from the Cooper Union: First Empire to First World War. Exhibition catalogue. New York: Cooper Union Museum, 1955.

A few jewelry designs from the collection are illustrated.

Recent Acquisitions by the Cooper Union Museum: A Picture Book in Honor of Calvin S. Hathaway. New York: Cooper Union Museum, 1964.

This volume describes and illustrates 40 exceptional items, including prints and drawings. A late Gothic architectural drawing and cartoon drawings by Christine Malman are among the items illustrated.

The Royal Pavilion at Brighton. Exhibition catalogue. New York: Cooper-Hewitt Museum, 1977.

This illustrated catalogue accompanied an exhibition organized by The Royal Pavilion, Museums, and Art Gallery in Brighton, England, in conjunction with the Cooper-Hewitt Museum. Eighty-seven of the designs executed by John Crace and Son for the pavilion's decoration are listed.

The Two Sicilies: Drawings from the Cooper-Hewitt Museum. Exhibition catalogue by Elaine Evans Dee. New York: Finch College, 1970.

This volume includes 85 drawings, primarily Neapolitan and Sicilian, from the museum's collection; most of the drawings are illustrated.

Winslow Homer, 1836–1910. Exhibition catalogue by John Wilmerding and Elaine Evans Dee. Washington, D.C.: Smithsonian Institution Press, 1972.

More than 100 drawings, prints, and paintings from the Cooper-Hewitt collection are illustrated. An index by title of work is included.

Photoduplication Service

Available at prevailing rates, subject to rules and procedures of Cooper-Hewitt Museum.

Exhibition Program

Although the Department of Drawings and Prints does not have its own exhibition gallery, drawings and prints figure significantly in most of the museum's 12 major exhibitions per year. Additionally, the department is a constant and generous lender to exhibitions in the United States and abroad.

Loan Policy
Objects are loaned to institutions for exhibition. Borrowing institutions must file a facilities report. Drawings on wood-pulp paper are rarely loaned. Drawings and prints must not be exhibited longer than 8 consecutive weeks, and traveling exhibitions are restricted to a maximum of 5 showings. Decisions regarding loans are made by the Loan Committee.

Public Access
By appointment; Tuesday–Friday, 10–5. Special tours may be arranged. For reference service, write: Curator of Drawings and Prints, Cooper-Hewitt Museum, 2 East 91st Street, New York, New York 10028.

2B LIBRARY

The Cooper-Hewitt Museum Library, a branch of the Smithsonian Institution Libraries, is one of the outstanding design and decorative arts reference collections in America. Its holdings number approximately 33,000 volumes that date from the 15th century to the present and 16,000 art auction sales catalogues dating from the 1790s to the present. The subject areas of architecture, ornament, wallpaper, textile arts, and design are particularly well documented.

Many volumes in the library are rare and are illustrated with original woodcuts, engravings, or lithographs: 4 incunabula (books printed c1450–1500) include 2 copies of the *Nuremberg Chronicle* (1493), an early history of the world, illustrated with 1,000 woodcuts; a group of approximately 500 natural history color-plate books, mostly 18th–19th centuries, strong in botanical and ornithological works, including Albert Seba's *Locupletissimi rerum naturalium thesauri accurata descriptio* (Amsterdam, 1734–1765), Pierre Joseph Redouté's *Les Roses* (Paris, 1824), Mark Catesby's *The Natural History of Carolina, Florida, and the Bahama Islands* (London, 1731–1743), François Levaillant's *Histoire Naturelle des Oiseaux à Africa* (Paris, 1796–1812), Daniel G. Elliot's *A Monograph of the Paradiseidae* (London, 1873) and *A Monograph of the Phasianidae* (New York, 1872), both with hand-colored lithographs after Joseph Wolf and Joseph Smit; 17th-century and 18th-century architectural treatises, including works by Vitruvius, Andrea Palladio, Giovanni Battista Piranesi, Sebastiano Serlio, Giovanni Battista Falda, and Robert Adam.

The library's encyclopedic Picture Collection, begun by the Misses Hewitt as scrapbook collections of pictures of all kinds of subjects clipped from books and periodicals, now numbers more than 1.5 million items and functions as a design reference file. Classified by subject and period, the clippings have been enhanced

by the addition of photographs, engravings, greeting cards, fashion plates, and art reproductions. The George A. Kubler Collection of 66,000 woodcuts and engravings from 18th- and 19th-century magazines and the John Maximus Collection of reproductions of the work of commercial artists provide additional visual resources. The Thérèse Bonney Collection of 3,000 photographs documents art deco and art moderne decorative arts and fashions in Paris, 1925–1940.

Archival collections include the papers (correspondence, sketches, ephemera) of interior designer Mary McClelland, advertising and graphic designer Ladislav Sutnar, and industrial designers Henry Dreyfuss, Donald Deskey, and Frances Miller.

Finding Aids
- Card Catalogue for books, providing author, title, and subject access.
- Subject Guide to Picture Collection headings.
- Subject Index to Kubler Collection.

Photoduplication Service
Available at prevailing rates, subject to rules and procedures of the library.

Loan Policy
Limited interlibrary loan outside the New York metropolitan area is available for books in the general collection and for auction catalogues. Rare books, items from the Picture Collection, and archival materials are loaned only to institutions for exhibition, and with approval of the Librarian.

Public Access
By appointment; Monday–Friday, 9–5:30. For reference service, write: Librarian, Cooper-Hewitt Museum Library, 2 East 91st Street, New York, New York 10028.

3 | Freer Gallery of Art

7. James Abbott McNeill Whistler, *The Marble Palace*. Chalk and pastel on paper, 1879–80

8. Sheykh Muhammed, *Prince with a Parakeet*. Black line and gold on paper, tinted with red and green, c1575

9. Katsushika Hokusai, *Hyakunin Isshū Ubaga Etoki* (Poems by 100 poets as explained by a wet nurse), no. 45. Ink on paper (drawing for a woodblock print), c1780

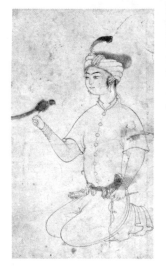

7

8

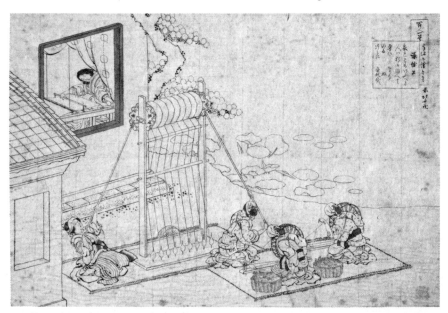

9

The Freer Gallery of Art houses one of the world's most distinguished collections of Far Eastern and Near Eastern art. The arts of China, Japan, Korea, India, and the Near East are represented by approximately 10,000 sculptures, paintings, manuscripts, ceramics, and lacquer and metal objects. A significant collection of 2,000 pieces of American art includes an important group of works (prints, paintings, drawings, and the Peacock Room) by James A. M. Whistler. Most of the museum's collection was donated to the nation by Charles Lang Freer (1856–1919), a Detroit industrialist who began acquiring art in the 1880s. Initially he collected the works of Whistler; this led to a friendship with the artist. Later, when Freer came to believe there was a relationship between Whistler's art and the art of the Far East, his collecting interests turned to Oriental art. Freer's promise to Whistler that his works would someday be housed in a public gallery, preferably one located in the nation's capital, led Freer to deed his collection to the nation in 1906. The collection moved to Washington when Freer died in 1919, and the gallery opened to the public in 1923. Additions to the Oriental collection are made each year through purchase and gift. Freer stipulated in his will that only objects in the collection could be exhibited in the Freer Gallery, and that these objects, once acquired, could not be loaned. A Study Collection of related materials not used for exhibition is available for comparison, laboratory analysis, and other educational purposes.

3A | ART COLLECTIONS

Paper was invented in China by the 2d century A.D., and its manufacture in the Far East subsequently reached a level of technical and aesthetic excellence unsurpassed in the ancient world. In China, Korea, and Japan, both paper and silk were used for paintings and calligraphy.

Chinese paintings in the Freer Gallery of Art number close to 1,000; of these, approximately 250 are on paper and date from the 12th to 20th centuries. Paintings in ink or ink and watercolor on paper are mounted as panels, hanging scrolls, handscrolls, albums, fans, and portfolios. Important early Chinese paintings on paper include a long 12th-century handscroll attributed to Fan-lung depicting the Buddhist subject of Sixteen Lohans, two 13th-century Ch'an (Zen) Buddhist hanging scrolls, a handscroll by Kung K'ai (1222–1304) depicting the travels of the demon-queller Chung K'uei, scroll paintings by Ch'ien Hsüan (c1235–1304), and the "Sheep and Goat" handscroll by Chao Meng-fu (1254–1322).

Calligraphy is regarded by the Chinese as the supreme artistic achievement. Examples of calligraphy on paper number approximately 20, excluding the numerous colophons or inscriptions written on or attached to paintings in the collection. Written calligraphy in the Freer collection dates from the 12th to 20th centuries and

includes 2 examples apparently written on single sheets of paper that measure over one meter wide and 3.5 meters long. More than 80 rubbings in ink on paper were made at later dates from engraved inscriptions on stone and tile which date from the 2d to 19th centuries. One important rubbing records an engraved inscription by Wang Hsien-chih (344–388). More than 400 other Chinese rubbings are kept in the Study Collection and record inscriptions and pictorial designs from stone carvings, tiles, and bronzes, some dated as early as the 12th century B.C.

Japanese works on paper are often enhanced with gold, silver, or other materials and include paintings in ink or ink and color. Paintings on paper number approximately 725, and date from the 12th to 20th centuries. The paintings are carried on panels, folding screens, fans, handscrolls, albums, and hanging scrolls. Important early works include 2 12th-century Buddhist sutras with illustrated frontispieces and calligraphy in gold ink on indigo-dyed paper. Among the several illustrated narrative handscrolls dating from the 13th to 16th centuries is the earliest extant example of the *Jizō Engi Emaki*. Other highlights of the painting collection include a round fan by Kōrin (1658–1716) and folding fans by Sesson (1504–1589) and Kenzan (1663–1743). Two of the 6 most important pairs of folding screens by Sōtatsu (fl. early 17th century) are among the Freer holdings. The collection is especially rich in paintings in the genre of *ukiyo-e*. Many of the painters of *ukiyo-e* also designed woodblock prints. Japanese woodblock prints number approximately 400, including some rare examples; the prints are complemented by 20 woodblocks with designs by major artists. Drawings include numerous works by Katsushika Hokusai (1760–1849), Kawanabe Gyōsai (1831–1889), and Andō Hiroshige (1797–1858).

Important examples in the developing collection of Japanese calligraphy (ink on paper) date from the 12th to 18th centuries and are mounted as handscrolls, hanging scrolls, albums, and folding screens. Additionally, some of the paintings accompany calligraphy. Manuscripts in the Study Collection contain a large group of drawings and calligraphy by Minagawa Kien (1734–1807).

Korean paintings on paper number 7 and include a recently acquired screen by Nanggök.

Illuminated and illustrated manuscripts from the Near East and India comprise approximately 1,000 folios (leaves), including both individual leaves and leaves in bound volumes. Manuscripts represent Christian, Islamic, Hindu, and Buddhist texts written in Arabic, Aramaic, Armenian, Coptic, Greek, Hindu, Persian, and Turkish; they date from the 3d century through the 19th century. Manuscripts are mainly on paper, with several examples on parchment, papyrus, and palm leaves. The Greek Biblical manuscripts are particularly significant, especially the "Washington Manuscript III," a 4th–5th century book of the Gospels; and the "Washington Manuscript V," a 3d-century papyrus roll of the minor prophets. The "Genizah Manuscript," a work from Cairo dated 11th–16th centuries, comprises 50 leaves in Arabic, Aramaic, and Hebrew. Significant manuscripts written in Arabic include early Korans executed on parchment, a copy of the *De materia medica* of Dioscorides completed in 1224 by Abdallah ibn al-Fadl, several folios from the 1315 *Automata,* and 83 leaves of a 14th-century *Ajaib al-Makhluqat* of al-Qazwini.

Fourteenth-century manuscripts written in Persian include the first illustrated version of the *Universal History* of al-Tabari and several copies of the *Shahnama* of

Firdausi. The early 15th-century *Diwan* of Sultan Ahmad Jalair, the early 16th-century *Anthology* with a painting signed by Behzad, and the mid-16th-century *Haft Awrang* of Jami are among the outstanding manuscripts in the collection, together with an album of drawings executed in the 17th century.

The manuscripts from Mughal India include a copy of the Persian translation of the *Ramayana* with 130 illustrations, 3 paintings from the oversized *Hamzanama* made around 1560, and folios from several imperial albums produced for Jahangir and Shah Jahan. One of the celebrated pre-Mughal works is the *Vasanta Vilāsa* scroll produced in the 15th century.

American paintings, drawings, and prints in the Freer collection number approximately 1,400, the majority of which are prints and drawings. Works by Whistler constitute the greatest number of American items and comprise 48 watercolors, 10 monochromes, 78 pastels, 66 pencil drawings, 11 pen and ink drawings, 6 drawings in pencil and watercolor, 193 lithographs, and 761 etchings. Etched copper plates number 38. Works by other American artists include 12 pastels and 3 silverpoint drawings by Thomas Wilmer Dewing; 3 watercolors and 36 pastels by Dwight William Tryon; 3 watercolors by Winslow Homer; one watercolor by Abbott Handerson Thayer; and one watercolor by Charles Adams Platt, the architect who designed the Freer Gallery building.

A few works on paper by English and European artists are in the Freer collection because of their association with Whistler. These include portrait prints of Whistler by Mortimer Menpes, Carlo Pellegrini ("Ape"), Thomas Robert Way, and Mrs. James A. M. Whistler; and portrait drawings of Whistler by Sir Edward Poynter, Emile Dessain, and George Butler.

Other graphic art in the Freer collection includes 85 zinc metal-cut plates by French artist Charles Gillot (1854–1903), done after drawings by Hokusai for a series of 100 prints, never completed, entitled *Hyakunin Isshū Ubaga Etoki* (Poems by 100 poets as explained by a wet nurse). The plates and impressions from them serve as a record for the incompletely preserved series of drawings by Hokusai.

Finding Aids

● Cumulative Card Catalogue for works of art, arranged in order of accession. Includes information on artist, title or subject, date of execution, media, and dimensions, with a small photograph of the work on the back of each card.

● Classified Card Catalogue, classified by medium or format (e.g., amber, bone, bronze, calligraphy, paintings, prints, manuscripts, rubbings). Within medium/format, subdivided by country of origin; within country of origin, subdivided by period, school, and artist if known. Includes information identical to Cumulative Card Catalogue, plus a small photograph on the back of each card.

● Information Sheets. Cumulative records kept on all objects in the collection. Include detailed curatorial and technical information compiled from the date of purchase on, notes made by each person who examines the object, and a bibliography on each object. Also include summaries of condition and treatment reports made by the Freer's Technical Laboratory. Detailed technical data retained in files of the Technical Laboratory.

Selected Publications

Armenian Manuscripts in the Freer Gallery of Art. Sirarpie Der Nersessian. Freer Oriental Studies, no. 6. Washington, D.C.: Smithsonian Institution Press, 1963.

More than 100 reproductions illustrate all the miniatures and decorative pages from the Armenian manuscripts in the Freer collection.

Art of the Arab World. Exhibition catalogue by Esin Atil. Washington, D.C.: Freer Gallery of Art, 1975.

This volume devotes a section of each chapter to manuscript illumination. Included are 50 reproductions of illuminated and illustrated folios from the Freer collection.

Brush of the Masters: Drawings from Iran and India. Exhibition catalogue by Esin Atil. Washington, D.C.: Freer Gallery of Art, 1979.

This catalogue documents and illustrates 82 drawings from the 15th to 18th centuries.

Chinese Figure Painting. Thomas Lawton. Washington, D.C.: Freer Gallery of Art, 1973.

Published on the occasion of the Freer's 50th anniversary exhibition, this volume describes and illustrates 58 paintings and examples of calligraphy, 19 of which are on paper.

The Coptic Manuscripts in the Freer Collection. William H. Worrell, ed. University of Michigan Studies, Humanistic Series, no. 10. New York and London: Macmillan, 1923.

This scholarly text illustrates 18 Coptic manuscripts in the Freer collection, including the Psalter, 2 fragments from Job, and 2 homilies dated 975.

A Decade of Discovery; Selected Acquisitions, 1970–1980. Exhibition catalogue by Julia K. Murray. Washington, D.C.: Freer Gallery of Art, 1979.

Works from China, Japan, Korea, India and Southeast Asia, and the Near East are described. More than 20 examples of painting, calligraphy, manuscript illumination, and prints are included.

East Christian Paintings in the Freer Collection. Charles Rufus Morey. University of Michigan Studies, Humanistic Series, no. 12. New York: Macmillan, 1914.

Two miniatures from a manuscript by Saint John Climacus and 8 miniatures from a manuscript of the Gospels are discussed.

Exhibition of 2500 Years of Persian Art. Exhibition catalogue by Esin Atil. Washington, D.C.: Freer Gallery of Art, 1971.

Thirty-nine examples of calligraphy, illumination, and painting from Iran are included.

Facsimile of the Washington Manuscript of the Minor Prophets in the Freer Collection. University of Michigan Studies, Humanistic Series, no. 21. New York, Macmillan, 1927.

The complete manuscript is reproduced.

Fragments from the Cairo Genizah in the Freer Collection. Richard J. H. Gottheil and William H. Worrell. University of Michigan Studies, Humanistic Series, no. 13. New York and London: Macmillan, 1927.

Fifty fragments of primarily Arab texts written in Hebrew are transcribed, translated, and discussed. The manuscripts deal with various aspects of Jewish life in Egypt, c1000–1500.

The Freer Gallery of Art. Tokyo: Kodansha, 1971, 1972; reprinted 1981.
Two volumes, one on China and one on Japan, include many color reproductions of
Chinese and Japanese art. The sections on paintings include works of art on paper.

The Illustration of an Epic: The Earliest Shahnama Manuscripts. Marianna
Shreve Simpson. New York: Garland, 1979.
Originally presented as the author's dissertation for Harvard University, the
volume describes and illustrates some of the Persian manuscripts in the Freer.

Masterpieces of Chinese and Japanese Art: Freer Gallery of Art Handbook.
Washington, D.C.: Smithsonian Institution, 1976.
Fifty-five Chinese and Japanese paintings on paper, including the Hiroshige sketch-
book of 75 studies, are described and illustrated.

The New Testament Manuscripts in the Freer Collection. Henry Arthur San-
ders. University of Michigan Studies, Humanistic Series, no. 9. New York:
Macmillan, 1918.
This scholarly text discusses the "Washington Manuscript of the Gospels" and the
"Washington Manuscript of the Epistles of Saint Paul." A facsimile of the former
was published by the University of Michigan in 1912.

The Old Testament Manuscripts in the Freer Collection. Henry Arthur San-
ders. University of Michigan Studies, Humanistic Series, no. 8. New York:
Macmillan, 1917.
The "Washington Manuscripts of Deuteronomy and Joshua" and the "Washington
Manuscript of the Psalms" are described. A facsimile of the former was published
by the University of Michigan in 1910.

*Paintings, Pastels, Drawings, Prints, and Copper Plates by and attributed to
American and European Artists, Together with a List of Original Whistleriana
in the Freer Gallery of Art.* Burns A. Stubbs. Washington, D.C.: Freer Gallery
of Art, 1967.
All of the American prints and drawings in the Freer collection are listed by artist,
then by medium; title of work, dimensions, and support are included. For prints by
Whistler, the corresponding Kennedy number is included.

Turkish Art of the Ottoman Period. Exhibition catalogue by Esin Atil.
Washington, D.C.: Freer Gallery of Art, 1973.
Nine examples of calligraphy, paintings, and drawings are illustrated.

Ukiyo-e Painting. Harold P. Stern. Washington, D.C.: Smithsonian Institu-
tion, 1973.
This volume, published for the 50th anniversary exhibition of the Freer Gallery of
Art, discusses the museum's Japanese genre paintings and studies. More than 100
works—paintings, drawings, studies, prints, woodblocks—are illustrated.

*The Vasanta Vilāsa: A Poem of the Spring Festival in Old Gujarātī accompa-
nied by Sanskrit and Prakrit Stanzas and Illustrations with Miniature Paint-
ings.* William Norman Brown, ed. New Haven, Conn.: American Oriental
Society, 1962.
The complete pre-Mughal work in the Freer collection is reproduced.

Ars Orientalis. Washington, D.C. 1—. 1954—. (Issued jointly by the Freer Gallery of Art and the Fine Arts Department, University of Michigan.)
Freer Gallery of Art. Occasional Papers. Washington, D.C. 1—. 1947—.
Freer Gallery of Art. Oriental Studies. Washington, D.C. 1—. 1933—.
These three irregular publications are devoted to the subject areas in which the Freer specializes and often contain articles on objects in the Freer collection.

Photoduplication Service
Available at prevailing rates, subject to rules and procedures of the Freer Gallery of Art.

Exhibition Program
At any one time, approximately 8 percent of the Freer collection is exhibited in the museum. Several special exhibitions are arranged each year; these may include, or may focus on, works of art on paper. Since the terms of Charles Lang Freer's bequest prohibit the Freer Gallery from borrowing objects, all exhibitions are drawn from the museum's own collections. Some exhibitions are accompanied by complete scholarly catalogues, while others are accompanied by an illustrated checklist. Checklists for exhibitions and leaflets on more general topics are distributed free in the museum. To date leaflets or brochures have been published on the following subjects relevant to this survey: *Art of the Court of Shah Tahmasp, Chinese Calligraphy, Islamic Calligraphy and Illumination,* and *Japanese Screens.*

Loan Policy
The terms of the Freer bequest prohibit accessioned objects from leaving the building, and also prohibit exhibition of objects borrowed from other collections. Some objects from the Study Collection may be loaned under restricted conditions.

Public Access
By appointment with curator responsible for the appropriate cultural area, American, Chinese, Japanese, or Near Eastern (including Indian) art; Monday–Friday, 10–4:30. Access may be restricted for works in fragile condition. Photography of objects not currently on exhibition is not permitted. For reference service, write: Freer Gallery of Art, Smithsonian Institution, Washington, D.C. 20560.

3B | LIBRARY AND ARCHIVAL COLLECTIONS

The Library of the Freer Gallery of Art maintains a collection of approximately 27,000 books dealing with subjects represented by the museum's art collections. A number of the books include original prints as illustrations, while others are port-

folios of Oriental prints. Included are some early woodblock-printed books from China and Japan. Other visual resources include approximately 30,000 slides and 8,000 photographs. A manuscript collection of approximately 600 letters includes correspondence by artists Thomas Wilmer Dewing, Abbott Handerson Thayer, Dwight William Tryon, James A. M. Whistler, and Frederick S. Church, plus correspondence between Charles Lang Freer and his associates. Many of the Church letters contain sketches.

The Freer Library maintains several archival collections for the Freer Gallery; two of these collections contain prints and drawings. The Myron Bement Smith Islamic Archives document portions of the student and professional life of this Yale-trained architect. In addition to approximately 10,000 photographs of Islamic content (half in negative form), notebooks, diaries, and correspondence, the collection contains: approximately 150 pencil-and-ink sketches and architectural drawings of the Masjid-i Juma in Isfahan and other Iranian monuments (1933–1937); 40 pencil-and-watercolor architectural designs done as student work in the 1920s; an album of bookplates designed by Smith; approximately 150 kalemkar (block prints) collected by Smith in Isfahan; architectural drawings by Robert VanNice, Smith's assistant in Isfahan.

The Ernst Herzfeld Archive (1905–1930s) deals with the archeologist's work in the Near East, particularly Iran. The collection is fully indexed and includes: approximately 5,000 black-and-white photographs; 700 architectural drawings and sketches of buildings, decorative details, inscriptions, pottery, textiles, and bronzes from Iranian and Syrian archeological sites; approximately 70 drawings of maps and site locations for Baghdad and the Euphrates Valley; 35 sketchbooks; over 200 "squeezes," three-dimensional molded paper impressions of cuneiform inscriptions taken from rock reliefs.

Finding Aids
• Card Catalogue for books, arranged alphabetically by author, title, subject, and artist.
• Index to Manuscript Collection, arranged by author of letter. Special files include names mentioned in correspondence, names of places, titles of artworks mentioned, and names of journals. Cards indicate whether letter contains sketch.
• Index to the Herzfeld Archive, organized by geographic location.

Photoduplication Service
Available at prevailing rates, subject to rules and procedures of Freer Library.

Loan Policy
Books and manuscripts are not loaned. Slides may be loaned.

Public Access
Monday–Friday, 10–4:30. For reference service, write: Librarian, Freer Gallery of Art, Smithsonian Institution, Washington, D.C. 20560.

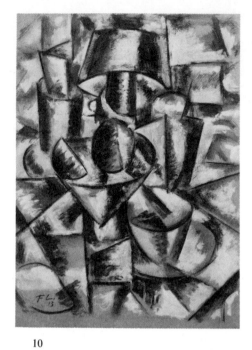

10

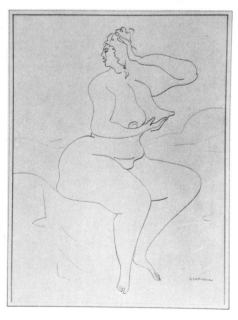

11

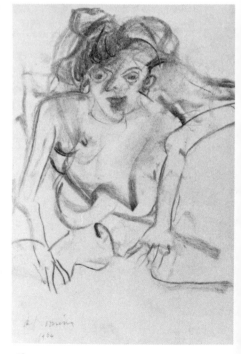

12

4 | Hirshhorn Museum and Sculpture Garden

10. Fernand Léger, *La Lampe*. Ink and gouache on paper, 1913
11. Gaston Lachaise, *Seated Nude*. Pencil on paper, c1928
12. Willem de Kooning, *Woman*. Pencil on paper, 1964

In 1966, financier Joseph H. Hirshhorn presented the nation with his personal collection of sculpture, paintings, prints, and drawings, the result of more than forty years of dynamic and discriminating acquisition. The subsequent opening of the Hirshhorn Museum and Sculpture Garden on the Smithsonian Mall in 1974 provided the nation's capital with its first major collection of contemporary art. The approximately 6,000 pieces donated by Mr. Hirshhorn reflect the scope and great variety of his collecting interests, ranging from 18th-century French sculpture to late 19th-century paintings by the American masters Eakins, Homer, Sargent, and Whistler, and to 20th-century sculpture, paintings, and graphics by acknowledged European and American masters. Small collections of Benin bronzes, antiquities, and pre-Columbian sculpture illustrate some of the sources of contemporary art. Many artists are represented in depth; the significant number of quality works by Thomas Eakins, Henry Moore, and Willem de Kooning, to name a few, provide an important research resource. Additions to the collection, through purchase and gift, continue to strengthen and expand the museum's program of documenting the major developments in modern art.

Works on paper number approximately 2,500 and consist of 1,200 drawings, 500 prints, and 800 watercolors. Art by European masters constitutes one of the major strengths of the Hirshhorn collection. Nineteenth-century works on paper include drawings by Jean-Baptiste Carpeaux, a watercolor by Antoine-Louis Barye, 2 wash drawings by Auguste Rodin, and the 1889 suite of 12 color lithographs by Pierre Bonnard, *Quelques Aspects de la Vie de Paris.* Twentieth-century European works on paper include important individual works by major artists and significant numbers of works by others: 4 drawings by Fernand Léger, plus his fine Cubist gouache *La Lampe* of 1913; 6 drawings by Henri Matisse; 34 prints and 2 drawings and watercolors by André Masson; a 1942 crayon drawing by Balthus; 25 drawings of Berlin life by George Grosz; a 1920 etching by Jacques Villon, *Baudelaire avec Socle;* the 1922 suite *Kleine Welten* by Wassily Kandinsky which includes etchings, woodcuts, and color lithographs; several studies by Hans Richter for the 1943 painting *Victory in Stalingrad,* also owned by the museum; a 1914 Cubist watercolor, *Landscape,* by Man Ray; a 1940 drawing by László Moholy-Nagy. Graphic art by Picasso consists of a 1938 pencil drawing (a portrait of Dora Maar) and 75 prints, 28 of which are linocuts, including 2 important linocuts entitled *Nature Morte sous la Lampe.* British painter Graham Sutherland is represented by a watercolor and the lithographic series *A Bestiary and Some Correspondences,* 1965–1968; David Hockney is represented by the 1973 ink drawing *Portrait of Henry Geldzahler.*

Thomas Eakins (1844–1916), Louis Eilshemius (1864–1941), Oscar Bluemner (1867–1938), and Philip Evergood (1901–1973) are examples of the museum's concentration on individual artists. The Thomas Eakins collection, one of the largest in the country, derives from collections originally belonging to two of Eakins's former students. The collection comprises paintings, drawings, sketches for major compositions, photographs, documents, and memorabilia. The earliest sketches date from the 1850s, probably drawn when Eakins was a high school student; anatomical drawings date from the 1870s. Of almost 200 works by Eilshemius in the Hirshhorn collection, 75 are drawings or watercolors. The nearly 60 watercolors and drawings by early abstractionist Oscar Bluemner trace his career from

his early days in Germany to later accomplishments in America. The 68 pieces by Philip Evergood, one of the most extensive collections of his work in a public museum, include 36 works on paper.

The Hirshhorn Museum and Sculpture Garden holds a significant group of drawings by 20th-century sculptors such as David Smith, Alexander Calder, Constantin Brancusi, Alexander Archipenko, Giacomo Manzù, Alberto Giacometti, Jean Arp, Jacques Lipchitz, Gaston Lachaise, Marino Marini, George Segal, Reuben Nakian, Chaim Gross, Seymour Lipton, Ann Truitt, John Storrs, Theodore Roszak, and Robert Arneson. Some of these were done as preliminary studies for three-dimensional works in the Hirshhorn collection. Sculptor Henry Moore is another example of the museum's concentration on an individual artist; his nearly 60 sculptures are complemented by 20 works on paper.

Trends and developments in American art are well documented by the Hirshhorn collections. Graphic works by late 19th-century and early 20th-century American painters include pastels by William Merritt Chase, James A. M. Whistler, and Mary Cassatt; watercolors by Winslow Homer and John Singer Sargent; and 3 drawings by Childe Hassam. Twentieth-century American graphics include: drawings by Marsden Hartley; more than 20 watercolors by Milton Avery and more than 100 works on paper by Randall Davey; 7 drawings by sculptor Elie Nadelman which are complemented by 22 drypoints published posthumously in 1952 by Curt Valentin; 20 works on paper, including 2 portraits of Eilshemius, by Joseph Stella; 9 drawings by Max Weber and 8 by Arshile Gorky; a series of watercolors, 6 of dancer Isadora Duncan, by Abraham Walkowitz; an important 1924 collage, *Huntington Harbor,* by Arthur Dove; a 1921 watercolor by Thomas Hart Benton, *Artist in His Studio;* 9 gouaches by Jacob Lawrence; Reginald Marsh's 1948 wash drawing *Bowery Quartet;* 24 drawings and 22 prints by Raphael Soyer; prints and collages by William Dole; a drawing, c1950, by painter Myron Stout; a pastel by Georgia O'Keeffe; 75 prints by R. B. Kitaj; nearly 70 drawings and watercolors by poet e.e. cummings; 4 caricatures and 20 watercolors by David Levine. Six of The Eight—Henri, Luks, Davies, Shinn, Sloan, Prendergast—are represented by more than 50 drawings and watercolors.

Contemporary American masters are represented in depth and include: 23 works by Larry Rivers, including a portrait of Willem de Kooning; 3 drawings by Jasper Johns, one of which is a charcoal study for the 1960 *Painting with Two Balls;* the lithographic series *Stoned Moon* by Robert Rauschenberg; an important Richard Estes color silkscreen, *Qualicraft Shoes/Chinese Lady,* 1974; the *Aluminum Series* and *Copper Series* by Frank Stella; the *Haystack* and *Cathedral* series by Roy Lichtenstein; 14 works on paper by Robert Motherwell. The Hirshhorn holds nearly 50 works by Willem de Kooning, 17 of which are drawings. List Art Posters, commissioned from major artists in the 1960s and designed to stimulate appreciation of the poster as an art form, number approximately 50.

Finding Aids
Computer Printout, classified by medium into drawings, prints, watercolors. Within each class, organized alphabetically by artist. Provides title of work, date of work, medium and ground, dimensions, and original Hirshhorn collection number.

Selected Publications
Arshile Gorky: The Hirshhorn Museum and Sculpture Garden Collection.
Exhibition catalogue by Phyllis D. Rosenzweig. Washington, D.C.: Smithsonian Institution Press, 1979.
This catalogue documents and illustrates the 29 works by Gorky, including his drawings, in the Hirshhorn collection.
e.e. cummings: The Poet as Artist. Exhibition catalogue by Frank B. Gettings. Washington, D.C.: Smithsonian Institution Press, 1977.
All 67 works in the Hirshhorn collection are documented and illustrated.
George Grosz: The Hirshhorn Museum and Sculpture Garden Collection.
Exhibition catalogue by Frank B. Gettings. Washington, D.C.: Smithsonian Institution Press, 1978.
Thirty-seven works, primarily drawings and watercolors, are illustrated.
Louis M. Eilshemius: Selections from the Hirshhorn Museum and Sculpture Garden. Exhibition catalogue by Paul J. Karlstrom. Washington, D.C.: Smithsonian Institution Press, 1978.
The museum holds one of the most representative Eilshemius collections, almost 200 pieces. This catalogue documents and illustrates 85 of the works, many of them drawings or watercolors.
Oscar Bluemner: The Hirshhorn Museum and Sculpture Garden Collection.
Exhibition catalogue by Judith Zilczer. Washington, D.C.: Smithsonian Institution Press, 1979.
Fifty-two drawings and watercolors are illustrated.
Philip Evergood: Selections from the Hirshhorn Museum and Sculpture Garden. Exhibition catalogue by Kendall Taylor. Washington, D.C.: Smithsonian Institution Press, 1978.
This checklist documents 42 of the 68 Evergood works in the collection, including drawings and watercolors. Nine works are illustrated.
The Thomas Eakins Collection of the Hirshhorn Museum and Sculpture Garden. Exhibition catalogue by Phyllis D. Rosenzweig. Washington, D.C.: Smithsonian Institution Press, 1977.
This major publication documents all work by Eakins in the collection, including drawings and sketches for important paintings.
Twentieth-Century Sculptors and Their Drawings: Selections from the Hirshhorn Museum and Sculpture Garden. Exhibition catalogue by Cynthia Jaffe McCabe. Washington, D.C.: Smithsonian Institution Press, 1979.
An exhibition organized by the Hirshhorn Museum and Sculpture Garden and the Smithsonian Institution Traveling Exhibition Service, this catalogue illustrates 25 sculptures and 25 drawings by 25 sculptors.

Photoduplication Service
Available at prevailing rates, subject to rules and procedures of the Hirshhorn Museum and Sculpture Garden.

Exhibition Program
Approximately 4 to 6 small exhibitions are organized each year. Several larger exhibitions are also installed and are generally accompanied by an illustrated catalogue.

Loan Policy
Objects are loaned to institutions for exhibition. Borrowing institutions must file a facilities report concerning the area in which the work is to be exhibited. Loans must be approved by the Conservator, the Chief Curator, and the Director.

Public Access
By appointment with Curator of Prints and Drawings; Monday–Friday, 10–5. For reference service, write: Curator of Prints and Drawings, Hirshhorn Museum and Sculpture Garden, Smithsonian Institution, Washington, D.C. 20560.

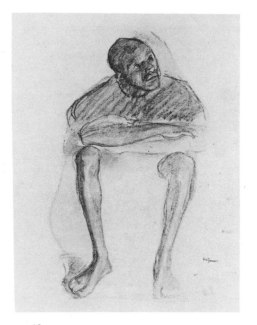

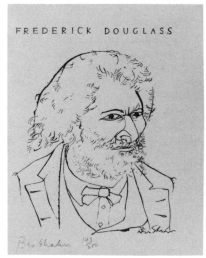

13

14

15

5 Museum of African Art

The Museum of African Art is the newest museum in the Smithsonian Institution, officially joining the commonwealth in August 1979. Founded by Warren M. Robbins in 1964, the museum houses nearly 9,000 objects and currently occupies nine renovated townhouses in the historic district of Capitol Hill. One of the houses was the first Washington residence of 19th-century black abolitionist and publisher Frederick Douglass. The primary collecting interest of the museum is traditional African sculpture; it also holds the largest extant collection of works, some 200, by 19th-century Afro-American artists. An archive of 100,000 slides, photographs, and film segments, the work and bequest of *Life* magazine photographer Eliot Elisofon, documents African art and environment.

5A | DEPARTMENT OF ART

Prints, drawings, and watercolors number approximately 750 and date from the late 19th and 20th centuries. Significant works of art on paper include: nearly 30 drawings, pastels, watercolors, and etchings by Henry Ossawa Tanner (1859–1937); nearly 30 watercolors and drawings by Edward M. Bannister (1833–1901), enhanced by a sketchbook-album of Bannister's that includes additional drawings, newspaper clippings, and photographs; some 20 drawings and prints by Afro-American artists William Johnson (1901–1970), Charles White, Hale Woodruff, Emma Amos, and Sam Gilliam, Jr. Other prints and drawings include: 13 prints by Ben Shahn, including his 4 serigraph portraits of Frederick Douglass (1965); four watercolors by Eliot Elisofon; approximately 500 19th-century wood engravings from *Harper's Weekly* which caricature black life in America; and 100 engraved maps of Africa which date from the 16th to 20th centuries.

Finding Aids
Index of Artists, arranged alphabetically by artist. Includes title of work, medium, edition, size, dimensions, source, and acquisition number.

Selected Publications
The Art of Henry O. Tanner (1859-1937). Exhibition catalogue with essays by Warren Robbins and Carroll Greene, Jr. Washington, D.C.: Smithsonian Institution, 1969.
Thirty-five items in this exhibition were from the Museum of African Art's collection of 60 works, the largest single collection of Tanner's work. Several drawings and watercolors are illustrated.

Photoduplication Service
Available at prevailing rates, subject to rules and procedures of the Museum of African Art.

Loan Policy
Objects are loaned to institutions for exhibition, with approval of the Curator and the Director.

Public Access
By appointment with Curator of Collections; Monday–Friday, 11–5. For reference service, write: Curator of Collections, Museum of African Art, 316-322 A Street, N.E., Washington, D.C. 20002.

5B | LIBRARY

The Library of the Museum of African Art is a branch of the Smithsonian Institution Libraries. Holdings include 7,000 volumes with a subject strength in African and Afro-American art and culture. Prints are limited to approximately 200 engraved plates, primarily 19th-century, from illustrated books on travels in Africa.

Finding Aids
Card Catalogue for books. Arranged alphabetically by author, title, and subject entries. Does not include finding aids for prints.

Photoduplication Service
Available at prevailing rates, subject to rules and procedures of the Museum of African Art.

Loan Policy
Books are available through interlibrary loan. Prints are loaned to institutions for exhibition, with approval of the Librarian and the Director.

Public Access
By appointment; Monday–Friday, 11–5. For reference service, write: Librarian, Museum of African Art, 316-332 A Street, N.E., Washington, D.C. 20002.

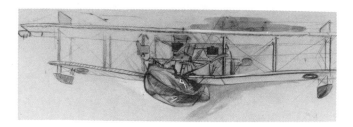

16

17

18

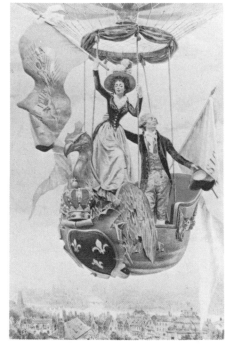

19

6 | National Air and Space Museum

16. Unidentified artist, *NC-4*. Pencil with watercolor on paper, c1920
17. Richard Lippold, *Triple Hero to the Sun*. Diazo print, 1971
18. Robert Rauschenberg, *Sky Garden*. Lithograph, 1969
19. Maurice Leloir, *Une Ascension, Il y a Cent Ans*. Color engraving, c1890

The new National Air and Space Museum opened to the public in the celebratory month of July 1976, revealing to the nation the world's largest collection of historical air and space materials. Documented by the museum's holdings are all aspects of flight, from kites and balloons to rockets and guided missiles to commercial aviation, aerial warfare, and speculation regarding future space exploration. Among the monuments of aviation history on view at the National Air and Space Museum are the Wright brothers' 1903 Flyer, Lindbergh's *Spirit of St. Louis*, the Apollo Lunar Module, the Viking Mars Lander, and the *Gossamer Condor*.

The construction of this museum building brought together various aeronautical artifacts which had been on display at the Smithsonian, albeit in temporary quarters, since 1920. In 1946, the National Air Museum was established "to memorialize the national development of aviation; collect, preserve, and display aeronautical equipment and data pertaining to the development of aviation; and provide educational material for the historical study of aviation." As collections grew and reflected advances in space flight technology, the name was changed to the National Air and Space Museum in 1966.

6A | DEPARTMENT OF ART

The Art Department of the National Air and Space Museum has curatorial responsibilities for the museum's 3,000 works of art, all of which illustrate themes related to air or space flight. Approximately 2,000 of these works are prints, drawings, or watercolors. The earliest works date from the 1780s and record manned balloon flights, while the most recent illustrate mankind's reach into space in the 1960s and 1970s.

The largest single collection of graphic art at the museum relates to America's space program. These 1,700 items were transferred to the museum during 1974–1978 from the National Aeronautics and Space Administration. Approximately 50 lithographs, 400 drawings, and 1,250 watercolors record the human and technological drama of America's manned space flight program, which started in the early 1960s and culminated in the Apollo missions to the moon, 1968–1972. In 1962, the National Aeronautics and Space Administration began an art program through which artists were asked to record those aspects of the space program each found most compelling. The first civilian agency of the government to invite artists to document its activities, NASA was assisted in the selection of artists by the National Gallery of Art. Prints from this program include a color lithograph by Robert Rauschenberg, monotypes by Mitchell Jamieson, lithographs by Albert Christ-Janer and John Meigs, serigraphs by Len Gittleman and Michael R. Fossick, woodcuts and serigraphs by Jack Perlmutter and Wilhelm Geissler, and etchings by

Giuseppe Tiberio (Madeleine). Artists who worked in watercolor include Henry C. Pitz, Peter Hurd, Dong Kingman, Jamie Wyeth, Billy Morrow Jackson, Stevan Dohanos, Paul Sample, Lamar Dodd, H. L. Cooke, Philip Jamison, Robert McCall, John W. McCoy, and Dale Myers. Artists who contributed drawings include William Thon, Theodore Hancock, Fletcher Martin, Mitchell Jamieson, Paul Calle, Tom O'Hara, and Mario Cooper.

The Harry F. Guggenheim Collection and the Bella C. Landauer Collection came to the museum from the American Institute of Aeronautics and Astronautics when its museum closed in 1962. The Landauer Collection incorporates prints, sheet music, and illustrated books on aeronautic themes. The 35 prints comprise a variety of 19th- and 20th-century ballooning and early aircraft subjects, including color woodcuts by Bai Sotei (1861) and Kunisada (1860), 2 color etchings by John Taylor Arms (1920s), and 2 etchings by Inger Veise (c1930). (The sheet music and books are now part of the National Air and Space Museum Library; see 6B.) The Harry F. Guggenheim Collection comprises 141 18th- and 19th-century prints, mostly English and French, which deal with ballooning and early air flight. Seven lithographs by Honoré Daumier published in Le Charivari are included.

Other significant graphic art in the National Air and Space Museum includes: 82 drawings of World War II heroes; 18 drawings and watercolors by pioneer space scientist Robert H. Goddard; watercolors by Alma Thomas; prints by Lowell Nesbitt, Man Ray, Pierre Alechinsky, and Roberto Matta Echaurren; and a series of ink drawings, by Hank Ketcham, of Dennis the Menace at the National Air and Space Museum.

Finding Aids
• Makers File, arranged by artist. Includes all artists in the American Institute of Aeronautics and Astronautics transfer and other assorted donations.
• Index to accession records, arranged by subject.
• Annotated List of 35 prints in the Landauer Collection. Includes artist, date, medium, subject.

Selected Publications
 "The Artist and Space." James Dean. In: *Interdisciplinary Science Reviews* 3 (September 1978), 244–59.
Dean directed the Art Program of NASA for most of its existence and describes here its philosophy and the work of its artists. The article is illustrated with some works now in the museum collection.
 Eyewitness to Space: Paintings and Drawings Related to the Apollo Mission to the Moon, Selected, with a few exceptions, from the Art Program of the National Aeronautics and Space Administration (1963 to 1969). Collaborator: Hereward Lester Cooke with James D. Dean. New York: Harry N. Abrams, 1971.
"Space travel," the author states, "started in the imagination of the artist, and it is reasonable that artists should continue to be witnesses and recorders of our efforts in this field." Hence, the efforts of NASA to document the space program are recorded in this volume, illustrated with 258 of the art works now in the NASM collection. More than 200 of these works are drawings or watercolors.

Photoduplication Service
Available at prevailing rates, subject to rules and procedures of the National Air
and Space Museum.

Exhibition Program
One gallery of NASM is devoted exclusively to exhibitions of art. Additionally,
prints and drawings are displayed in many other public galleries throughout the
museum, as well as in the NASM office area.

Loan Policy
Objects are loaned to institutions for exhibition, dependent on condition of the
individual piece and facilities of the borrowing institution. Loans are made with
approval of the Curator of Art and the Director.

Public Access
By appointment with Curator of Art; Monday–Friday, 10–4. For reference service,
write: Curator of Art, National Air and Space Museum, Smithsonian Institution,
Washington, D.C. 20560.

6B | LIBRARY

The Library of the National Air and Space Museum is a branch of the Smithsonian
Institution Libraries. Subject specializations encompass all aspects of the history of
aeronautics and astronautics, flight technology, astronomy, rocketry, and balloon-
ing; holdings number 30,000 volumes, 500,000 technical reports, and an archive of
over 900,000 aviation photographs, documents, and printed ephemera.

The Admiral DeWitt Clinton Ramsey Room houses the library's special collec-
tions of rare and unusual aeronautical and astronautical works, along with manu-
scripts and memorabilia. The Bella C. Landauer Collection contains 1,500 pieces of
19th- to early 20th-century sheet music, all with illustrated covers incorporating
flight themes, and 200 children's books illustrated with images of air or space flight.
The children's books date from the 19th and early 20th centuries and are mostly
American; the original Barney Baxters, Flash Gordons, and Buck Rogerses share
space with the likes of *The Children's Book of the Atmosphere* (Boston, 1833),
Sarah A. Myer's *The Balloon* (Philadelphia, 1855), and Sinclair Lewis's *Hike and
the Airplane* (New York, 1912). The William A. M. Burden Collection of early
ballooning works includes such illustrated examples as Vincenzo Lunardi's *An
Account of the First Aerial Voyage in England* (London, 1784), with the rare en-
graved frontispiece by Francesco Bartolozzi; Leopoldo Galluzzo's *Altre scoverte*

fatte nella luna dal Sigr. Herschel (Naples, 1836), with 6 hand-colored lithographs about a moon colonization hoax; and a scrapbook of early aeronautica (1783–1840) compiled by William Upcott which includes engravings and lithographs of balloons, aerostatic equipment, and suspended objects.

Finding Aids
● Card Catalogue for books; filed by author and title, with a separate subject file.
● Card Catalogue for sheet music; filed by title, composer, songwriter, and artist if known.

Photoduplication Service
Restricted, subject to condition of item and/or copyright status.

Exhibition Program
Small, temporary exhibitions of materials from special collections are installed in a display case in the library.

Loan Policy
Restricted. All loans are considered individually by the Librarian.

Public Access
Monday–Friday, 10–5:15. Public visitors must sign book at guard's desk on first floor of museum to visit NASM Library. For reference service, write: Librarian, National Air and Space Museum, Smithsonian Institution, Washington, D.C. 20560.

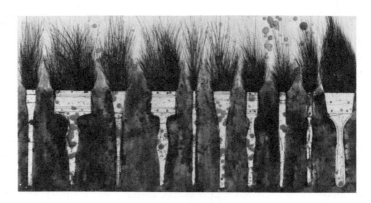

20

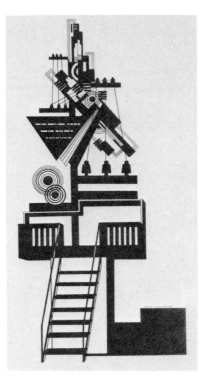

21

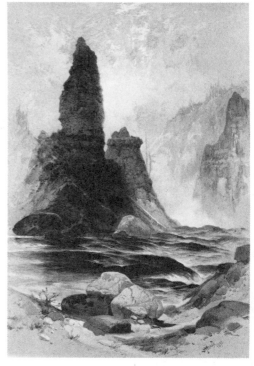

22

7 | National Museum of American Art

20. Jim Dine, *Five Paintbrushes* (fourth state). Etching, aquatint, drypoint, and mezzotint on paper, 1973

21. Louis Lozowick, stage setting for *Gas*. Pen and ink, brush and ink, tempera, and pencil on paperboard, 1926

22. Thomas Sidney Moran, *Canyon of the Yellowstone*. Watercolor on paper, 1872

The National Museum of American Art, formerly the National Collection of Fine Arts, is a center for the collection, exhibition, preservation, and study of American art. The collections actually predate the Smithsonian Institution, tracing their origins to privately and publicly owned works gathered together under the National Institute, founded in 1840. In establishing the Smithsonian Institution in 1846, Congress gave it authority over all works of art belonging to the federal government, not otherwise assigned. To the National Institute's holdings, other collections were added in the 1860s. The collection bore the title of The National Gallery of Art from 1906 to 1937; in 1937 it was renamed the National Collection of Fine Arts. Although the collection contains a relatively small number of European works from earlier donations, since 1968 the museum has focused on the arts of America. To emphasize this focus, in 1980 the name was changed to the National Museum of American Art. Sharing the renovated space of the Old Patent Office Building with the National Portrait Gallery and the Archives of American Art, and operating in addition the Renwick Gallery and the Alice Pike Barney Studio House, the National Museum of American Art contains more than 26,000 paintings, sculptures, prints, and drawings.

7A ALICE PIKE BARNEY MEMORIAL COLLECTION

Alice Pike Barney (c1859–1931) was a social and cultural leader in Washington, D.C., at the turn of the century. In her youth, she studied painting in Europe, most notably as a pupil of James A. M. Whistler, and painting remained her lifelong avocation. Mrs. Barney was a faithful donor of decorative arts to the Smithsonian, and in 1951, her two daughters, Laura Dreyfus-Barney and Natalie Clifford Barney, established a memorial collection at the National Museum of American Art. The collection now consists of oil paintings and pastels by Alice Pike Barney, art works purchased by Mrs. Barney and her daughters, approximately 1,500 decorative art objects, Studio House in Washington, D.C., and archival materials relating to Mrs. Barney and her family.

The 228 works of art on paper in the Barney Collection include 199 pastels by Mrs. Barney (portraits of family and friends, figure studies, and "pictorial interpretations"); an etching by Anders Zorn; watercolors by James Henry Moser, Francis Hopkinson Smith, Henry Bacon, Will Howe Foote, A. Arrunategin, Eyre de Lanaux, and others; pastels by Juliet Thompson and Pierre Carrier-Belleuse; and a charcoal drawing by Charles E. A. Carolus-Duran.

Finding Aids
Computer Checklist, arranged alphabetically by artist's name. Includes title of work, date, dimensions, medium, accession number, and signature.

Selected Publications
Alice Pike Barney: Portraits in Oil and Pastel. Washington, D.C.: Smithsonian Institution, 1957.
Ninety-nine works by Mrs. Barney, including her portraits of Whistler, G. K. Chesterton, George Bernard Shaw, and Edward Leiter, are illustrated.
Catalogue of the Alice Pike Barney Memorial Lending Collection. Delight Hall. Washington, D.C.: Smithsonian Institution, 1965.
This volume contains biographical notes, plus illustrations of 79 works by Mrs. Barney. A list of works by other artists in the collection—9 illustrated—is also included.
Where Shadows Live: Alice Pike Barney and Her Friends. Exhibition catalogue by Donald R. McClelland. Washington, D.C.: Smithsonian Institution Press, 1978.
Forty-one works from the Barney Collection, including some works of art on paper, are listed.

Photoduplication Service
Available at prevailing rates, subject to rules and procedures of the National Museum of American Art.

Exhibition Program
Many items from the Barney Collection are on view at Studio House, the Barney home on Sheridan Circle in Washington, D.C.

Loan Policy
Objects are loaned to institutions for exhibition, with approval of the Curator, the Registrar, and the Director. Pastels are restricted to borrowers in the Washington, D.C., area.

Public Access
By appointment with Assistant Registrar; Monday–Friday, 10–4. For reference service, write: Assistant Registrar, National Museum of American Art, Smithsonian Institution, Washington, D.C. 20560.

7B JOSEPH CORNELL STUDY CENTER

The Joseph Cornell Study Center, a curatorial and research unit within the Department of 20th-Century Painting and Sculpture, National Museum of American Art, comprises a variety of archival materials from the estate of American artist Joseph Cornell. The collection was a gift to the museum in 1978 from Mr. and Mrs. John

A. Benton, Cornell's sister and brother-in-law. Although the Study Center is devoted primarily to furthering research on the artist, materials are useful also to scholars working on ballet, theater, music, and Americana.

In addition to 900 books from Cornell's personal library, the collection includes approximately 3,000 pieces of graphic art collected by Cornell for reference and inspiration: 19th-century theater handbills, ballet-related souvenir lithographs, fashion plates, 19th-century birth and marriage certificates, postcards, maps, sheet music, programs, posters of early silent films, illustrations from books and magazines, bookplates, and an abundance of cartes de visite, mostly of theatrical figures. Nineteenth- and 20th-century photographs include works by Julia Margaret Cameron, Kay Bell, Man Ray, and Clarence John Laughlin, plus daguerreotypes, tintypes, and European scenic views. There are 2 collages by Cornell's sister Betty Voorhis (Benton) and 22 prints and drawings by artistic acquaintances of Cornell including Salvador Dali, Pavlik Tchelitchew, Ludwig Bemelmans, Muriel Streeter, Sonia Sekula, Hugh Kappel, and Julio de Diego. Sixty colored pencil-and-ink drawings by Robert Cornell, Joseph's brother who died in 1965, are mostly naive and many were done after art reproductions. Original works by Joseph Cornell include 5 drawings, 34 paper collages (17 finished, 17 unfinished), and 8 textile designs, tempera on paper, done while Cornell was associated with the Traphagen Design Studio, New York, c1934–1940.

Finding Aids
No finding aids for the collection currently exist, but an inventory is in progress. Upon completion of the inventory, researchers will have subject and media access to the documentary materials, artist and media access to artworks, and subject, title, and author access to books.

Photoduplication Service
Available at prevailing rates, subject to rules and procedures of National Museum of American Art.

Exhibition Program
An exhibition of Study Center materials, accompanied by a major publication on Cornell, is planned for 1982 at the National Museum of American Art.

Loan Policy
Objects are loaned to institutions for exhibition, with approval of the Curator, the Registrar, and the Director.

Public Access
By appointment; Monday–Friday, 10–5. For reference, write Curator, Joseph Cornell Study Center, National Museum of American Art, Smithsonian Institution, Washington, D.C. 20560.

7 C DEPARTMENT OF PRINTS AND DRAWINGS

The Department of Prints and Drawings was established in 1966 and now houses about 14,000 works of art on paper: approximately 7,000 of these works are prints, with the remainder divided between drawings and watercolors. The department was conceived of as a survey of American works on paper, and the collecting policy has emphasized the acquisition of representative examples by a wide range of major and minor American artists of all periods working in a variety of techniques. While the majority of works date from the 20th century, the collection does include examples of 18th- and 19th-century works.

Among significant 19th-century works on paper are 3 watercolors of birds by John James Audubon, 1811–1812; popular lithographs by Currier & Ives and other major lithographic firms of the period; a comprehensive collection of the etchings of J. Alden Weir, c1887–1893; watercolors by Winslow Homer and Frederick S. Church; sketches and watercolors of national parks and natural monuments of the American West, 1870s–1890s, by Thomas Moran; and 50 drawings by Elihu Vedder for the *Rubáiyát,* 1883–1884.

Several large collections of works by individual American artists have come to the nation as gifts and are part of the collections in the National Museum of American Art: drawings, watercolors, and prints by William H. Johnson (1901–1970); prints by Werner Drewes, one of the first Bauhaus-trained artists to settle in the United States; prints of urban landscapes and views of the southwest United States by Howard Cook; the works of H. Lyman Saÿen (1875–1918), a member of the Matisse circle in Paris in the early years of the 20th century; approximately 200 drawings by sculptor Paul Manship; drawings, watercolors, photographs, and memorabilia from sculptor Solon Borglum, painter Morris Kantor, and William and Marguerite Zorach.

Other prints and drawings that illustrate the developments and trends in American art during the 20th century, the period represented in greatest strength, are significant both in number and quality. Representative works include: 40 prints, drawings, and watercolors by seven artists of The Eight—Robert Henri, John Sloan, William Glackens, Everett Shinn, Arthur B. Davies, Maurice Prendergast, and George Luks; 5 lithographs by George Bellows; prints, drawings, and watercolors from the 1920s by Charles Demuth, Edward Hopper, and Charles Burchfield; a richness of works on paper from the 1930s and 1940s by artists such as Isabel Bishop, Reginald Marsh, Rockwell Kent, Martin Lewis, Yasuo Kuniyoshi, Louis Schanker, Peggy Bacon, Ben Shahn, Thomas Hart Benton, and Grant Wood. There are nearly 70 lithographs by Louis Lozowick, including *Crane* (1928), and 3 drawings that include one executed as a stage setting for *Gas.*

A gift of approximately 700 etchings from the Chicago Society of Etchers in 1935 includes works by members Gordon Grant, Bertha Jaques, Roi Partridge, John Taylor Arms, and Samuel Chamberlain.

Within the 20th-century collection, there are approximately 500 prints and numerous drawings produced by artists employed through New Deal art projects of the 1930s and early 1940s. The collection includes prints by Will Barnet, Stuart Davis, Dox Thrash, Elizabeth Olds, Russell Limbach, Raphael Soyer, Anthony Velonis, and many others. There are mural studies by Philip Guston, George S. Hill, Victoria Hutson Huntley, Anton Refregier, and Lee Gatch. A more recent federal art project is documented by the drawings and maquettes executed as studies for art pieces for installation in government buildings throughout the country. Sponsored by the General Services Administration (GSA) and the National Endowment for the Arts (NEA) through the Art-in-Architecture Program from 1972 to 1979, the nearly 90 works include drawings by Robert Arneson, Leonard Baskin, Rockne Krebs, George Segal, and Jack Beal.

Contemporary American artists represented in the Department of Prints and Drawings include Willem de Kooning, Richard Diebenkorn, Jim Dine, Richard Estes, Helen Frankenthaler, Red Grooms, Jasper Johns, Claes Oldenburg, Philip Pearlstein, Joseph Raffael, Robert Rauschenberg, Carol Summers, Wayne Thiebaud, Andy Warhol, and William T. Wiley.

Works by continental European and English artists number among some of the early gifts to the national art collections. A small group of late 19th-century and early 20th-century French works on paper, some a gift to the United States from the Republic of France in 1915, include a watercolor by Paul Signac, lithographs by Henri Fantin-Latour, etchings by Charles Daubigny, and a pencil drawing by Auguste Rodin. There is also a small collection of Italian Old Master drawings. Portrait miniatures include 6 profiles on paper, and the museum holds approximately 40 19th-century cut paper silhouettes.

Finding Aids
Computer Checklist, arranged alphabetically by artist. Includes title, date of work, birth/death dates of artist, dimensions, medium, and subject. Checklist also available in NMAA Office of Registrar.

Selected Publications
Across the Nation: Fine Art for Federal Buildings, 1972–1979. Exhibition catalogue. Washington, D.C.: Smithsonian Institution Press, 1980.
Eighty-eight projects commissioned by the General Services Administration and the National Endowment for the Arts for the Art-in-Architecture Program are described. Drawings and maquettes are illustrated.
American Prints from Wood. Exhibition catalogue by Jane M. Farmer, Washington, D.C.: Smithsonian Institution Press, 1975.
This catalogue of woodcuts and wood engravings documents and illustrates more than 100 prints, many from NMAA collections.
" . . . and there was light." Exhibition catalogue with essay by Abraham Rattner. Washington, D.C.: Smithsonian Institution Press, 1976.
Twenty-eight designs executed by the artist between 1957 and 1969 for the stained glass window in the Chicago Loop Synagogue are illustrated.

Art for All: American Print Publishing between the Wars. Exhibition catalogue by Janet A. Flint, Washington, D.C.: Smithsonian Institution Press, 1980. Flint discusses prints published or distributed by many of the artists' groups, gallery projects, or print societies formed between two world wars in order to create and promote American prints. Works from NMAA are included.

George Miller and American Lithography. Exhibition catalogue by Janet A. Flint. Washington, D.C.: Smithsonian Institution Press, 1976. This checklist documents 76 prints pulled by Miller for major American artists. Many of the prints are from NMAA collections.

H. Lyman Saÿen. Exhibition catalogue by Adelyn D. Breeskin. Washington, D.C.: Smithsonian Institution Press, 1970. This volume illustrates 46 works, a gift from the artist to the nation. Watercolors, drawings, and collages are included.

Herman A. Webster: Drawings, Watercolors, and Prints. Exhibition catalogue by Janet A. Flint. Washinton, D.C.: Smithsonian Institution Press, 1974. This checklist documents 75 works by the American etcher.

J. Alden Weir, An American Printmaker. Exhibition catalogue by Janet A. Flint. Provo, Utah: Brigham Young University Press, 1972. Flint describes and illustrates 65 etchings by Weir; 21 previously unrecorded prints, mainly unfinished works, are also listed and illustrated.

Jacob Kainen: Prints, A Retrospective. Exhibition catalogue. Washington, D.C.: Smithsonian Institution Press, 1976. Many of the artist's prints from NMAA collections are documented and illustrated. A checklist of all known prints by Kainen has been included.

Louis Lozowick: Drawings and Lithographs. Exhibition catalogue by Janet A. Flint. Washington, D.C.: Smithsonian Institution Press, 1975. Twenty-three drawings and 54 lithographs are listed, with 6 illustrations.

Modern American Woodcuts. Exhibition catalogue by Janet A. Flint. Washington, D.C.: Smithsonian Institution Press, 1973. This checklist includes 30 woodcuts from the 20th-century collection at NMAA. Representative artists include John Storrs, Max Weber, Wanda Gág, Irving Amen, Milton Avery, Carol Summers, and Lyonel Feininger.

Peggy Bacon: Personalities and Places. Exhibition catalogue by Roberta K. Tarbell and Janet A. Flint. Washington, D.C.: Smithsonian Institution Press, 1975. The first in-depth study of Bacon's life and work, this volume includes a checklist of 192 prints, all of which are illustrated. There is a listing of public collections, including NMAA, that hold copies of the prints and an index by title of prints mentioned in the checklist.

Prints for People: Selections from New Deal Graphics Projects. Exhibition catalogue by Janet A. Flint. Washington, D.C.: Smithsonian Institution Press, 1979. Sixty-seven prints done for the WPA/Federal Art Project and now in the NMAA collection are described.

Romaine Brooks, "Thief of Souls." Exhibition catalogue by Adelyn D. Breeskin. Washington, D.C.: Smithsonian Institution Press, 1971. Thirty-seven of the some 80 works in the NMAA collection are illustrated.

Solon H. Borglum, 1969–1922. Exhibition catalogue by Janet A. Flint. Washington, D.C.: Smithsonian Institution Press, 1972.
Eight sculptures and 15 drawings from the NMAA collection are listed.
Steinberg at the Smithsonian: The Metamorphosis of an Emblem. Exhibition catalogue with essay by John Hollander. Washington, D.C.: Smithsonian Institution Press, 1973.
Thirty-six drawings from a series done in 1967 when Saul Steinberg was Artist-in-Residence at the Smithsonian are illustrated. Each drawing incorporates the emblem of the Smithsonian from its official stationery.
Two Decades of American Prints, 1920–1940. Exhibition catalogue by Janet A. Flint. Washington, D.C.: Smithsonian Institution Press, 1974.
This listing of 76 works by 76 printmakers includes many items from the NMAA collection. Prints by Abraham Walkowitz, John Marin, Milton Avery, and John Taylor Arms are mentioned.
Werner Drewes Woodcuts. Exhibition catalogue by Jacob Kainen and Caril Dreyfuss. Washington, D.C.: Smithsonian Institution Press, 1969.
More than 30 prints are listed and illustrated.
William H. Johnson, 1901–1970. Exhibition catalogue by Adelyn D. Breeskin. Washington, D.C.: Smithsonian Institution Press, 1971.
This major publication on a prominent Afro-American artist illustrates 52 watercolors and gouaches, 11 drawings, and 11 prints. All these works were a gift from the Harmon Foundation to NMAA in 1967.
WPA/FAP Graphics. Exhibition catalogue with essay by Francis V. O'Connor. Washington, D.C.: Smithsonian Institution Press, 1976.
This exhibition, organized by the Smithsonian Institution Traveling Exhibition Service, included 33 prints from NMAA. Eleven works are illustrated.

Photoduplication Service
Available at prevailing rates, subject to rules and procedures of National Museum of American Art.

Exhibition Program
Selected works from the Department of Prints and Drawings are installed in an area on the first floor of the museum; exhibitions are changed every 6–12 months. Additionally, the department organizes and prepares approximately 4 special exhibitions per year that combine NMAA works with works borrowed from other institutions. These exhibitions are usually accompanied by a catalogue or checklist.

Loan Policy
Loans are made to museums for exhibition. Loans are generally limited to a period of 6 months. Loans must be approved by the Conservator, the Curator, the Registrar, and the Director of NMAA.

Public Access
Print and Drawing Study Room open by appointment with Curator; Monday–Friday, 10–4. For reference service, write: Curator of Prints and Drawings, National Museum of American Art, Smithsonian Institution, Washington, D.C. 20560.

7D LIBRARY

The Library of the National Museum of American Art and the National Portrait Gallery comprises nearly 40,000 volumes with an emphasis on American painting, sculpture, graphic arts and photography, American history and biography, and portraiture. A vertical file of information about American artists, art galleries, museums, societies, and other art institutions consists of some 400 drawers of clippings, pamphlets, and printed ephemera. Approximately 200 volumes are housed as a special collection of rare books, periodicals, and exhibition catalogues, some of which contain original prints as illustrations. Illustrated volumes include: Johann Caspar Lavater's *Essays on Physiognomy* (London, 1779–1798); a complete set of the French review of art, *Verve* (1937–1960); Richard Wilbur's *A Bestiary* (New York, 1955), with drawings by Alexander Calder; Josef Albers's *Interaction of Color* (New Haven, 1963); works by Leonard Baskin from the Gehenna Press.

The library holds 16 volumes of the *Random Records* of William Henry Holmes (1846–1933), anthropologist, archeologist, and director of the museum from 1920 to 1932. In addition to journal entries, correspondence, and documents, the *Random Records* contain a number of drawings, watercolors, and sketches by Holmes. The earliest, dated 1871, is a watercolor of the Smithsonian Mall; others include field sketches and drawings from his work and travels in the western United States and in Europe. Within the *Random Records,* there are several watercolors and sketches by artists other than Holmes, e.g., Thomas Moran and William Henry Jackson. The *Random Records* have been microfilmed for research use. An additional 50 sketches by Holmes, primarily undated field sketches not part of the *Random Records,* are also housed in the library.

Finding Aids
● Card Catalogue for books, periodicals, and exhibition catalogues, arranged alphabetically by author, title, and subject. May also include illustrator.
● Summary of contents for Holmes's *Random Records.* For each of 16 volumes, lists text, documents, and illustrations (photographs, drawings, watercolors, oils, sketches).

Photoduplication Service
No photocopies are made of rare materials. Photographs may be ordered, available at prevailing rates and subject to rules and procedures of National Museum of American Art–National Portrait Gallery Library.

Loan Policy
Books and exhibition catalogues in the general collection are available through in-

terlibrary loan. Periodicals do not circulate. Rare books are loaned with special permission of the NMAA–NPG Librarian.

Public Access

Monday–Friday, 10–5. For reference service, write: Librarian, National Museum of American Art–National Portrait Gallery Library, Smithsonian Institution, Washington, D.C., 20560.

8 National Museum of American History

23

24

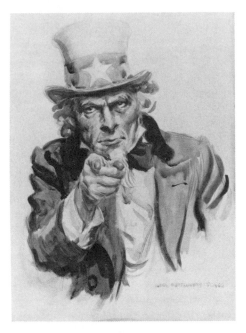

25

The National Museum of American History, formerly the National Museum of History and Technology, celebrates the American experience from colonial days to the present. The museum houses a multitude of collections which illuminate the entire history of the United States, including the external influences that have helped shape the national character: advertising, agriculture, ceramics and glass, clothing, commerce, domestic and community life, manufacturing, medicine, military history, mining, music, photography, politics, printing and printmaking, science and engineering, textiles, and transportation. Several of the collections are international in scope, most notably the renowned numismatic and philatelic collections. The Dibner Library Collection of rare books and manuscripts describing the history of science and technology is also located in this museum. (For a description of the Dibner Library Collection, *see* **12A**, Special Collections Branch, Smithsonian Institution Libraries.)

The museum's earliest collections derived from the Smithsonian's anthropological holdings; from transfers of patent models and the National Cabinet of Curiosities formerly in the United States Patent Office; and from objects exhibited in the 1876 Centennial Exhibition in Philadelphia. Many of these collections were originally housed in the Arts and Industries Building and the Smithsonian Institution Building.

The present building opened to the public in 1964. The name of the museum was changed to the National Museum of American History on October 14, 1980.

8A | COLLECTION OF BUSINESS AMERICANA

The Collection of Business Americana is a research collection consisting of approximately 1.5 million items related to American business and trade history. Holdings include a variety of printed materials, such as advertisements, trade catalogues, tickets, books, greeting cards, business documents, packaging labels, magazine covers, advertising cards, posters, postcards, and cartoons; approximately 25 percent of the collection consists of three-dimensional objects.

The Collection of Business Americana derives primarily from four archival business collections. The Warshaw Collection, which contains 1 million items illustrating business and advertising history, was begun by book dealer Isadore Warshaw in the 1920s and acquired by the Smithsonian in 1967; materials date primarily from the 19th and early 20th centuries, although a few items date from the 18th century. The N. W. Ayer Company Collection comprises 450,000 pieces of advertising material including page proofs for most of the published advertisements produced for Ayer's clients from 1889 to 1960. The Norcross Collection contains 50,000 greeting cards published by the company between 1920 and 1970. The Waterbury Company

Collection is composed of late 19th-century advertising objects, primarily clothing ornaments and military insignia. Other major groups of materials in the Collection of Business Americana include 15,000 postcards and approximately 500 fruit box labels.

Finding Aids
- Subject Index for all printed materials. No access through name of artist or designer.
- Warshaw Collection documents filed by size and subject, e.g., agriculture, baking powder, banking. Materials not listed by company name or product name.
- Trade catalogues arranged by subject; approximately 30 percent indexed by manufacturer.
- Norcross Collection (greeting cards) arranged by special day (birthdays) or celebration (Christmas, Easter, Valentine's Day).
- Ayer Collection (advertisement proofs) arranged by name of client; within client name, arranged chronologically.
- Postcards arranged by geographic location (country, state, city) and by selected subject categories, e.g., cats, World War I.

Photoduplication Service
Available at prevailing rates, subject to rules and procedures of the National Museum of American History.

Loan Policy
Loans are granted primarily to educational institutions for exhibition. Loans must be approved by the Curator and the Registrar and are subject to review by the Collections Committee of NMAH. An information sheet for borrowers is available from NMAH Office of Registrar.

Public Access
By appointment only. For reference service, write: Curator, Collection of Business Americana, National Museum of American History, Smithsonian Institution, Washington, D.C. 20560.

8B DIVISION OF CERAMICS AND GLASS

The Division of Ceramics and Glass maintains collections of ceramics and glass made in America, England, continental Europe, the Far East, and the ancient world. The approximately 50 prints and drawings related to these objects include: 12 paintings illustrating Chinese porcelain manufacture, first half of the 19th cen-

tury, gouache on paper; 4 ink-and-watercolor designs for stained glass windows in Westminster Abbey, c1890s; several prints of New York in the 1790s used as prototypes for transfer-printed English ceramics.

Finding Aids
None available.

Photoduplication Service
Available at prevailing rates, subject to rules and procedures of NMAH.

Loan Policy
Loans are granted primarily to educational institutions for exhibition. Loans must be approved by the Curator and the Registrar and are subject to review by the Collections Committee of NMAH. An information sheet for borrowers is available from NMAH Office of Registrar.

Public Access
By appointment with Curator; Monday–Friday, 10–5. For reference service, write: Curator, Division of Ceramics and Glass, National Museum of American History, Smithsonian Institution, Washington, D.C. 20560.

8c | DIVISION OF COMMUNITY LIFE

The Division of Community Life contains objects related to ethnic American cultural history and to daily life outside the American home. Collections encompass the fields of education, religion, sports, entertainment, and social, professional, fraternal, and labor organizations. Graphic arts date primarily from the 19th and early 20th centuries and include a variety of printed materials, among them schoolbooks; sports trading cards, mostly of baseball subjects; sheet music of popular American tunes; trade literature documenting American commercial organizations; cut paper puppets; sports and entertainment tickets and programs; movie, theater, and circus posters; prints of saints and other religious subjects, the American West, and circuses. Other notable items include: 20th-century rubbings of 17th- and 18th-century New England gravestones; copper plates engraved with images of saints; examples of fraktur, decorative handwriting practiced by German settlers in Pennsylvania; set designs by Don Roberts for the television show *All in the Family;* posters, booklets, and prints illustrating P. T. Barnum's *Greatest Show on Earth.*

Finding Aids
- Card Catalogue, filed by accession number. Generally includes information on date, maker, dimensions, and subject if known.
- Makers File, organized by artist/maker; in process.
- Subject File, classified under the categories of education, entertainment, commercial, community, religion, and sports; subdivided within each category into more specific subjects.

Photoduplication Service
Available at prevailing rates, subject to rules and procedures of NMAH.

Loan Policy
Loans are granted primarily to educational institutions for exhibition. Loans must be approved by the Curator and the Registrar and are subject to review by the Collections Committee of NMAH. An information sheet for borrowers is available from NMAH Office of Registrar.

Public Access
By appointment with Curator; Monday–Friday, 10–5. For reference service, write: Curator, Division of Community Life, National Museum of American History, Smithsonian Institution, Washington, D.C. 20560.

8D | DIVISION OF COSTUME

The Division of Costume collects representative examples of American fashion and periodicals that have influenced American fashion. Prints are limited to a research collection of approximately 3,200 fashion plates. A small but growing collection of about 40 original fashion sketches by 20th-century designers such as Balenciaga and Mad-Carpentier complement the costume collections.

Fashion plates are those published colored illustrations that serve as how-to-dress guidelines for women, men, and children. Printed in English, French, German, and American periodicals, they date from the 1790s through the 1890s. Consisting of engravings and lithographs, the fashion plates represent nearly 40 magazine titles of the 19th century—*Allgemeine Modenzeitung* to *Young Englishwoman*. Plates are organized alphabetically by title of magazine, then chronologically within title; a photograph file of some of these plates has been made to facilitate research. Additionally, the division houses significant runs of nine of the more influential fashion journals: *La Belle Assemblée, Le Bon Ton and Le Moniteur de la Mode United, Demorest's Monthly Magazine, Godey's Lady's Book, Graham's*

Magazine, Le Moniteur de la Mode, Peterson's Magazine, Le Petit Messager, World of Fashion.

A special collection of approximately 50 items includes satiric prints and cartoons of underwear, hairstyles, and other extremes of fashion, dating from the 18th to early 19th centuries.

Approximately 75 paper dressmaking patterns enhance the costume collections; several date from the late 19th century, but most date from the 1920s to the present.

Finding Aids
- Card Catalogue, filed by catalogue number. Provides title of print, name of magazine, date, dimensions, and source.
- Subject Index, listing plates by specific types/articles of dress, e.g., children's clothing, corsets, parasols, wedding attire.

Photoduplication Service
Available at prevailing rates, subject to rules and procedures of National Museum of American History.

Loan Policy
Loans are granted primarily to educational institutions for exhibition. Loans must be approved by the Curator and the Registrar and are subject to review by the Collections Committee of NMAH. An information sheet for borrowers is available from NMAH Office of Registrar.

Public Access
By appointment; Monday–Friday, 10–5. For reference service, write: Curator, Division of Costume, National Museum of American History, Smithsonian Institution, Washington, D.C. 20560.

8E | DIVISION OF DOMESTIC LIFE

The Division of Domestic Life collects and studies objects related to the American household from the 17th century to the present. Furniture, metalwares, objects of household technology, and examples of folk art used in the home are among the primary collecting interests. The division holds approximately 1,900 prints and drawings which illustrate aspects of everyday life in America's past. The folk art collections include approximately 50 works on paper from the 18th and 19th centuries (decorated family records, portraits, landscapes, calligraphic drawings, cut paper pictures, mourning pictures); 1,700 of the prints constitute the Harry T. Peters

America On Stone Lithography Collection. The majority of the prints and drawings date from the 19th century, although there are examples from the 18th and 20th centuries.

The division houses 19 architectural drawings of the Harral-Wheeler House of Bridgeport, Connecticut. Designed in 1846 by Alexander Jackson Davis, the house was an outstanding example of American Gothic Revival style. Although the building was torn down in 1958, one bedroom survives in a National Museum of American History installation. The collection includes 8 of Davis's drawings (ink and pencil with watercolor): 4 floor plans, 1 section, 3 elevations; and 11 drawings of ceiling and wall designs (3 pencil, 8 pencil and watercolor), probably produced by Anthony Kimball & Sons of New York. Because of their fragile condition, the Davis drawings have been photographed for research use.

Finding Aids
- Card Catalogue, arranged by catalogue number. Includes artist or maker, title, dimensions, date, and condition.
- Makers File, arranged by artist/maker. Includes title or subject of work, date, dimensions, and catalogue number.

Selected Publications
Bridgeport's Gothic Ornament: The Harral-Wheeler House. Anne Castrodale
Golovin. Washington, D.C.: Smithsonian Institution Press, 1972.
This essay discusses the Harral-Wheeler House and illustrates some of the drawings housed in the Division of Domestic Life.

Photoduplication Service
Available at prevailing rates, subject to rules and procedures of National Museum of American History.

Loan Policy
Loans are granted primarily to educational institutions for exhibition. Loans must be approved by the Curator and the Registrar and are subject to review by the Collections Committee of NMAH. An information sheet for borrowers is available from NMAH Office of Registrar.

Public Access
By appointment; Monday–Friday, 10–4:30. For reference service, write: Curator, Division of Domestic Life, National Museum of American History, Smithsonian Institution, Washington, D.C. 20560.

8. E1 Harry T. Peters *America On Stone* Lithography Collection

Harry T. Peters (1881–1948), coal merchant, sportsman, and print connoisseur, spent a lifetime collecting American lithographs. His research on lithographs and their makers led to three major publications on lithography. The 1,700 lithographs held by the Division of Domestic Life are those prints that formed the basis for Peters's work, *America On Stone: The Other Printmakers to the American People* (1931), the first general survey of American lithography. The prints were a gift to the Smithsonian Institution in 1959 from the family and heirs of Harry T. Peters.

The collection mostly encompasses, as Peters described it in his book, "the single-stone hand-colored American lithograph . . . from its appearance in 1819 to its practical disappearance, before other methods and media, in the eighties," although examples of lithography from as late as 1910 do appear in the collection. Peters viewed lithographs as "furtive scraps of paper pulled from yesterday's stones that still hold the pictures of the spirit of America in her romantic age." In addition to chronicling the course of American lithography for almost a century, the Peters Collection richly documents all aspects of 19th-century American life—politics, humor, fashion, family life, sport and social activities, westward expansion, war, rural and urban life, temperance, whaling, coaching, technical progress, and growing industrialization.

The prints represent the work of more than 100 American lithographers and lithographic firms: the Ackermans, Julius Bien, J. T. Bowen, Britton & Rey, J. H. Bufford, Childs & Inman, Francis D'Avignon, Peter Duval, the Endicotts, Ensign & Thayer, Charles Fenderich, Leopold Grozelier, August Hoen, the Kelloggs, Nagel & Weingaertner, Albert Newsam, Louis Prang, Henry R. Robinson, Sarony & Major, and Bass Otis, who is credited with making the first lithograph in America. Distinguished artists in the collection include John James Audubon, George Catlin, F. O. C. Darley, Rembrandt Peale, William Sidney Mount, Eastman Johnson, Winslow Homer, and Benjamin Russell. (A notable, and deliberate, exception to the Peters Collection is the work of Currier & Ives, perhaps the best-known American lithographers and the subject of another book by Peters. Only 20 Currier & Ives prints are found in the collection, the bulk of Peters's Currier & Ives prints having been donated to the Museum of the City of New York.)

The Peters Collection contains approximately 80 views of California in the 1840s–1860s, including 8 lettersheets, stationery incorporating lithographed scenes of frontier life. Among the collection's lithographs is the first American one, a portrait of Rev. F. W. P. Greenwood printed in Boston in 1840 by William Sharp. The Peters Collection has been photographed to facilitate research.

Finding Aids

• Card Catalogue, filed by catalogue number. Provides all known information on

each print, including artist, title, medium, dimensions, lithographer, printer, place of printing, brief subject description.

• Makers File, arranged alphabetically by artist, by lithographer and/or lithography firm, by publisher, by printer.

• Subject Index, divided into 36 major categories (e.g., advertising, architecture, flowers, portraits), with numerous subheadings in each category. Each print listed under all applicable subject headings, often as many as 10 or 12. The categories "portraits" and "views" include all prints with identifiable persons or places.

Selected Publications

America On Stone: The Other Printmakers to the American People. Harry T. Peters. Garden City, New York: Doubleday, Doran, 1931.

Peters described the work of numerous American lithographers and reproduced more than 150 prints from his own collection. Most of the illustrated prints are now part of the collection housed in the Division of Domestic Life.

Political Cartoons in the 1848 Election Campaign. Anne Marie Serio. Washington, D.C.: Smithsonian Institution Press, 1972.

The author illustrates her discussion with 9 cartoons from the Peters Collection.

Track and Road: The American Trotting Horse; A Visual Record 1820 to 1890 from the Harry T. Peters "America On Stone" Lithography Collection. Peter C. Welsh. Washington, D.C.: Smithsonian Institution Press, 1967.

This illustrated book on trotting prints includes a checklist of 83 such prints in the Peters Collection.

The Victorian American. Anthony N. B. Garvan and Peter C. Welsh. Washington, D.C.: Smithsonian Institution, 1961.

This illustrated essay provides a brief introduction to the Peters Collection.

The Way of Good and Evil: Popular Religious Lithographs of Nineteenth-Century America. Exhibition catalogue with essay by Janet A. Flint. Washington, D.C.: Smithsonian Institution Press, 1972.

This exhibition at the National Museum of American Art incorporated many prints from the Peters Collection, several of them illustrated.

Photoduplication Service

Available at prevailing rates, subject to rules and procedures of National Museum of American History.

Exhibition Program

Prints from the Peters Collection are incorporated into special exhibitions throughout NMAH and other Smithsonian museums.

Loan Policy

Loans are granted primarily to educational institutions for exhibition. Loans must be approved by the Curator and the Registrar and are subject to review by the Collections Committee of NMAH. An information sheet for borrowers is available from NMAH Office of Registrar.

Public Access

By appointment; Monday–Friday, 10–4:30. For reference service, write: Curator, Division of Domestic Life, National Museum of American History, Smithsonian Institution, Washington, D.C. 20560.

8F DIVISION OF ELECTRICITY AND MODERN PHYSICS

The Division of Electricity and Modern Physics houses those collections that deal with electricity, telegraphy, telephony, radio, television, and 20th-century physics. Prints and drawings are not actively collected, although many of the archival collections contain scientific notebooks with sketches and drawings. Approximately 40 graphic works include broadsides and prints of ships laying the Atlantic cable, published portrait prints of scientists by "Spy" (Sir Leslie Ward), and a 1911 etching of chemist Fritz Haber by Adolf Luntz.

Finding Aids
None available.

Photoduplication Service
Available at prevailing rates, subject to rules and procedures of National Museum of American History.

Loan Policy
Loans are granted primarily to educational institutions for exhibition. Loans must be approved by the Curator and the Registrar and are subject to review by the Collections Committee of NMAH. An information sheet for borrowers is available from NMAH Office of Registrar.

Public Access
By appointment; Monday–Friday, 10–5. For reference service, write: Curator, Division of Electricity and Modern Physics, National Museum of American History, Smithsonian Institution, Washington, D.C. 20560.

8G DIVISION OF EXTRACTIVE INDUSTRIES

Work in the Division of Extractive Industries deals with the history and technology of American agriculture, forestry, mining, the petroleum industry, and fisheries (including whaling). Graphic art is limited to 7 ink-and-wash drawings by Han Chin

U, a late 18th-century Korean artist, that depict scenes of Korean agrarian life.

Finding Aids
None available.

Photoduplication Service
Available at prevailing rates, subject to rules and procedures of National Museum of American History.

Loan Policy
Loans are granted primarily to educational institutions for exhibition. Loans must be approved by the Curator and the Registrar and are subject to review by the Collections Committee of NMAH. An information sheet for borrowers is available from NMAH Office of Registrar.

Public Access
By appointment; Monday–Friday, 10–5. For reference service, write: Curator, Division of Extractive Industries, National Museum of American History, Smithsonian Institution, Washington, D.C. 20560.

8H | DIVISION OF GRAPHIC ARTS

The Division of Graphic Arts houses a comprehensive collection documenting the history and technology of printing and printmaking. Approximately 10,000 original prints, 13,500 drawings, and 20,000 photomechanical prints illustrate most printing techniques and complement collections of printing presses, type and matrices, and engraving tools and plates. Small collections of tools used in the related crafts of papermaking and bookbinding, examples of printing for the blind and of banknote engraving, and printed maps are held for their technological interest.

The print collection contains work by artists of all nationalities and dates from the 15th century to the present. Approximately half of the prints are by American artists. The primary purpose in the division's print collecting has been to illustrate printmaking techniques in as much variety as possible; thus, the collection may include prints in several states of engraving and printing, together with the plates themselves. Drawings are collected as examples of a preparatory stage in the printmaking process. Significant holdings among the American print collection include some 150 wood engravings and woodcuts by Alexander Anderson and his school; nearly 50 wood engravings by Timothy Cole, including annotated proofs on India paper; nearly 300 etchings, plus drawings, watercolors, and plates by Stephen J. Ferris and J. L. G. Ferris; 50 etchings by Thomas Moran, plus a watercolor and a chromolithograph by Louis Prang of Moran's *View of Yosemite Valley;* some 80 chromolithographs done after J. J. Audubon's *Birds of North America*, primarily by Julius Bien & Company; approximately 2,000 lithographs by Currier & Ives;

numerous chromolithographs by Louis Prang & Company; 17 etchings by William Glackens for illustrations in the novels of Charles Paul de Kock; nearly 40 prints by John Sloan, including etchings, artist's proofs, and posters; 30 wood engravings, woodblock prints, and watercolor printing by Rudolph Ruzicka; nearly 80 prints, including 50 monotypes, by Charles W. Dahlgreen; almost 150 lithographs by Jean Charlot, in addition to working proofs, color trials, and published prints for the lithograph *Sunday Dress;* a series of annotated proofs from the lithographic workshop of Lynton Kistler. Works by European and Asian artists in the collection include: more than 30 works by Thomas Rowlandson, including caricature etchings and wash drawings; 31 etchings by Canaletto; some 20 engravings of Venetian views and monuments by Michele Marieschi (1710–1843); 27 color woodcuts by John Baptist Jackson (1701–1786); prints by German Expressionists Max Beckmann, Karl Schmidt-Rottluff, Erich Heckel, and Ernst Ludwig Kirchner; nearly 200 woodcuts, posters, and illustrated books by HAP Grieshaber; 168 intaglio prints by Sri Lankan artist Ranil Deraniyagala.

In addition to prints, the division holds a number of etched and engraved plates by various artists: e.g., Randall Davey, Stuart Davis, Chaim Goldberg, William Sartain, William Home Lizars for John James Audubon, and James E. Smillie. The collection of relief printing is enhanced by woodblocks and trial proofs by Irving Amen, woodblocks and progressive proofs for a color print by Carol Summers, plus blocks by Alexander Anderson, George Baxter, Friedrich Wilhelm Gubitz, Dox Thrash, and others. The division houses approximately 3,500 woodblocks used for illustrations in the publications of the Bureau of American Ethnology.

Drawings in the Division of Graphic Arts include approximately 13,000 pattern drawings for type matrices from the American Type Founders Company of New York, representing about 100 type families. A collection of cartoon drawings by American artists numbers approximately 300 and includes works by Rube Goldberg, Walt Disney, and John Tinney McCutcheon.

The 20,000 examples of commercial printing, including some 2,500 examples of early photomechanical printing (c1845–1880), constitute the primary strength of the Division of Graphic Arts. These holdings had their origin in the personal collection of John Walter Osborne, an early photolithographer who gathered experimental photomechanical works from his colleagues around the world during the 1860s. Examples of the photolithographic process include works by Osborne himself and other Australians; the American Photo-Lithographic Company of which Osborne was superintendent; L. H. Bradford of Boston; Ernest Edwards and Sir Henry James of England; Percival Gibbons of Scotland; Alphonse Louis Poitevin, Lemercier, and C. M. Tessie du Motay of Paris; Leggo Brothers of Montreal; and Toovey of Belgium. Early photomechanical relief prints include works by Brown, Barnes, and Bell (Luxotype); Pennington & Company; Charles Henry; Moss Engraving Company; Paul Pretsch; and Frederick E. Ives of Philadelphia, including an early experiment in three-color halftone. Photogravure is documented by the works of Joseph Nicéphore Niepce, Charles Nègre, Hippolyte-Louis Fizeau, William Henry Fox Talbot, Frederik von Egloffstein, Walter B. Woodbury, and others.

Finding Aids
• Card Catalogue, filed by Graphic Arts catalogue number. Provides title/subject, medium, dimensions, date of work, artist, and provenance.

• Makers File, organized by name of artist or printer. Lists prints by Graphic Arts catalogue number for each artist.
• Subject File (in process). To date, includes only American prints.
• Photomechanical File, classified by relief, intaglio, and lithographic process; within each classification, filed by maker or firm.
• Information Sheets, Include listings of all Currier & Ives prints and all original comic art in the division as of 1965.

Selected Publications

American Prints from Wood. Exhibition catalogue by Jane Farmer. Washington, D.C.: Smithsonian Institution Press, 1975.

This catalogue accompanied a show of wood engravings and woodcuts organized by the Smithsonian Institution Traveling Exhibition Service; more than 100 prints, many from the Division of Graphic Arts, are listed and illustrated.

Cut on Wood: The Art of American Wood Engraving, 1790–1900. Exhibition catalogue by Elizabeth M. Harris. Washington, D.C.: Smithsonian Institution Press, 1979.

This checklist of 73 prints, drawings, tools, and blocks accompanied an exhibition organized by the Division of Graphic Arts and the Smithsonian Institution Traveling Exhibition Service.

An Engraver's Potpourri: Life and Times of a 19th-Century Banknote Engraver. Exhibition catalogue by Elizabeth M. Harris. Washington, D.C.: Smithsonian Institution Press, 1979.

Listed are 72 works from a collection of prints that belonged to Stephen Schoff, a professional engraver of the 19th century, and are now in the Division of Graphic Arts.

The Etchings of Canaletto. Exhibition catalogue by Jacob Kainen. Washington, D.C.: Smithsonian Institution Press, 1967.

All 31 etchings, the complete etched oeuvre of Canaletto, are documented and illustrated.

In Touch: Printing and Writing for the Blind in the 19th Century. Exhibition catalogue by Elizabeth M. Harris. Washington, D.C.: Smithsonian Institution Press, 1981.

This booklet describes experiments in printing and writing systems for the blind, and the gradual acceptance of braille.

John Baptist Jackson: 18th-Century Master of the Color Woodcut. Exhibition catalogue by Jacob Kainen. Washington, D.C.: Smithsonian Institution, 1962.

A major publication on Jackson, this volume documents some 80 prints by Jackson and his workshop. Twenty-four of the prints are from the Division of Graphic Arts and are illustrated.

The Lithographs of Childe Hassam: A Catalog. Fuller Griffith. Washington, D.C.: United States National Museum, 1962.

This checklist of Hassam's 45 lithographs includes 31 works from the Division of Graphic Arts.

Mr. Audubon and Mr. Bien: An Early Phase in the History of American Chromolithography. Exhibition catalogue by Peter C. Marzio. Washington, D.C.: Smithsonian Institution Press, 1975.
Marzio lists 33 prints from the Division of Graphic Arts and discusses the chromolithographic process.
Pochoir. Exhibition catalogue by Elizabeth M. Harris. Washington, D.C.: Smithsonian Institution Press, 1977.
This distinctive volume contains an essay on pochoir, a stencil process, and illustrates a number of works from the collection.
What's in a Map? Exhibition catalogue by Elizabeth M. Harris. Washington, D.C.: Smithsonian Institution Press, 1976.
Twenty-four maps from the Division of Graphic Arts illustrate this essay on the making of maps.
Anatomy of a Gallop: Lithographs by Currier & Ives, Photographs by Eadweard Muybridge (1974).
Chaim Goldberg's Shtetl (1973).
Etching as a Painter's Medium in the 1880s (1974).
Mother and Child: Prints by Jean Charlot (1976).
Pop Hart (1972).
Prang's American Chromos (1973).
The above brochures, published by the Division of Graphic Arts to accompany exhibitions, are sparsely illustrated; they are available from the Division of Graphic Arts.

Photoduplication Service
Available at prevailing rates, subject to rules and procedures of National Museum of American History.

Exhibition Program
The Hall of Printing and Graphic Arts in NMAH is a long-term exhibition in which all kinds of printmaking processes are explained and illustrated. A small adjacent gallery holds special exhibitions from the collections; these exhibitions are changed every 6–12 months. A number of items from the collections which relate to the history of journalism are exhibited in the Henry R. Luce Hall of News Reporting, adjacent to the Graphic Arts Hall.

Loan Policy
Loans are granted primarily to educational institutions for exhibition. Loans must be approved by the Curator and the Registrar and are subject to review by the Collections Committee of NMAH. An information sheet for borrowers is available from NMAH Office of Registrar.

Public Access
By appointment; Monday–Friday, 10–5. For reference service, write: Curator, Division of Graphic Arts, National Museum of American History, Smithsonian Institution, Washington, D.C. 20560.

8I DIVISION OF MATHEMATICS

The Division of Mathematics collects objects that illustrate the historical and technological developments of mathematical instruments and machines. Graphic works are limited to blueprints of calculating machines and computer systems and to drawings and diagrams of geometric configurations and of electronic circuits. All graphics date from the 20th century.

Finding Aids
Computerized Checklist, classified by subject.

Photoduplication Service
Available at prevailing rates, subject to rules and procedures of National Museum of American History.

Loan Policy
Loans are granted primarily to educational institutions for exhibition. Loans must be approved by the Curator and the Registrar and are subject to review by the Collections Committee of NMAH. An information sheet for borrowers is available from NMAH Offices of Registrar.

Public Access
By appointment; Monday–Friday, 9:30–4:30. For reference service, write: Curator, Division of Mathematics, National Museum of American History, Smithsonian Institution, Washington, D.C. 20560.

8J DIVISION OF MECHANICAL AND CIVIL ENGINEERING

Collections in the Division of Mechanical and Civil Engineering document technological innovations and developments in all branches of the field of civil engineering, especially bridge and tunnel engineering; in power-producing machinery; and

in pumping and refrigeration equipment. Prints and drawings, dating from c1720 to 1970, number approximately 400 and are actively collected; for the most part, they illustrate bridges, hydraulic works, tunnels, and portraits of engineers and inventors. Additionally, many archival collections contain engineering drawings of steam engines and other prime movers, pumping engines, canal and railroad structures, and industrial buildings, as well as bridges and a wide variety of civil engineering works.

Significant prints in the collection include: 31 etchings of urban landscapes by Otto Kuhler (1920s); 34 offset lithographs of railroad depots and locomotives by Frederick Bartlett III (1960s); Thomas Sinclair's chromolithograph of Jasper F. Cropsey's 1865 painting *American Autumn, Starucca Valley, Erie R. Road;* William Strickland's aquatint of the Lancaster-Schuylkill Bridge; Frank B. Masters's poster of railways of the future (1920s); and a Baxter oil print, c1850, of the Britannia Tubular Bridge over the Menai Strait.

Other notable items are: 12 watercolors by Cecil K. Jennings of the Newburgh-Beacon Bridge under construction (1960s); 14 watercolors of American railway stations by Ranulph Bye (1960s); 5 drawings of the history of the rock drill by L. R. Bachelor (1947); and approximately 30 19th-century drawings on linen and paper of railroad bridges and stations of the Philadelphia & Reading Railroad.

Archival records that contain numerous drawings include: the Sun Shipbuilding & Dry Dock Company Collection with 500 engineering drawings of Wetherill Corliss engines, 1875–1921; the Southwark Foundry & Machine Works Collection with approximately 4,000 engineering drawings of power-producing machinery manufactured in Philadelphia, c1880-1920; the Erasmus D. Leavitt, Jr., Papers with approximately 3,000 engineering drawings of steam engines and mining machinery designed by Leavitt for the Calumet & Hecla Mining Company, c1874–1905.

Finding Aids
• Subject File for prints and drawings, classified under the heads: bridges, tunnels, lighthouses, mechanical engineering, recent art, and portraits. Includes title of work, date, description (engineering interest), and sometimes artist/maker.
• Inventory lists for archival collections.

Photoduplication Service
Available at prevailing rates, subject to rules and procedures of National Museum of American History.

Loan Policy
Loans are granted primarily to educational institutions for exhibition. Loans must be approved by the Curator and the Registrar and are subject to review by the Collections Committee of NMAH. An information sheet for borrowers is available from NMAH Office of Registrar.

Public Access
By appointment with Curator; Monday–Friday, 10–4. For reference service, write: Curator, Division of Mechanical and Civil Engineering, National Museum of American History, Smithsonian Institution, Washington, D.C. 20560.

8K | DIVISION OF MECHANISMS

Collections in the Division of Mechanisms embrace the historical and technological aspects of watches, clocks, typewriters, office equipment and supplies, phonographs, locks and keys, and automatically controlled devices. Graphic works comprise approximately 200 engineering drawings of watchmaking machinery, dating primarily from the early 20th century.

Finding Aids
None available.

Photoduplication Service
Available at prevailing rates, subject to rules and procedures of National Museum of American History.

Loan Policy
Loans are granted primarily to educational institutions for exhibition. Loans must be approved by the Curator and the Registrar and are subject to review by the Collections Committee of NMAH. An information sheet for borrowers is available from NMAH Office of Registrar.

Public Access
By appointment; Monday–Friday, 10–5. For reference service, write: Curator, Division of Mechanisms, National Museum of American History, Smithsonian Institution, Washington, D.C. 20560.

8L | DIVISION OF MEDICAL SCIENCES

The work of the Division of Medical Sciences deals with the historical development of medicine, dentistry, public health, and pharmacy. Approximately 3,500 graphic works dating from the 15th to 20th centuries illustrate various aspects of these fields.

The Squibb Ancient Pharmacy Collection was assembled in Europe and acquired in 1932 by E. R. Squibb & Sons; in 1951 it was placed on exhibit at the Smithsonian Institution. Along with pharmaceutical shelfware and utensils, the collection includes approximately 200 prints, books, and documents pertaining to European pharmacy in the 15th to 19th centuries, with emphasis on the 16th to 18th centuries. Graphic works include examples of calligraphy and manuscript illumination, cartoons of socialized medicine and traveling "quacks," prints of pharmacies and laboratories, and portrait engravings of botanists, pharmacists, and physicians. Woodcut illustrations are contained in early printed herbals, botanical works, pharmacopoeias, and formularies.

Three thousand prescription labels, the majority of which are printed, date from the early 19th century to the present. Originally tied to the necks of drug bottles, many of the labels contain symbolic imagery, coats of arms, or designs reflecting the art of healing.

Other graphic works in the division include: approximately 50 posters warning against venereal disease, c1914–1918; 6 World War I Red Cross posters, American and French, by Waldo Peirce, D. Charles Fouqueray, Harrison Fisher, and Jessie Wilcox Smith; 6 color woodcuts depicting Japanese medicine, late 19th century; approximately 300 19th-century lithographed botanical prints illustrating plants used in healing; 3 etchings of hospitals by Ernest D. Roth, 1940s; 4 lithographs of Civil War hospitals, 1860s, printed by Charles Magnus; contemporary posters, broadsides, and ephemera concerned with health.

Finding Aids
- List of books in the Squibb Ancient Pharmacy Collection.
- Inventory of graphic arts material (in process).

Selected Publications
The Squibb Ancient Pharmacy: A Catalogue of the Collection. George Urdang and F. W. Nitardy. New York: E. R. Squibb & Sons, 1940.
This is an illustrated checklist of the Squibb Collection as it existed in 1940.

Photoduplication Service
Available at prevailing rates, subject to rules and procedures of National Museum of American History.

Loan Policy
Loans are granted primarily to educational institutions for exhibition. Loans must be approved by the Curator and the Registrar and are subject to review by the Collections Committee of NMAH. An information sheet for borrowers is available from NMAH Office of Registrar.

Public Access
By appointment; Monday–Friday, 10–4. For reference service, write: Curator, Division of Medical Sciences, National Museum of American History, Smithsonian Institution, Washington, D.C. 20560.

8 M | DIVISION OF MILITARY HISTORY

Collections in the Division of Military History chronicle the history of the United States Army from the colonial period to the present day. Approximately 1,600 graphic works—including prints, drawings, posters, maps, sheet music covers, and cartoons—enhance the collections of uniforms, military dress, and heraldry.

World War I is the period best documented by the division's collections. There is a significant collection of drawings, charcoals, watercolors, and oil sketches by the eight illustrators commissioned to serve as official artists with the American Expeditionary Forces in France, 1917–1918: W. J. Aylward, W. J. Duncan, Harvey Dunn, George Harding, Wallace Morgan, Ernest Peixotto, J. A. Smith, and Harry Townsend. These eight produced some 700 pictures, of which the division holds approximately 500. The AEF works are complemented by examples of "soldier art" done by amateurs: 24 drawings by Rudolph Stanley-Brown, an American soldier-artist; 29 drawings by Will Dyson, a lieutenant with the Australian Imperial Expeditionary Force; 47 oil sketch portraits of American officers by Joseph Cummings Chase.

The Civil War is documented by a small collection of illustrated sheet music covers and fashion plates of military dress, the lithographs of Kurz & Allison and Louis Prang, and the etchings of Edwin Forbes. A number of sketches and drawings, some by participants in the war, record battles and camp life; artists include Alfred R. Waud, William DeLaney Trimble Travis, and Colonel Francis Titcomb of the Confederate States Army.

The military and war poster collection numbers approximately 1,100 and dates from the 1840s through the 1960s, covering conflicts from the Mexican War through the war in Vietnam. Nearly half the posters, American and foreign, are of World War I vintage and deal primarily with enlistment, recruitment, and conduct within the Army. Many of these posters were designed by such well-known illustrators as Howard Chandler Christy, J. C. Leyendecker, Gordon Grant, Willy Pogany, Charles Dana Gibson, and James Montgomery Flagg. Flagg's original watercolor sketch for the most famous of all war posters—Uncle Sam pointedly tells the viewer, *I Want You for the U.S. Army*—is also part of this collection, a gift to the Smithsonian from the artist. Two hundred and fifty of the posters date from World War II.

Original cartoon art comprises 6 ink drawings by Bill Mauldin for *Willie and Joe* (World War II), 2 by Lichty for *Grin and Bear It* (Vietnam War), and 6 by Mike Hodgson (Vietnam War).

Other significant graphic art in the Division of Military History includes: approximately 40 pencil and charcoal drawings, some by W. K. Sweeny, of the U.S. Army

in the West, 1890s–1900; lithographic views of Monterrey, Mexico, 1845–1846; American and European uniform studies, watercolor, 18th-20th centuries; 14 watercolors by Charles Johnson Post (1873–1956) of the Santiago Campaign during the Spanish-American War, 1898; and approximately 30 19th-century lithographs of the Revolutionary War and the War of 1812.

Finding Aids
• Card Catalogue, classified into format areas of pictorial art and poster art. Filed by name of donor; often includes information on artist, date, medium, subject.
• Checklist of works by the 8 artists with the American Expeditionary Forces, 1917–1918. Listed by artist, with title of work, accession number, catalogue number. All AEF works have been photographed for research use.

Selected Publications
Battle Art: American Expeditionary Forces, 1918. Exhibition catalogue by Edgar M. Howell. Washington, D.C.: Smithsonian Institution Press, 1967. Based on an exhibition in the National Museum of American History, this booklet describes 46 items and illustrates 10.

Photoduplication Service
Available at prevailing rates, subject to rules and procedures of National Museum of American History.

Exhibition Program
Graphic art is included in the permanent exhibition of the division's collection and, when appropriate, in temporary exhibitions.

Loan Policy
Loans are granted primarily to educational institutions for exhibition. Loans must be approved by the Curator and the Registrar and are subject to review by the Collections Committee of NMAH. An information sheet for borrowers is available from NMAH Office of Registrar.

Public Access
By appointment; Monday–Friday, 10–5. For reference service, write: Curator, Division of Military History, National Museum of American History, Smithsonian Institution, Washington, D.C. 20560.

8ᴺ DIVISION OF MUSICAL INSTRUMENTS

Collections in the Division of Musical Instruments are concerned with the history, technology, and performance of musical instruments in America and western Europe from the 17th century to the present. Although the division does not actively collect graphic art, it holds 2 original cartoon drawings related to musical instruments: a watercolor by Charles Addams and an ink drawing by Virgil Partch, both 1960s.

Finding Aids
None available.

Photoduplication Service
Available at prevailing rates, subject to rules and procedures of National Museum of American History.

Loan Policy
Loans are granted primarily to educational institutions for exhibition. Loans must be approved by the Curator and the Registrar and are subject to review by the Collections Committee of NMAH. An information sheet for borrowers is available from NMAH Office of Registrar.

Public Access
By appointment; Monday–Friday, 10–5. For reference service, write: Curator, Division of Musical Instruments, National Museum of American History, Smithsonian Institution, Washington, D.C. 20560.

8ᴼ DIVISION OF NAVAL HISTORY

The Division of Naval History is concerned with the history and activities of the United States Navy, Marine Corps, and Coast Guard. Approximately 2,000 prints, drawings, and watercolors complement collections of uniforms and accessories,

ship models, ship fittings, flags, navigation instruments, weapons, and equipment for polar and underwater exploration. Graphic works date from the 18th century to the present and include posters, maps, technical drawings, prints by European and American artists, and Japanese woodblock prints.

Posters in the collection number about 500 and primarily reflect recruitment efforts by the Navy and Marine Corps during World War I. Other posters illustrate wartime activities of civilian agencies such as Liberty Loans and Food Administration. Poster artists include Charles Dana Gibson, Howard Chandler Christy, Kenyon Cox, F. X. Leyendecker, and James S. Daughty. Posters by James Montgomery Flagg are enhanced by the artist's original watercolor sketch for the poster *Do You Want To Fight?* and his pencil sketch for *Tell It to the Marines!*

Prints include approximately 30 colored Japanese woodblock prints of the 1850s depicting the arrival of Matthew C. Perry in Japan, 19th-century lithographs of 18th- and 19th-century ships and naval battles, and engravings and lithographs of United States ports and harbors.

Significant among the drawings and watercolors are 5 charts of the coast of South America, 1790s, from the Spanish *Malaspina* expedition; nearly 80 drawings of naval activities during World War I by Vernon Howe Bailey; watercolors of shipyards and shipbuilding during World War I by Frederick K. Detwiller; watercolors and oil sketches by artists with the American Expeditionary Forces during World War I—W. J. Aylward, W. J. Duncan, Ernest Peixotto, J. Andre Smith; watercolors and oil sketches by combat artists serving with the Coast Guard during World War II; approximately 200 drawings and plans of ships by Howard I. Chapelle published in *The History of the American Sailing Navy* (1949). A collection of 1,000 pencil drawings of lighthouses and buoys date from the 1850s to the 1930s. Among archival holdings are more than 500 technical drawings, c1900–1950, of windlasses made for the U.S. Navy by the Hyde Windlass Company of Maine. The Thomas C. Dudley Papers, c1847–1864, contain wood engravings of China and Japan and sketchbooks kept by Dudley, a purser's clerk on the *Powhatan* with Perry's expedition to Japan.

Finding Aids
● Card Catalogue, arranged alphabetically by name of donor. Includes artist, medium, dimensions, date, subject.
● Subject/Format File, arranged alphabetically. Includes categories such as art, paintings, posters.

Selected Publicatons
The History of the American Sailing Navy. Howard I. Chapelle. New York: W. W. Norton, 1949.
Chapelle's history reproduces nearly 200 of the drawings housed in the Division of Naval History.

Photoduplication Service
Available at prevailing rates, subject to rules and procedures of National Museum of American History.

Loan Policy
Loans are granted primarily to educational institutions for exhibition. Loans must be approved by the Curator and the Registrar and are subject to review by the Collections Committee of NMAH. An information sheet for borrowers is available from NMAH Office of Registrar.

Public Access
By appointment; Monday–Friday, 10–5. For reference service, write: Curator, Division of Naval History, National Museum of American History, Washington, D.C. 20560.

8.P DIVISION OF PHOTOGRAPHIC HISTORY

Collections in the Division of Photographic History document the development of the art and technology of photography. The majority of the division's approximately 100 prints are wood engravings and lithographs published as illustrations in 19th-century American, French, and English journals such as *Harper's Weekly, Le Charivari,* and *Illustrated London News.* These include advertisements for daguerreotype studios, portraits of photographers, and scenes of photographers at work; illustrators include Honoré Daumier and Amédée de Noé ("Cham"). Motion picture prehistory is documented by hand-colored phénakistiscope (1832) and Fantascope (1833) discs, by zoetrope strips (c1867), and by woodcuts showing peep shows; the division also houses some of the actual early devices used to produce the illusion of motion. Books of the 16th and 17th centuries illustrate early versions of the camera. Examples of early photomechanical prints—Ippertypes, Woodburytypes, autotypes—document these techniques. The division holds 4 18th-century physiognotraces, one of which is by Gilles-Louis Chrétien, inventor of the process.

Finding Aids
● Card Catalogue, arranged by catalogue number. Provides information on artist, title, date, dimensions, condition, and provenance, as well as a brief description of the item. All catalogued holdings included in this file, prints along with artifacts.
● Makers Index, filed alphabetically by name of artist, illustrator, or maker.
● Title/Subject Index (in process).

Photoduplication Service
Available at prevailing rates, subject to rules and procedures of National Museum of American History.

Loan Policy

Loans are granted primarily to educational institutions for exhibition. Loans must be approved by the Curator and the Registrar and are subject to review by the Collections Committee of NMAH. An information sheet for borrowers is available from NMAH Office of Registrar.

Public Access

By appointment; Wednesday, 10–5. For reference service, write: Curator, Division of Photographic History, National Museum of American History, Smithsonian Institution, Washington, D.C. 20560.

8Q DIVISION OF PHYSICAL SCIENCES

The Division of Physical Sciences collects materials in the fields of the history of astronomy, chemistry, physics, and cartography. Prints and drawings date from the 17th to 20th centuries and complement the collections of scientific instruments and apparatus. Most of the approximately 200 graphic works are engravings, with the remainder divided among a variety of techniques. Almost half of the prints and drawings deal with astronomical subjects—celestial charts, pictures of globes and orreries, observatories and telescopes. Significant among the graphic works are:

1. woodcuts and engravings of celestial cartography from astronomical atlases, 17th–19th centuries.

2. engraved and lithographed maps of American cities, states, territories, and regions, 18th–19th centuries, including Andrew Ellicott's 1792 plan of Washington, D.C.

3. 18th-century prints of alchemists at work.

4. portrait prints of men and women of science, 17th–19th centuries.

5. 13 lithographs by E. L. Trouvelot, 1868–1878, of celestial phenomena such as eclipses, sunspots, and meteors.

6. 2 ink-and-wash sketches, 17th–18th centuries, of salt works and water purification plant, Volterra, Italy.

7. 2 watercolor sketches, c1895, by George Gladwin, of surveying activities.

8. "Urania's Mirror," 32 engraved cards illustrating celestial constellations; 19th century.

Finding Aids

Card Catalogue arranged by broad subject heading (e.g., astronomy, maps, scientific pictures) and by catalogue number within subject.

Selected Publications

The Sky Explored: Celestial Cartography 1500–1800. Deborah Jean Warner. New York and Amsterdam: Alan R. Liss & Theatrum Orbis Terrarum, 1979. Warner is Curator of the History of Astronomy in the Division of Physical Sciences. Twenty-three of the illustrations in this volume are works owned by the Smithsonian.

Photoduplication Service

Available at prevailing rates, subject to rules and procedures of National Museum of American History.

Loan Policy

Loans are granted primarily to educational institutions for exhibition. Loans must be approved by the Curator and the Registrar and are subject to review by the Collections Committee of NMAH. An information sheet for borrowers is available from NMAH Office of Registrar.

Public Access

By appointment; Monday–Friday, 10–5. For reference service, write: Curator, Division of Physical Sciences, National Museum of American History, Smithsonian Institution, Washington, D.C. 20560.

8R | DIVISION OF POLITICAL HISTORY

Collections in the Division of Political History document America's social, intellectual, and political movements from the pre-Revolutionary era through the present day. Approximately 3,500 graphic works illustrate aspects of American history such as political campaigns, protest movements, the presidency and presidential inaugurations, the White House and its First Ladies, the home front during war, abolition, women's suffrage, and modern women's history, black history, and Native Americans. Graphic works date from the 17th century to the present and encompass posters, American and European prints, drawings, watercolors, cartoons, maps, sheet music covers, portrait prints of famous Americans, 18th-century almanacs, tearsheets from 19th-century American journals, broadsides, and other printed ephemera.

Posters dealing with civilian efforts during World Wars I and II number approximately 1,700 and exhort citizens to such patriotic endeavors as "buy bonds," "be with him at every mail call," and "produce for victory." Issuing agencies include

the United States Food Administration, the Committee on Public Information, the Red Cross, Near East Relief Fund, National War Garden Commission, Liberty Loans, and War Savings Stamps. Poster artists include J. C. Leyendecker, Adolph Treidler, George Harding, Howard Chandler Christy, Boardman Robinson, Sidney H. Riesenberg, Edward Penfield, Albert Sterner, W. Haskell Coffin, Herbert Paus, A. H. Palmer, and Walter Whitehead. An additional 400 posters and broadsides, including some original art work for the posters, relate to national American political campaigns from 1789 to the present. Contemporary posters and placards reflect American protest and reform movements such as antiwar, civil rights, voting rights, gay rights, family planning, and women's rights. The original watercolor design by Dottie Erwin for the official poster of the International Women's Year Conference (1977) is housed in this division.

The division holds 30 pencil-and-watercolor sketches of the Washington, D.C., area (c1850), by General Montgomery C. Meigs (1816–1892), an Army engineer active in Washington from the 1840s until his death.

Cartoon art includes approximately 100 pen drawings by Herblock, Frederick Burr Opper, F. Victor Gillam, William A. Ireland, and James Swinnerton. Clifford Berryman, cartoonist for the *Washington Post* and *Evening Star* and famous for his 1902 drawing of Theodore Roosevelt as ''Teddy bear,'' is represented by 126 ink drawings, dating from 1906 to 1950. The Ralph E. Becker Collection of Political Americana yields 100 published wood engravings from *Harper's Weekly* by Thomas Nast, 1869–1885, complementing Nast's self-portrait in oil. Published political cartoons from *Puck* and *Judge* number approximately 300.

Approximately 25 maps of North America date from 1655 to the 1790s; most are engravings, with one early ink-and-watercolor drawing of Virginia and Florida. Cartographers and map publishers include: Pieter Schenk, Frederik de Wit, N. J. Visscher, Pierre Du Val, Gilles Robert de Vagondy, Guillaume Delisle, Hugo Allard, Jan Jansson, and Pierre Mariette.

Other graphic art in the Division of Political History includes: 74 pastels by Freida L. Reiter of major news events of the 1970s, including Watergate, covered by ABC News; 8 watercolors of famous homes of notable Americans by Henry W. Herrick (1870s–1880s); 2 ink-and-watercolor drawings by Joachim Richardt, 1858, of the U.S. Capitol and the Smithsonian Institution Building; watercolors by Robert Dudley of the laying of the Atlantic cable; an etching by Jacques Reich of Chief Justice John Marshall and a pencil drawing by Frank Bradstock of Justice John Harlan; a watercolor of Philadelphia's Memorial Hall by architect Samuel Sloan; design and decoration sketches, c1892–1944, in the scrapbooks of interior designer Grace Lincoln Temple, including her work for a Children's Room once located at the Smithsonian Institution Building.

Finding Aids

● Card Catalogue, filed by name of donor. May include information on artist, medium, date, subject.

● Subject File. Includes format categories almanacs, art, cartoons, documents, and pictorial; under these headings, objects identified by donor name and accession number.

Selected Publications

U.S. World War I Posters, from the Collection of the Smithsonian Institution's Division of Political History. Exhibition catalogue. Washington, D.C.: Smithsonian Institution Press, 1974.

This illustrated catalogue of war posters includes title, artist, dimensions, and issuing agency in illustration captions.

Photoduplication Service

Available at prevailing rates, subject to rules and procedures of National Museum of American History.

Loan Policy

Loans are granted primarily to educational institutions for exhibition. Loans must be approved by the Curator and the Registrar and are subject to review by the Collections Committee of NMAH. An information sheet for borrowers is available from NMAH Office of Registrar.

Public Access

By appointment; Monday–Friday, 10–5. For reference service, write: Curator, Division of Political History, National Museum of American History, Smithsonian Institution, Washington, D.C. 20560.

8s | DIVISION OF TEXTILES

Prints and drawings in the Division of Textiles are collected as research aids to document the history of American textiles and the development of textile technology. Graphic works comprise:

1. weaver's pattern book by Georg Laud, from the Reading, Pennsylvania, area, c1810–1850, containing 66 pen-and-ink drawings for coverlet patterns, both black/white and colored designs.

2. 50 fashion plates, most of which illustrate shawls. These are engravings and lithographs—published as guides on how to dress—from French and American fashion journals, 1806–1860s.

3. engraved plates of 4 textile subjects from Denis Diderot's *Encyclopédie* (1751–1765), illustrating lacemaking, embroidery, the stocking machine, and silk manufacture.

4. approximately 75 patterns for embroidery designs, primarily 19th century; pencil, ink, or watercolor on paper.

5. approximately 40 prints in various techniques illustrating textile industry activities, e.g., looms, factories, employment of women, the cotton industry.

Finding Aids
Short-Title List of graphic works.

Photoduplication Service
Available at prevailing rates, subject to rules and procedures of National Museum of American History.

Loan Policy
Loans are granted primarily to educational institutions for exhibition. Loans must be approved by the Curator and the Registrar and are subject to review by the Collections Committee of NMAH. An information sheet for borrowers is available from NMAH Office of Registrar.

Public Access
By appointment; Monday–Friday, 10–4:30. For reference service, write: Curator, Division of Textiles, National Museum of American History, Smithsonian Institution, Washington, D.C. 20560.

8T | DIVISION OF TRANSPORTATION

The Division of Transportation maintains collections in the fields of American marine transportation and maritime history, railroad and fire fighting equipment, and road vehicles (autos, carriages, cycles, buses, and trucks). Prints and drawings are actively collected, especially in the areas of rail and marine transportation, and presently number approximately 200. Many archival collections contain drawings and plans of ships, sails, ship fittings, and automobile bodies.

Lithographs of locomotives number approximately 30 and date from 1833 to 1870. Published by locomotive builders, the lithographs were actually engineering drawings of accurate mechanical detail which could be distributed as advertising material. Artist/engineers include Zerah Colburn, Charles T. Parry, S. L. Frizzell, Emil Reuter, and Matthias N. Forney; lithography firms include Bufford, Thayer, Brett, Crosby, Rosenthal, and Hoen. Other significant rail transportation material includes 7 watercolors by Howard Fogg (1950s), commissioned by author Lucius Beebe as book illustrations, and Reginald Marsh's 1948 lithograph *Switch Engines, Erie Yards, Jersey City.*

Graphic art illustrating road vehicles is limited to approximately 10 19th-century sketches of American carriages and approximately 15 prints, the most significant being 7 French posters advertising automobiles, c1890s–1910.

Approximately 50 prints illustrate aspects of American maritime history: sheet

music covers incorporating ships; engraved cards of sailing ships, c1849, used for advertisement; 15 engraved maps and ocean charts, 18th and 19th centuries, including Henry Popple's 1733 map of the British Empire in North America, the largest map of North America printed during the colonial period. Prints of American ports include Sarony & Major's 1846 lithograph of New York and Brooklyn, Britton & Rey's 1854 lithograph of Honolulu viewed from the Catholic church, Major & Knapp's 1864 lithograph of New Berne, North Carolina, and a 1760 engraving of Charlestown, South Carolina. Other significant prints include Currier & Ives's *Steamship Vanderbilt* and *A Night on the Hudson–Through at Daylight* by F. F. Palmer (1864), White and Brayley's chromolithograph of *The Grand Saloon of the World-Renowned Steamers "Bristol" and "Providence,"* and one of Anthony Imbert's lithographs of the celebration on opening of the Erie Canal (1826). Approximately 20 drawings relating to maritime history include watercolors of California lighthouses, a wash drawing by Robert Fulton of a steam engine (1807), and a watercolor of John Fitch's steamboat (1786) on a 1791 French patent. Archival resources include 26 drawings of eastern vessels by William Maxwell Blake; more than 1,000 drawings of American watercraft made for the Historic American Merchant Marine Survey, 1936–1937; drawings by marine historian Howard I. Chapelle, 1920s–1970s, many drawn for his numerous publications.

Finding Aids
• Index to locomotive prints, arranged by builder and railroad.
• Index to prints and drawings of marine transportation, arranged by type of craft or name.
• Card File of illustrative material for marine transportation. Includes information on type of ship, date of manufacture, date of print publication, and sometimes artist.

Selected Publications
The History of American Sailing Ships. Howard I. Chapelle. New York: W. W. Norton, 1935.
This volume illustrates many of the drawings in one of the division's archival collections.
"Locomotives on Stone." John H. White, Jr. in: *The Smithsonian Journal of History* 1 (Spring, 1966): 49–60.
White is Curator in the Division of Transportation and has illustrated his article with some of the division's locomotive lithographs.

Photoduplication Service
Available at prevailing rates, subject to rules and procedures of National Museum of American History.

Exhibition Program
Prints and drawings are incorporated into permanent exhibitions such as *Hall of American Marine Enterprise* and, when feasible, into small temporary exhibits.

Loan Policy

Loans are granted primarily to educational institutions for exhibition. Loans must be approved by the Curator and the Registrar and are subject to review by the Collections Committee of NMAH. An information sheet for borrowers is available from NMAH Office of Registrar.

Public Access

By appointment; Monday–Friday, 10–5. For reference service, write: Curator, Division of Transportation, National Museum of American History, Smithsonian Institution, Washington, D.C. 20560.

8U NATIONAL NUMISMATIC COLLECTIONS

The National Numismatic Collections record the use and manufacture of money as an integral part of the world's economic and social history. Collections of coins, paper currencies, and medals illustrate the history of money and monetary art, the history of banking and finance, and the history of medallic art.

The 500,000 pieces of printed currency date from 14th-century Chinese items to present-day American and European notes; these items are primarily the products of the letterpress or gravure process. The collections of paper currency contain the largest collection of foreign currency and scrip in the United States, and include more than 100,000 pieces of Austrian money from the 18th to 20th centuries. Paper currency of the United States numbers approximately 250,000 pieces that date from 1690 to the present and include colonial and Confederate notes; obsolete state banknotes, many with vignettes depicting scenes of everyday life in America; and certified proofs of United States currency, 1870s to the present, transferred from the United States Bureau of Engraving and Printing. Other printed items in the collection include checks, traveler's checks, bonds, and stock certificates. There is a special study collection of counterfeits. Some engraved plates used in the printing of currency are also part of the collection.

Original sketches for paper and hard currencies, and for medallic art, number approximately 100. Among artists, designers, engravers, and printers represented are the names of Nathaniel Hurd, Paul Revere, Benjamin Franklin, Thomas Sully, James Barton Longacre, Christian Gobrecht, William Kneass, and George T. Morgan.

The National Numismatic Collections house approximately 200 cartoon drawings, 1950s–1970s, pertaining to the use of credit cards, primarily the Diners Club card.

Finding Aids
None available.

Selected Publications
The Beauty and Lore of Coins, Currency, and Medals. Elvira and Vladimir Clain-Stefanelli. Croton-on-Hudson, New York: Riverwood Publishers Limited, 1974.
This comprehensive account of the historic role of money and medals includes illustrations of some of the paper currencies and scrip in the National Numismatic Collections.
"History of the National Numismatic Collections." Vladimir Clain-Stefanelli. In: *United States National Museum Bulletin. Contributions from the Museum of History and Technology* 229 (1970): 1–108.
In this history of the mission and growth of the National Numismatic Collections, the author reproduces some of the printed banknotes, as well as some of the drawings for coins, banknotes, and medallic art in the collection.

Photoduplication Service
Available at prevailing rates, subject to rules and procedures of National Museum of American History.

Exhibition Program
Numerous printed banknotes and currency are included in the permanent exhibition *History of Money and Medals* in NMAH.

Loan Policy
Loans are granted primarily to educational institutions for exhibition. Loans must be approved by the Curator and the Registrar and are subject to review by the Collections Committee of NMAH. An information sheet for borrowers is available from NMAH Office of Registrar.

Public Access
By appointment. For reference service, write: Curator, National Numismatic Collections, National Museum of American History, Smithsonian Institution, Washington, D.C. 20560.

8 V NATIONAL PHILATELIC COLLECTIONS

The National Philatelic Collections consist of more than 14 million items related to all aspects of postal history and philately. Most of the objects in the collections are postage stamps and are the products of three printing processes—letterpress, gravure, or lithography. A special collection of some 40,000 certified plate proof sheets for all United States postage stamps printed by the United States Bureau of Engraving and Printing since 1894 is unique.

The National Philatelic Collections contain some artist's designs for postage stamps, primarily United States stamps, and a few hundred postal route maps. There are approximately 25 satiric sketches drawn by British artists to ridicule William Mulready's official lettersheet issued in 1840; caricaturists include Jacob Bell, Thomas White, William Spooner, and John Leech.

Finding Aids
Card Catalogue, now in preparation, organized by country and chronologically within country. Researchers interested in pursuing design work by particular artists must know the country of origin and the date of the stamp for which the design was executed.

Photoduplication Service
Available at prevailing rates, subject to rules and procedures of National Museum of American History.

Exhibition Program
The permanent exhibition on the third floor of the museum contains representative examples of all aspects of postal history and philately, such as stamp design, postage stamps, postal route maps, postal stationery, and three-dimensional objects.

Loan Policy
Loans of National Philatelic Collections objects are not available.

Public Access
By appointment only. Application for appointment should be made in writing, preferably three weeks in advance, to: Curator, National Philatelic Collections, National Museum of American History, Smithsonian Institution, Washington, D.C. 20560.

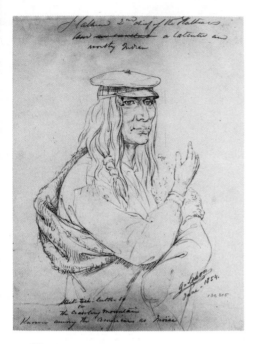

26

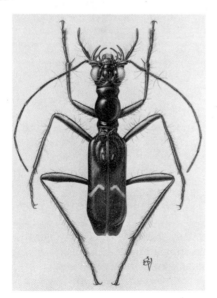

27

28

9 | National Museum of Natural History and National Museum of Man

26. Gustavus Sohon, *Streit-tish-lutse-so or the Crawling Mountain. Known among the Americans as Moise. 2nd chief of the Flatheads, a talented and worthy Indian.* Pencil on paper, 1854

27. Frederick A. Walpole, *Pinus monticola* Douglas ex Lambert (western white pine). Brush and ink on paper, 1899

28. George L. Venable, *Ctenostoma laeticolor* (Bates). Carbon dust on video paper, c1974 (for illustration in Terry L. Erwin, *Ground Beetles of Central America*, forthcoming)

Specimens of the natural world and its inhabitants have been part of the Smithsonian's collections and research programs since the Institution was established in 1846. Building on collections of specimens bequeathed by English chemist and mineralogist James Smithson, the eight distinguished naturalists and scientists who have headed the institution as Secretary have forged the Smithsonian into one of the world's major centers for the study of all aspects of natural history. Today, nearly 60 million specimens and artifacts that describe the anthropological, botanical, geological, and zoological worlds are incorporated into exhibitions and studied through specialized research in the National Museum of Natural History. Erected in 1911, this building and its later additions provide more than 20 acres of exhibition, storage, and research facilities. The National Museum of Man presently exists within the National Museum of Natural History as a concept that emphasizes the study of human culture and its relationship with the natural environment.

Scientific research in the seven departments of the museum—anthropology, botany, entomology, invertebrate zoology, mineralogy, paleobiology, and vertebrate zoology—is documented by a wealth of scientific drawings used to illustrate publications relating to natural history studies. These publications include monographs, professional journals, and the Smithsonian scientific series. Drawings date from the mid-19th century to the present and are the work of curators, staff illustrators, and commissioned artists. Although these drawings are not actually considered part of the accessioned and catalogued collections of the museum, they provide a visual resource for scientists, illustrators, and historians. Drawings and sketches in the manuscript and archival collections of the National Anthropological Archives have been catalogued or inventoried and are available to researchers through traditional finding aids.

9A | DEPARTMENT OF ANTHROPOLOGY

Collections and research in the Department of Anthropology pertain to the fields of archeology, ethnology, linguistics, and physical anthropology. Collections represent most cultures of the world, especially peoples of North America, Central and South America, Africa, Asia, and Oceania.

Historical materials, including works of art on paper, are generally housed in the National Anthropological Archives, a special unit within the Department of Anthropology (see 9A1. National Anthropological Archives). Scientific illustrations that date from the late 19th century to the present are retained in departmental offices. Approximately 8,000 drawings range from work by Edward Schumacher, the first full-time staff illustrator hired by the Smithsonian, to contemporary illustrations by Marcia P. Bakry, George Robert Lewis, and Ellen M. Paige.

Finding Aids **Photoduplication Service**

None available. Available at prevailing rates, subject to rules and procedures of National Anthropological Archives.

Public Access

By appointment only. For appointment with appropriate office, write: Chairman, Department of Anthropology, National Museum of Natural History, Smithsonian Institution, Washington, D.C. 20560.

9A1 National Anthropological Archives

The National Anthropological Archives was established in 1965 as the successor to the archives of the Bureau of American Ethnology, a federal organization founded in 1879 to conduct research among North American Indians. The National Anthropological Archives serves as a depository for official records of the Department of Anthropology (**9A**), and within the department as a special unit which collects and makes available to qualified researchers original manuscript and archival materials documenting human culture throughout the world and the history of anthropology.

Materials relating to Indians of North America, the traditional interest of the Bureau of American Ethnology, constitute the majority of the National Anthropological Archives' holdings; materials transferred from the present Department of Anthropology are primarily photographs which describe peoples of Central and South America, Africa, Asia, and Oceania. Manuscript and archival holdings comprise approximately 5 million items and date from the mid-19th century to the early 1970s. Photographs number nearly 250,000; most are dated between 1850 and 1930.

Prints and drawings in the National Anthropological Archives range from fine art to scientific illustrations to sketches by anonymous amateur artists. The greatest number of drawings and sketches portray North American Indian culture during the late 19th and early 20th centuries; many of these works were collected by soldiers and Indian agents. Among these holdings are, for example, almost 100 colored drawings of Indian activities, c1873–1876, by Dakota Indians; drawings of Hopi Kachinas, c1889–1900, by Hopi Indians; some 60 drawings by Acoma Indians of Kachina masks and other ceremonial objects, plus 40 watercolors (1928) by Henry Hunt of the same subjects; and 130 drawings by Alaskan Eskimos of native life, 1890–1900. Drawings by Gustavus Sohon, a private in the United States Army acting as guide and interpreter for a treaty-making and exploring expedition, date from 1853 to 1862; these record flora and fauna of the northwest territory, life among the Nez Perce, battle scenes, and Indian portraits. The papers of James Owen Dorsey include drawings for beadwork and other designs used by Siouan tribes (1879–1880), and drawings of Omaha Indian tents and robes, c1889, by

George Miller. The life of Sitting Bull (*d.* 1890) of the Hunkpapa Dakota is recorded in 3 pictographic series: 55 ink-and-watercolor drawings in a series by Four Horns date from 1870; 2 series in ink, pencil, crayon, and watercolor were drawn by Sitting Bull himself and date from 1882. Thirty-six pen-and-pencil drawings by Red Horse, 1881, describe the Battle of the Little Big Horn. More than 40 pencil-and-crayon drawings by the Kiowa, Making Medicine, were done between 1875 and 1878 while he was a prisoner at Fort Marion in St. Augustine, Florida. The Acee Blue Eagle (1907–1959) collection contains nearly 30 drawings in ink and pencil by Blue Eagle, and 36 paintings by Blue Eagle and other Indian artists; these works are primarily of tribal ceremonies, legends, and Indian designs. Thirteen drawings of sand paintings by Navajos date from 1935. Watercolors by Henry Wood Elliott date from the 1890s and depict fishing and hunting activities of Eskimos in Alaska and British Columbia.

Other works include 6 watercolor drawings by Alfred T. Agate portraying natives of Oceania, dating from Agate's assignment with the United States Exploring Expedition to the Pacific, 1838–1842; sketches by a crew member on Matthew C. Perry's expedition to Japan, 1852; drawings by anthropologists, ethnologists, and archeologists such as William Henry Holmes, Franz Boas, and Matilda Coxe Stevenson; and many of the original drawings used to illustrate the publications of the Bureau of American Ethnology and the United States National Museum.

Finding Aids
- Card Catalogue, arranged alphabetically by name of tribe, linguistic group, or name of individual. Includes date of material, brief subject description, where published, collector, and name of artist if known. Card catalogue covers approximately 25 percent of materials in National Anthropological Archives, primarily concerning North American Indians.
- Inventories and Registers for manuscript collections.

Selected Publications
 Catalog to Manuscripts of the National Anthropological Archives. Boston: G. K. Hall, 1975.
This 4-volume reference work reproduces the card catalogue of NAA. The catalogue primarily describes those collections relating to the Indians of North America. Format entries for drawings and illustrations are also included.

Photoduplication Service
Available at prevailing rates, subject to rules and procedures of NAA.

Loan Policy
Materials are loaned to institutions for exhibition, dependent on environment and security of borrowing facility. Loans are made by permission of the Director of NAA.

Public Access
Appointment preferred; Monday–Friday, 9–5. For appointment or reference service, write: Director, National Anthropological Archives, National Museum of Natural History, Smithsonian Institution, Washington, D.C. 20560.

9B | DEPARTMENT OF BOTANY

Research in the Department of Botany deals with all areas of plant systematics. Work is generally organized around the fields of cryptogams, ferns, grasses, palynology, phanerogams, and plant anatomy.

Drawings in the department consist primarily of published and unpublished scientific illustrations that date from the late 19th century to the present; most of this work has been done by the scientific staff, staff illustrators, or artists on contract. Among the department's holdings are approximately 150 drawings and watercolors by Frederick A. Walpole (1861–1904), one of the best scientific illustrators of the late 19th century. Walpole's drawings portray lilies, succulents, conifers, willows, and the flora of Alaska, Mexico, and Oregon. Twentieth-century scientific illustrations include the work of Mary Eaton, Regina O. Hughes, Florence Lambeth, Mary Monsma, Lyman B. Smith, Gesina Threlkeld, and Alice Tangerini.

Finding Aids
None available.

Selected Publications
"Frederick Walpole, Botanical Artist." James J. White. In: *Pacific Discovery* 31 (March–April 1978): 8–13.
Written by a former Supervisor of the Herbarium Services Unit in the Department of Botany, this biographical sketch of Walpole's life and career is illustrated with 10 of his drawings.
Paintings and Drawings by Frederick A. Walpole. Exhibition catalogue by John V. Brindle. Pittsburgh, Pa.: Hunt Institute for Botanical Documentation, Carnegie-Mellon University, 1974.
This brief catalogue lists more than 100 of Walpole's drawings and illustrates several.

Photoduplication Service
Available at prevailing rates, subject to rules and procedures of National Museum of Natural History.

Public Access
By appointment only. For appointment with appropriate office, write: Chairman, Department of Botany, National Museum of Natural History, Smithsonian Institution, Washington, D.C. 20560.

9 C DEPARTMENT OF ENTOMOLOGY

Scientific research in the Department of Entomology is based on the study of invertebrate animals of the terrestrial arthropod group, which includes insects, arachnids, and myriapods.

Scientific illustrations for publications are produced by artists on contract and by departmental staff illustrators. Approximately 9,000 scientific drawings are housed in the department; artists whose work is available include Lawrence Michael Druckenbrod, Elsie Froeschner, Elaine Hodges, Vichai Malikul, André Pizini, Young T. Sohn, and George L. Venable.

Finding Aids
None available.

Photoduplication Service
Available at prevailing rates, subject to rules and procedures of National Museum of Natural History.

Public Access
By appointment only. For appointment with appropriate office, write: Chairman, Department of Entomology, National Museum of Natural History, Smithsonian Institution, Washington, D.C. 20560.

9 D DEPARTMENT OF INVERTEBRATE ZOOLOGY

The Department of Invertebrate Zoology is concerned with scientific studies of marine, freshwater, and terrestrial invertebrate animals other than insects. Research is organized around the areas of crustaceans, echinoderms, corals, sponges, mollusks, and worms.

Approximately 6,000 drawings of invertebrate animals date from the late 19th century to the present day. Most of the drawings were executed primarily for use in

publications and were done by former or current scientific staff, staff illustrators, or collaborators. Drawings of crustaceans include works by Fenner A. Chace, Carolyn B. Gast, Harriet Richardson, Mary Jane Rathbun, Waldo L. Schmitt, and Clarence R. Shoemaker. Scientific illustrations of echinoderms include drawings by Addison Emery Verrill (late 19th century) and Maynard M. Metcalf (1920s), and Charles Cleveland Nutting's work on American hydroids (1900-1915). Research in mollusks and worms is also documented by scientific drawings; illustrations of mollusks by William Healey Dall and Paul Bartsch are particularly significant.

Finding Aids
None available.

Photoduplication Service
Available at prevailing rates, subject to rules and procedures of National Museum of Natural History.

Public Access
By appointment only. For appointment with appropriate office, write: Chairman, Department of Invertebrate Zoology, National Museum of Natural History, Smithsonian Institution, Washington, D.C. 20560.

9 E | DEPARTMENT OF MINERAL SCIENCES

Research in the Department of Mineral Sciences is involved with the study of meteorites, minerals, rocks, and volcanos. Most of the department's work is documented by photography; occasionally, scientific drawings are commissioned to illustrate publications.

Finding Aids
None available.

Photoduplication Service
Available at prevailing rates, subject to rules and procedures of National Museum of Natural History.

Public Access
By appointment only. For appointment with appropriate office, write: Chairman, Department of Mineral Sciences, National Museum of Natural History, Smithsonian Institution, Washington, D.C. 20560.

9 F | DEPARTMENT OF PALEOBIOLOGY

Scientific research in the Department of Paleobiology encompasses the fields of paleobotany and vertebrate and invertebrate paleontology. Sedimentology is a related field of study in the department.

Scientific drawings housed in the department illustrate the fossil remains of plants and animals and are primarily the work of staff members. Illustrators whose work is available in the department include William Crockett, Carolyn B. Gast, and Lawrence B. Isham.

Finding Aids
None available.

Photoduplication Service
Available at prevailing rates, subject to rules and procedures of National Museum of Natural History.

Public Access
By appointment. For appointment with appropriate office, write: Chairman, Department of Paleobiology, National Museum of Natural History, Smithsonian Institution, Washington, D.C. 20560.

9 G | DEPARTMENT OF VERTEBRATE ZOOLOGY

The Department of Vertebrate Zoology has research responsibilities for the systematics, morphology, behavior, life history, and ecology of birds, fishes, mammals, reptiles, and amphibians. Drawings consist primarily of published and unpublished scientific illustrations that were done by past or present curators in the department or by illustrators on contract to the museum. Drawings of fishes number approximately 8,000 and are filed by scientific name; most were used to illustrate publications of the museum, while others were transferred from the United States Bureau of Fishes. Contemporary scientific illustrations of birds are complemented

by approximately 80 prints and drawings; significant among these works are a 1901 watercolor by Louis Agassiz Fuertes, 6 watercolors of rare birds of North America by Robert Ridgway, and lithographs of birds (1970s) by Don Richard Eckelberry and Roger Tory Peterson. Approximately 30 drawings of seals and whales date from the late 19th century.

Finding Aids
None available.

Photoduplication Service
Available at prevailing rates, subject to rules and procedures of National Museum of Natural History.

Public Access
By appointment only. For appointment with appropriate office, write: Chairman, Department of Vertebrate Zoology, National Museum of Natural History, Smithsonian Institution, Washington, D.C. 20560.

9H | LIBRARY

The National Museum of Natural History Library, a branch of the Smithsonian Institution Libraries, consists of approximately 212,000 volumes that directly support those fields of research pursued by the museum's scientific staff—anthropology, botany, entomology, invertebrate zoology, mineral sciences, paleobiology, and vertebrate zoology. The collections in anthropology, botany, entomology, mammalogy, mollusks, and ornithology are particularly extensive.

Rare books number about 5,000 and include many 18th- and 19th-century color plate books illustrated with engravings and lithographs. Among illustrated treasures are: Jean-Baptiste Audebert's *Histoire Naturelle des Singes et des Makis* (Paris, 1799–1800); Mrs. Edward Bury's *A Selection of Hexandrian Plants,* engraved and published by R. Havell, 1831–1834; A. P. Candolle's 3-volume work on succulents (Paris, 1799–1832), with plates by Pierre-Joseph Redouté; Jean Charles Chenu's *Illustrations Conchyliologiques* (Paris, 1843–1853), with hand-colored steel engravings; Pieter Cramer's *De Uitlandsche Kapellen* (Amsterdam, 1775–1784); George Perry's *Conchology* (1811), with hand-colored aquatints of sea shells; John Edwards Holbrook's *North American Herpetology* (Philadelphia, 1836–1840), one of the few complete sets in the United States; Herman Schlegel's *Der Toerakos* (Amsterdam, 1860), with lithographs of the birds of Southeast Asia; George Catlin's *North American Indians* (London, 1841); Thomas L. McKenney

and James Hall's *History of the Indian Tribes of North America* (Philadelphia, 1836–1844). Numerous works by John Gould include the lithographic masterpieces *The Birds of Europe* (1837), *The Birds of Australia* (1848, 1869), *The Birds of Asia* (1850–1883), *The Birds of Great Britain* (1873), and *The Birds of New Guinea* (1875–1888).

The library also holds 130 of the copper and steel plates engraved after drawings made during the United States Exploring Expedition to the South Seas and Pacific Ocean, 1838–1842, under the command of Lieutenant Charles Wilkes. These plates of flora, fauna, and geological phenomena were used in publications about the expedition.

Finding Aids

• Card Catalogue, arranged by main entry (author or title). Includes author, title, date and place of publication, publisher, and subject. May also include name of artist.

• List of plates from United States Exploring Expedition, 1838–1842. Includes name of artist and name of engraver.

• Alternate Means Listings. Consists of inventories of special collections of library materials not fully catalogued.

Photoduplication Service

Restricted, subject to condition of item and/or copyright status.

Loan Policy

Books from the general collection are available through interlibrary loan. Rare books are loaned only to institutions for exhibition.

Public Access

Monday–Friday, 9–5. For reference service, write: Librarian, National Museum of Natural History, Smithsonian Institution, Washington, D.C. 20560.

10 National Portrait Gallery

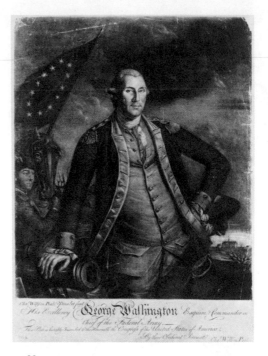

29

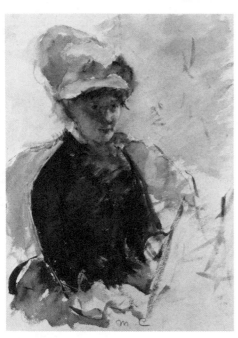

30

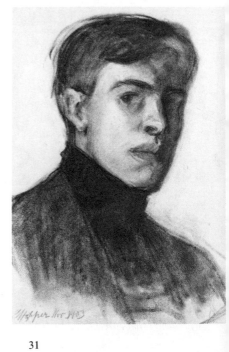

31

The National Portrait Gallery is primarily a museum of American history, told in terms of the men and women who have made that history, and secondarily, a museum of the art of portraiture. Established by Act of Congress in 1962 and opened to the public in 1968, the museum shares the gracious space of the Old Patent Office Building with the National Museum of American Art (formerly the National Collection of Fine Arts) and the Archives of American Art. Portraits in the collection may be in any medium, but must be from life or at least contemporary with their subjects. With the exception of Presidents and Vice-Presidents of the United States, or in the case of a special exhibition, portraits are neither admitted to the Permanent Collection nor displayed until ten years after the death of their subjects. Authors and astronauts, artists and athletes, statesmen and scientists, soldiers and sailors, doctors, lawyers, and Indian chiefs—the whole colorful spectrum of American life—are represented in the National Portrait Gallery.

10A | DRAWING AND PRINT COLLECTIONS

Drawings, pastels, and watercolors number approximately 400 and date from the 18th century to the present. Among the 18th-century and early 19th-century works are drawings by John Vanderlyn, John Trumbull, Thomas Sully, and James Sharples. Twentieth-century examples include many portraits of Americans prominent in literature and the performing arts: Winold Reiss's 1920s pastel series of black Americans, many of them major figures of the Harlem Renaissance; Soss Melik's charcoal portraits of authors; an 1890 ink drawing of Charles Ives by Raymond Crosby, reputedly the composer's only nonphotographic portrait; drawings (pencil, crayon) by Peggy Bacon of dancer Bill "Bojangles" Robinson and artists Charles Demuth and Childe Hassam; John Butler Yeats's 1909 pastel of critic Van Wyck Brooks; William Glackens's 1917 pastel of actor Walter Hampden. There is an important group of artists' self-portraits: Mary Cassatt (watercolor, c1880), Edward Hopper (charcoal, 1903), Charles Sheeler (pastel, 1924). This group is complemented by portraits of artists done by their artist friends: Elihu Vedder by Francis Hopkinson Smith (pencil, undated), Jo Davidson by Rockwell Kent (pencil on cloth, 1925), Arshile Gorky by Raphael Soyer (watercolor, undated), Rico Lebrun by Leonard Baskin (ink, 1968). Additionally, there are portraits by such popular illustrators as F. O. C. Darley, Charles Dana Gibson, Thomas Nast, and James Montgomery Flagg.

Caricature, another aspect of portraiture, is also represented in the museum collections. Sir Leslie Ward ("Spy") and Carlo Pellegrini ("Ape"), British caricaturists for *Vanity Fair,* are represented by 7 works. The art of caricature is further enlivened by the self-portraits of two talented amateur artists—actor John Barrymore and singer Enrico Caruso.

An extensive collection of the work of James Barton Longacre constitutes one of the two most important holdings of this portraitist's oeuvre in America. Consisting of watercolors, drawings, prints, and related manuscript material, the collection descended in the Longacre family until it was acquired by the museum. Many of the prints, several of which are copied from Longacre's life portraits in watercolor, were made for *The National Portrait Gallery of Distinguished Americans,* published by Longacre and James Herring in 1834–1839.

The Print Department of the National Portrait Gallery, established in 1974, now contains in its Permanent and Study Collections approximately 2,000 portrait prints of American men and women. Holdings include prints by both American and European artists, rare books and magazines illustrated with portrait engravings, early American almanac relief cuts, posters, sheet music covers that incorporate portraits, and a few Japanese woodblock prints. A Graphics File of some 40,000 images, composed of 19th-century steel engravings, photographs, and ephemera, is used for reference purposes.

Prints date from the 17th through 20th centuries. The earliest is Simon van de Passe's 1616 engraving of Pocahontas published in a volume entitled *Baziliologia* (London, 1618) which the National Portrait Gallery also owns. Modern works include Ben Shahn's 1948 lithograph of Harry S Truman and Thomas E. Dewey, lithographic self-portraits by Grant Wood (1939) and Ivan Albright (1947), and prints by George Bellows, John Sloan, and Childe Hassam. Many portrait prints are by major figures in various printmaking media: etchings by Anders Zorn; a monotype by William Merritt Chase; line engravings by Asher B. Durand and Peter Maverick; aquatints by William Strickland; stipple engravings by Robert Field, Cornelius Tiebout, and David Edwin; mezzotints by Peter Pelham, John Greenwood, Richard Jennys, Samuel Okey, Charles Willson Peale, and Edward Savage.

There are numerous 19th-century lithographic portraits after paintings, daguerreotypes, and photographs. Major lithographic firms are represented—Pendleton, Childs & Inman, Bufford, Duval, Sarony—as are some of the important lithographic artists: Rembrandt Peale, Albert Newsam, Charles Fenderich, Francis D'Avignon. Lesser lithographic masters include Charles G. Crehen and Leopold Grozelier. Lithographic portrait series include Mathew Brady's *Gallery of Illustrious Americans* (1850; 12 numbers in original wrappers) and 26 plates from the *National Plumbeotype Gallery* (1847) by John Plumbe, Jr., one of the largest collections of these prints extant.

Among books with portrait frontispieces and illustrations are Phillis Wheatley's *Poems on Various Subjects, Religious and Moral* (1773) and Olaudah Equiano's *The Interesting Narrative of Olaudah Equiano* (1789) which incorporate engraved portraits of two early Afro-American authors. A unique copy of the third edition of *Bickerstaff's Boston Almanack for 1787* provides the only known portrait, a woodcut, of the insurgent Daniel Shays.

The museum owns 761 portrait engravings by portraitist Charles Balthazar Julien Févret de Saint-Mémin (1770–1852), a collection originally formed by the artist himself and published by Elias Dexter in 1862. These prints are enhanced by four of Saint-Mémin's engraved copper plates, including those of George Washington and Charles Willson Peale, and by two chalk drawings. The Saint-Mémin engravings, a gift in 1974 from Mr. and Mrs. Paul Mellon, are exhibited in a special gallery of the

museum. Saint-Mémin's portraits in profile, made with the aid of a physiognotrace device, are complemented by other profile portraits by Edmé Quenedey and Gilles-Louis Chrétien, inventor of the physiognotrace process.

Silhouettes constituted a popular form of portrait art during the late 18th and 19th centuries, and this technique too is represented in the National Portrait Gallery. A cut paper silhouette of explorer Meriwether Lewis charms because the artist was First Lady Dolley Madison. A collection of 348 silhouettes cut between 1839 and 1844 by portraitist Auguste Amant Constance Fidèle Edouart is exhibited in a special gallery of the museum.

Finding Aids

• Card Catalogue for prints, drawings, and watercolors, arranged alphabetically by subject/sitter. Includes artist, date of execution, medium.

• Card Catalogue, arranged alphabetically by artist/printmaker/publisher.

Selected Publications

American Portrait Prints: Report of the Tenth Annual American Print Conference. Wendy Wick, ed. Charlottesville: University Press of Virginia for the National Portrait Gallery, 1982.

Many of the papers relate to the collections at the National Portrait Gallery and are illustrated with works from the Print Department.

Auguste Edouart's Silhouettes of Eminent Americans, 1839–1844. Andrew Oliver. Charlottesville: University Press of Virginia, 1977.

This volume reproduces the exhibited collection of Edouart silhouettes with a biographical sketch for each subject.

Fifty American Faces from the Collection of the National Portrait Gallery. Margaret C. S. Christman. Washington, D.C.: Smithsonian Institution Press, 1978.

More than one-quarter of the reproductions illustrate prints or drawings.

National Portrait Gallery: Permanent Collection Illustrated Checklist. Washington, D.C.: Smithsonian Institution Press, 1980.

The most valuable guide to the National Portrait Gallery collections, this volume illustrates all works in the Permanent Collection through 1979. Portraits are arranged alphabetically by subject; each subject has a brief biographical designation, plus information on artist, date of execution, medium, dimensions, and donor. There is an index by artist. Plans call for a new edition of the *Checklist* every two years, with an unpublished, unillustrated supplement available in the intervening years.

A Nineteenth-Century Gallery of Distinguished Americans. Exhibition catalogue by Robert G. Stewart. Washington, D.C.: Smithsonian Institution Press, 1969.

This catalogue documents a 1969 exhibition of source paintings for *The National Portrait Gallery of Distinguished Americans* by J. B. Longacre and James Herring, published in 1834–1839. Although this volume illustrates the paintings, it does include information on prints done after the paintings.

A definitive catalogue on Charles Balthazar Julien Févret de Saint-Mémin is being prepared by Ellen Miles, Associate Curator of Painting and Sculpture at the National Portrait Gallery.

Photoduplication Service
Available at prevailing rates, subject to rules and procedures of National Portrait Gallery.

Exhibition Program
One area of the museum is reserved for exhibitions of prints. Drawings and prints are integrated into the display of the Permanent Collection and are included in almost all special exhibitions.

Loan Policy
All loans are considered individually by the Director of NPG.

Public Access
By appointment only. For prints, appointments must be made with Curator of Prints; for drawings, watercolors, and pastels, appointments must be made with Curator of Painting. For reference service, write: Curator of Prints or Curator of Paintings, National Portrait Gallery, Smithsonian Institution, Washington, D.C. 20560.

10B | *TIME* COVERS COLLECTION

A collection of approximately 850 pieces of original art created for the covers of *Time* magazine from 1928 to 1978 was a gift from Time, Inc. Most of these are portraits of women and men influential in American or world history; approximately 180 of the covers illustrate nonportrait subjects such as tourism and United States medicine. The collection includes works on paper by such well-known artists as Pietro Annigoni, Boris Artzybasheff, Ernest Hamlin Baker, Aaron Bohrod, Boris Chaliapin, George Giusti, Peter Hurd, Dong Kingman, Henry Koerner, David Levine, Roy Lichtenstein, Peter Max, Sidney Nolan, Robert Rauschenberg, Rufino Tamayo, Robert Vickrey, Andy Warhol, S. J. Woolf, and Jamie Wyeth. There are also covers by cartoonists Herbert Block, Charles B. Schultz *(Peanuts),* Edward Sorel, and Gary Trudeau *(Doonesbury).*

Finding Aids
Checklist of *Time* covers, arranged alphabetically by subject/sitter. Includes artist,

medium, dimensions, signature, date of execution, occupation, accession number, and notes.

Selected Publications
National Portrait Gallery: Permanent Collection Illustrated Checklist. Washington, D.C.: Smithsonian Institution Press, 1980. The most valuable guide to the National Portrait Gallery collections, this volume illustrates all works, including the *Time* magazine covers, in the Permanent Collection through 1979. Portraits are arranged alphabetically by subject; each subject has a brief biographical designation, plus information on artist, date of execution, medium, dimensions, and donor. There is an index by artist. Plans call for a new edition of the *Checklist* every two years, with an unpublished, unillustrated supplement available in the intervening years.

Photoduplication Service
Application must be made to *Time,* Inc. Permission is usually given only to museums for exhibition publicity.

Exhibition Program
Selections from the *Time* Covers Collection are frequently exhibited in the museum. A projected special gallery of the museum will be reserved for display of *Time* covers.

Loan Policy
All loans are considered individually by the Director of NPG.

Public Access
By appointment only. For reference service, write: Registrar, National Portrait Gallery, Smithsonian Institution, Washington, D.C. 20560.

10c LIBRARY

The Library of the National Museum of American Art and the National Portrait Gallery comprises nearly 40,000 volumes with an emphasis on American painting, sculpture, graphic arts and photography, American history and biography, and portraiture. A vertical file of information about American artists, art galleries, museums, societies, and other art institutions consists of some 400 drawers of clippings, pamphlets, and printed ephemera. Approximately 200 volumes are housed as a special collection of rare books, periodicals, and exhibition catalogues, some of which contain original prints as illustrations. Illustrated volumes include: Johann

Caspar Lavater's *Essays on Physiognomy* (London, 1779–1798); a complete set of the French review of art, *Verve* (1937–1960); Richard Wilbur's *A Bestiary* (New York, 1955), with drawings by Alexander Calder; Josef Albers's *Interaction of Color* (New Haven, 1963); works by Leonard Baskin from the Gehenna Press.

The library holds 16 volumes of the *Random Records* of William Henry Holmes (1846–1933), anthropologist and archeologist. In addition to journal entries, correspondence, and documents, the *Random Records* contain a number of drawings, watercolors, and sketches by Holmes. The earliest, dated 1871, is a watercolor of the Smithsonian Mall; others include field sketches and drawings from his work and travels in the western United States and in Europe. Within the *Random Records*, there are several watercolors and sketches by artists other than Holmes, e.g., Thomas Moran and William Henry Jackson. The *Random Records* have been microfilmed for research use. An additional 50 sketches by Holmes, primarily undated field sketches not part of the *Random Records*, are also housed in the library.

Finding Aids
● Card Catalogue for books, periodicals, and exhibition catalogues, arranged alphabetically by author, title, and subject. May also include illustrator.
● Summary of contents for Holmes's *Random Records*. For each of 16 volumes, lists text, documents, and illustrations (photographs, drawings, watercolors, oils, sketches).

Photoduplication Service
No photocopies are made of rare materials. Photographs may be ordered, available at prevailing rates and subject to rules and procedures of National Museum of American Art–National Portrait Gallery Library.

Loan Policy
Books and exhibition catalogues in the general collection are available through interlibrary loan. Periodicals do not circulate. Rare books are loaned with special permission of the NMAA–NPG Librarian.

Public Access
Monday–Friday, 10–5. For reference service, write: Librarian, National Museum of American Art–National Portrait Gallery Library, Smithsonian Institution, Washington, D.C., 20560.

11 Smithsonian Institution Archives

32. Joseph Drayton, drawing of fish done for United States Exploring Expedition (Record Unit 7186). Ink and watercolor on paper, 1840

33. Robert Ridgway, drawing of bird (Record Unit 7167). Pencil and ink on paper, c1850–80

34. Cluss and Schulze (architects), Arts and Industries Building, Smithsonian Institution (Record Unit 92). Pencil and ink on paper, 1875

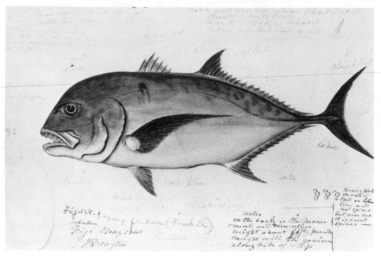

32

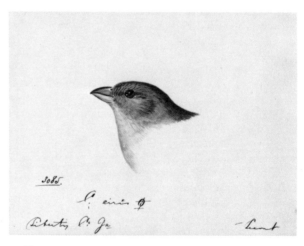

33

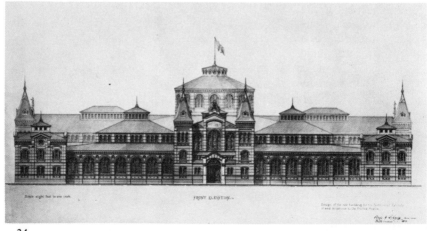

34

The Smithsonian Institution Archives collects, maintains, and makes available the official records of the Smithsonian Institution and the noncurrent papers of Smithsonian Institution staff. Housed in the Arts and Industries Building on the Smithsonian Mall, the Archives is particularly rich in the correspondence, records, journals, and field notebooks of naturalists and scientists associated with the Smithsonian during the 19th and early 20th centuries. In addition to the many natural history drawings in various archival collections, the following significant collections of prints and drawings are administered by the Archives:

1. Architectural drawings and plans of Smithsonian buildings, proposed buildings, and the Smithsonian grounds and Mall area (Record Unit 92). The original Smithsonian Institution Building is best documented by this collection, with drawings by architects John Notman, Isaiah Rogers, Owen G. Warren, B. Waterhouse Hawkins, and Cluss & Schulze. James Renwick's watercolors of the north and south elevations also survive. Other renderings include: the original 1847 survey of the Smithsonian grounds; 800 architectural drawings for the Arts and Industries Building (erected 1879–1881) by Cluss & Schulze, J. L. Smithmeyer, Ernest Pulsford, and Hornblower & Marshall; 725 architectural drawings for the Natural History Building, erected 1904–1911 by Hornblower & Marshall; drawings for other proposed Smithsonian buildings. Drawings are arranged by building name, then chronologically.

2. John Abbot Collection (Record Unit 7116): 130 watercolors of birds, presumably the birds of Georgia, by John Abbot (1751–c1840), ornithologist and entomologist.

3. Adelia Gates Collection (Record Unit 1010002): 286 watercolors of flowers by Adelia Gates, c1867–1880.

4. Badianus Manuscript Project (Record Unit 7269): approximately 115 gouache drawings by Marie-Thérèse Missionier-Vuillemin (1930s) of illustrations in the "Badianus Manuscript," an Aztec herbal.

5. Drawings of mollusks and fishes (Record Unit 7218): 12 sheets of drawings of fishes and shells for the plates of Histoire Naturelle des Iles Canaries, c1835–1850, drawn by Acarie-Baron, Paul-Louis Oudart, and Edouard Travies.

6. John L. Ridgway Drawings (Record Unit 7211): approximately 200 drawings of birds' eggs by John L. Ridgway, draftsman for the United States National Museum, 1881.

7. Robert Ridgway Papers (Record Unit 7167): approximately 1,700 drawings and sketches of birds and bird anatomy by Robert Ridgway, ornithologist for the United States National Museum. These works are dated c1850s–1880s.

8. Jean Louis Berlandier Papers (Record Unit 7052): approximately 150 drawings of Mexican botanical and zoological specimens, c1826–1851, by Jean Louis Berlandier, naturalist and geographer.

9. United States Exploring Expedition Collection (Record Unit 7186): approximately 400 drawings and sketches by artists associated with the United States Exploring Expedition which, under the direction of Lieutenant Charles Wilkes, surveyed and explored the Pacific Ocean and South Seas, 1838–1842. Artists include John H. Richard, Joseph Drayton, Alfred T. Agate, W. H. Dougal, Ts. or Js. Burkhardt, and Alexander Agassiz.

Finding Aids
- Guide to collections. Access through record unit number and subject.
- Inventories of architectural drawings.

Selected Publications
Guide to the Smithsonian Archives. Washington, D.C.: Smithsonian Institution Press, 1978.
All records and manuscript collections accessioned before June 1977 are included in this comprehensive survey of the Smithsonian Archives' holdings. Detailed information is given for many record units, and a bar graph shows the chronological coverage of each record unit. In addition to an index of proper names, there is an index by form of record, indicating those records that contain drawings, prints, and watercolors.

Photoduplication Service
Available at prevailing rates, subject to rules and procedures of Smithsonian Institution Archives. Policies and costs of reproduction depend upon whether the documents are on microfilm.

Loan Policy
Loans are made to institutions for exhibition, with approval of the Archivist.

Public Access
By appointment; Monday–Friday, 9–5. For reference service, write: Smithsonian Institution Archives, Arts and Industries Building, Smithsonian Institution, Washington, D.C. 20560.

12 | Smithsonian Institution Libraries

35. Léon Bakst illustration. In: Arsène Alexandre, *L'art decoratif de Léon Bakst* (Paris, 1913)

36. Woodcut (illustration) by unidentified artist. In: Claudius Ptolemaeus, *Epytoma . . . in Almagestum* (Venice, 1496)

37. Engraving (illustration) by unidentified artist. In: Thomas Pennant, *Genera of Birds* (London, 1781)

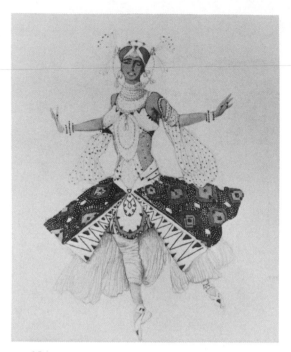

35

36

RED-HEADED KING-FISHER.

37

The Act of Congress that established the Smithsonian Institution in 1846 provided also for the formation of a library in which the collections would "pertain to all departments of knowledge." Among the most effective of the Institution's instruments for the "increase and diffusion of knowledge," the collections and services of the Smithsonian Institution Libraries directly support the diverse research and educational programs of the Smithsonian. Approximately 900,000 volumes and 17,000 serial titles in the fields of natural history, anthropology and ethnology, American culture, history of science and technology, tropical biology, decorative arts and design, history of aeronautics and astronautics, and museology support the work of Smithsonian scientists, historians, curators, and visiting scholars. Extensive holdings of trade and manufacturer's catalogues, and of museum and art auction sales catalogues, document many objects in the museums' collections.

The central library facility, housed in the National Museum of Natural History, maintains a union catalogue of materials in all Smithsonian libraries. Thirty-six branch libraries are located in the museums and scientific bureaus; additionally, there are numerous sectional libraries in curatorial and departmental offices. A Special Collections Branch is responsible for the libraries' collections of manuscripts and rare books, many of which are illustrated with original prints and drawings.

For descriptions of those library collections that contain numerous prints and/or drawings, *see:*

2B Cooper-Hewitt Museum Library
3B Freer Gallery of Art Library
5B Museum of African Art Library
6B National Air and Space Museum Library
7D National Museum of American Art–National Portrait Gallery Library
9H National Museum of Natural History Library
12A Special Collections Branch, Smithsonian Institution Libraries

Finding Aids
Card Catalogue, arranged by main entry (author or title). Includes author, title, publisher, date and place of publication, subject, and location. May also include information about illustrations and/or illustrator.

Photoduplication Service
Restricted, subject to condition of item and/or copyright status.

Loan Policy
Books from the general collection are available through interlibrary loan. Rare books and manuscripts are loaned only to institutions for exhibition.

Public Access
Monday–Friday, 9–5. For reference service, write: Smithsonian Institution Libraries, Washington, D.C. 20560.

12A SPECIAL COLLECTIONS BRANCH

The Special Collections Branch of the Smithsonian Institution Libraries has responsibility for the Dibner Library Collection and for all other rare books and manuscripts in Smithsonian libraries. The Dibner Library Collection and reference aids for the Special Collections Branch are located in the National Museum of American History.

The Dibner Library Collection consists of approximately 15,000 rare books and manuscripts relating to the history of science and the development of technology. Materials date from the 15th to 20th centuries and include 300 incunabula (books printed c1450–1500). The primary subject strength of the collection is the physical sciences, encompassing astronomy, chemistry, physics, mathematics, geology, and general science, with particular strength in the field of electricity and magnetism. Volumes about voyages of exploration and early treatises on architecture are included for their relevance to early scientific investigation. The majority of materials in the collection were donated to the Smithsonian in 1976 by Dr. Bern Dibner of the Burndy Library in Connecticut.

The books in the Dibner Library Collection have been collected for their scientific and technological information, but they are also pertinent to the history of book illustration and the history of printing. Many of the early printed volumes are illustrated with original woodcuts or engravings: Robert Valturius's *De re militari* (Verona, 1472), the first dated Italian woodcut book, with the cuts attributed to Matteo de Pasti; Bernard von Breydenbach's *Sanctaru peregrinationu in montem Syon* (Mainz, 1486), the first printed illustrated travel book, with woodcuts attributed to Erhard Reuwich; Johannes de Ketham's *Fasiculus medicinae* (Venice, 1495), with 10 full-page woodcuts in the style of Gentile Bellini; *Ortus sanitatis* (Strasbourg, 1499), an encyclopedia of medieval sciences that contains more than 1,000 woodcuts of flora, fauna, and minerals; Andreas Vesalius's *De humani corporis fabrica libri septem* (Basel, 1543), the first significant work on human anatomy based on scientific observation, with superb woodcut illustrations done for Vesalius by artists in the school of Titian; Agostino Ramelli's *Le diverse et artificiose machine* (Paris, 1588), with 195 engravings about Renaissance engineering, enhanced by 7 of Ramelli's original drawings (ink on vellum); Carlo Ruini's woodcut-illustrated *Anatomia del cavallo* (Venice, 1599), the first book devoted to the anatomy of a domestic animal. Prints by Jan van der Straet (Stradanus) comprise his engravings of contemporary inventions and discoveries for *Nova Reperta* (c1580), and the more than 200 engravings for *Venationes ferarum, auium, piscium* (c1570).

Works of the 19th and 20th centuries in the Special Collections Branch include

such diverse examples as Ackermann's *Repository of Arts, Literature, Commerce, etc.*, complete from 1809 through 1828 and with fabric samples; Louis Agassiz's *Etude sur les glaciers* (1840); 44 19th-century watercolors of Neapolitan costume, signed de Vito; Edward S. Curtis's opus in photogravure, *The North American Indian* (1907–1930); cartoonist William Marston's own set of *Wonder Woman* comic books; an extensive collection of printed works illustrated by HAP Grieshaber; and *New York Ten*, a 1965 portfolio of prints by Richard Anuszkiewicz, Jim Dine, Helen Frankenthaler, Richard Kulicke, Mon Levinson, Roy Lichtenstein, Claes Oldenburg, George Segal, and Tom Wesselmann.

The Special Collections Branch holds approximately 2,000 portrait prints of scientists and engineers, 16th to 19th centuries. Additional portraits may be found in books such as André Thevet's *Les Vrais Pourtraits et Vies des Hommes Illustres* (Paris, 1584), a collection of 226 biographies that includes the earliest portraits of many scientists and explorers.

Finding Aids
• Card Catalogue, arranged alphabetically by main entry (author or title). Includes date and place of publication, publisher and/or printer, and subject.
• Short-Title Catalogue. Printed list of all books in the Dibner Library Collection printed before 1800, plus 450 selected titles from 19th- and 20th-century works. Works indexed by author, title, place of publication, date, subject.
• Chronological File, arranged by date of publication.

Selected Publications
Heralds of Science. Rev. ed. New York: Neale Watson, 1980.
This annotated bibliography of 200 of the most significant works on early science in the Dibner Library Collection includes notes by Bern Dibner and an introduction by Robert P. Multhauf. Many illustrations from these early editions are reproduced.

Photoduplication Service
Available at prevailing rates, subject to rules and procedures of Special Collections Branch.

Exhibition Program
Three or four exhibitions of books and manuscripts from the Special Collections Branch are arranged each year.

Loan Policy
Restricted. Loans are usually made to institutions for exhibition, with approval of the Special Collections Librarian.

Public Access
By appointment; Monday–Friday, 10–5. For reference service, write: Special Collections Librarian, Smithsonian Institution Libraries, Washington, D.C. 20560.

Location Guide to Graphic Artists

The Location Guide to Graphic Artists is a computer-generated alphabetical listing of all graphic artists represented in the eight major art collections of the Smithsonian Institution: Cooper-Hewitt Museum, Freer Gallery of Art, Hirshhorn Museum and Sculpture Garden, Museum of African Art, Art Department of National Air and Space Museum, National Museum of American Art (formerly National Collection of Fine Arts), Division of Graphic Arts in National Museum of American History (formerly National Museum of History and Technology), and National Portrait Gallery.

The names in the Location Guide were compiled from the internal files of these eight major art collections. Because of the limitations imposed by the computer, diacriticals do not appear. Every effort has been made to stabilize the spelling of artist names and the alphabetical ordering of names with particles (e.g., De La Marcade) where there was orthographic variation from collection to collection, but errors may still exist in the list. Corrections to names and additional information about partially identified artists will be gratefully accepted from readers.

The Location Guide is a finding list directly for the eight major art collections, and does not function as an index for the material in this volume. However, to maintain consistent use of numerical designations throughout this volume, the numbers used in the Location Guide correspond to those used for collection descriptions in the text and for the Index: 2, Cooper-Hewitt Museum; 3, Freer Gallery of Art; 4, Hirshhorn Museum and Sculpture Garden; 5, Museum of African Art; 6, National Air and Space Museum (Art Department); 7, National Museum of American Art; 8H, National Museum of American History (Division of Graphic Arts); 10, National Portrait Gallery.

The designation *att.* denotes works attributed to a particular artist; *after* signifies graphic art copied from a painting or a print by the named artist. The alphabetical sort system is consistently letter-by-letter except for certain names with initial particles: Ma Shou-Chen precedes Maag, Johan.

Abacco, Antonio dell'
 (after), 2
Abbate, Niccolo dell'
 (after), 2
Abbema, W. von, 8H
Abbey, Edwin Austin, 2, 7
Abbo, Jussuf, 7
Abbott, Mary, 7
Abeles, Sigmund M., 7
Abelman, Ida, 7

Abesch, Anna-Barbara, 2
Abramowitz, Albert, 7
Abularach, Rodolfo, 7
Aceveda, Manuel
 Hernandez, 2
Ache. *See* Caran d'Ache
Achen, Hans von *(after)*, 2
Achenbach, Andreas, 2
Achener, Maurice V., 2, 7,
 8H

Achepohl, Keith, 7
Ackerman Lithographers,
 8H
Ackerman, James, 2
Ackerman, R., 2
Ackermann & Strand, 6
Acqua, Cristoforo dall', 2
Actinic Engraving
 Company, 8H
Adam, Jakob, 2

Anderson, Stanley, 2, 7
Anderson, Walter, 7
Anderton, G. J., 8H
Andre, 2
Andre, Ed., 8H
Andreani, Andrea, 2, 8H
Andrew, George T., 2
Andrew, John, 2, 8H
Andrews, J., 8H
Andrews, Jon, 10
Andrews, Joseph, 10
Andrieau, Bertran, 2
Andrina, 8H
Andriola, Alfred, 8H
Andrus, Vera, 8H
Anelay, Henry (after), 2
Angel, Rifka, 7
Angeli, Heinrich von
 (after), 2
Angerer, L., 8H
Angerer, V., 8H
Ango, J. R., 2
Anguiano, Raul, 2
Angus, 8H
Angus, William, 2
Anichini, Pietro, 2
Annan & Swan, 8H
Annan, T. & R., 8H
Annigoni, Pietro, 2, 10
Annin & Smith-Senefelder
 lithography company, 10
Annin, P., 8H
Annon, Pauline, 4
Anshutz, Thomas Pollock,
 4, 7
Ansorge, 2
Antelme, Mademoiselle, 2
Anthony, Andrew Varick
 Stout, 2, 8H
Antoine, Jacques-Denis
 (after), 2
Antonini, Annapia, 8H
Antonucci, Emil John, 2
Antreasian, Garo Zareh, 7
Anuszkiewicz, Richard, 2,
 4, 7
"Ape." See Pellegrini,
 Carlo
Apostool, C., 8H
Appel Manufacturing
 Company, 2
Appel, Karel, 7
Appel, Marianne, 7
Appelman, Barend (after),
 2
Appian, Adolphe, 2, 7, 8H
Appiani, Andrea, 2

Appleton, J. W., 7
Appold, 8H
Aquaroni, Antonio, 8H
Aquatone Corporation, 8H
Aquila, Francesco
 Faraone, 2, 8H
Aquila, Petrus, 2, 8H
Arakawa, Shusaku, 7
Aranda, Dino, 7
Arcay, 2
Archbold, Geoffrey, 8H
Archipenko, Alexander, 2,
 4, 7
Ardail, Albert, 2
Ardourel, Joe, 8H
Ardy, Bartolommeo, 8H
Arenal, Louis, 7
Arendzen,
 Petrus-Johannes, 2
Argus, 8H
Ariel (Mrs. Thomas
 Parkinson), 2
Arinelli, Luca, 2
Arlt, Paul, 6
Arman, 4
Armand-Dumaresq,
 Charles Edouard, 2
Armando, 2
Armin, Emil, 7
Armitage, Kenneth, 4
Arms, John Taylor, 2, 6, 7,
 8H
Armstrong, Cosmo, 8H
Armstrong, I. B., 8H
Armstrong, William G., 10
Armytage, James Charles,
 2, 7, 8H
Arnal, Francois, 7
Arnavon, J., 2
Arndt, W., 8H
Arneson, Robert Carston,
 4, 7
Arnest, Bernard Patrick, 7
Arneth, Joseph, 8H
Arno, Peter, 2
Arno, Roger, 6
Arnold, Ernst, 8H
Arnold, Floyd, 2
Arnold, Grant, 8H
Arnoldi, Per, 7
Arnoult, Nicolas, 2
Arnout, Jean-Baptiste, 2
Arnout, Louis-Jules, 8H
Aronson, Irene H., 7
Arp, Jean, 4
Arpino, Cavaliere d'. See
 Cesari, Giuseppe, 2

Arriola, Gus, 8H
Arrivet, (P. N.), 2
Arrivet, J., 2
Arrunategin, A., 7
Art, 8H
Art Amateur, 8H
Art Club, 8H
Art Etching Company, 8H
Art Publishing Company,
 8H
Art Reproduction
 Company, Ltd., 8H
Arthois, Jacobus van
 (after), 2
Arthur, B., 2
Artigue, E., 8H
Artlett, R. A., 8H
Artzybasheff, Boris, 10
Asawa, Ruth, 2
Ascenzi, Carlo, 7
Asch, Pieter-Jansz van
 (after), 2
Aschenbrenner, H., 8H
Ascher, Mary, 7
Ashby, Hal, 8H
Asher, Lila Oliver, 7
Aspari, Domenico, 8H
Aspden, Ruth, 7
Asprucci, Mario (the
 elder), 2
Asprucci, Mario (the
 younger), 2
Aspruck, Franz, 8H
Asselineau, Leon-Auguste,
 8H
Asselyn, Jan (after), 2
Assen, Benedictus Antonio
 van, 2
Asser & Toovey, 8H
Asser Procede, 8H
Asta, Barbara, 2
Atken, 8H
Atlan, 4
Attwood, (F. G.), 2
Attwood, J. M., 2
Atwood, Clara E., 8H
Atwood, Robert, 7
Aubert, Georges, 2
Aubert, Jean, 2, 8H
Auburtin, Jean-Francois, 7
Audenaerde, Robert van, 2
Audeni, R. V., 8H
Audin, Marius, 8H
Audinet, Philipp, 7
Audouin, P., 8H
Audran, Benoit, 8H
Audran, Benoit (II), 2

Audran, Charles, 2
Audran, Claude (III), 2
Audran, Gerard, 2, 8H
Audran, J., 10
Audran, Jean, 2
Audubon, John James, 2, 7, 8H
Auer, Alois, 8H
Auer, Josef (att.), 2
Auerbach, Leon, 2
Auerbach-Levy, William, 2, 7
Aufrichting, Norman, 2
Ault & Wiborg Printing Ink Company, 8H
Ault, George Christian, 4, 7
Aurell, David, Jr., 2
Autotype Company, 8H
Avati, Mario, 7
Aveele, Johannes van den, 2
Aveline, Antoine, 2
Aveline, Francois Antoine, 2
Aveline, J. F., 8H
Aveline, Pierre-Alexandre, 2, 8H
Avery, Milton Clark, 4, 7
Avesani, Severio, 2
A'via, Alexander, 8H
Aviler, Augustin Charles d', 2
Avinoff, Andrey, 7, 8H
Avirom, Joel, 2
Avniel, Mordechai, 8H
Avril, Jean-Jacques (the elder), 2
Avril, Jean-Jacques, 7, 8H
Avy, Joseph Marius, 7
Axmann, J., 8H
Ayoroa, Rudy, 7
Azuma, Norio, 7, 8H

Babbett, 8H
Babel, Pierre-Edme, 2, 8H
Baber, Alice, 2, 7
Babin, 2
Babson, Jane F., 6
Babson, R. E., 8H
Bach, Johann Samuel, 2
Bacharach, Herman, 8H
Bacheley, Jacques, 2
Bachelier, Jean-Jacques, 8H; works after, 2
Bacher, Otto Henry, 2, 7, 8H

Backer, Jacob Adriaensz (att.), 2
Backhuysen, Ludolf (after), 2
Bacon, 7
Bacon, Elizabeth C., 2
Bacon, F., 7, 8H
Bacon, Henry, 7
Bacon, J. H., 8H
Bacon, Peggy, 2, 4, 7, 8H, 10
Bacosi, Manlio, 8H
Bader, Ferdinand, 2
Badollet, Abraham, 2
Baer, Howard, 7
Baer, Joseph, & Company, 8H
Baer, William J., 2
Baertling, Olle, 7
Bagdatopoulos, William Spencer, 7
Bagelaar, Ernest-Willem-Jan, 2
Baggi, Giuseppe, 2
Bagley, Henry N., 8H
Bahuet, A., 8H
Bail, Joseph Claude, 7
Bailey, E., 8H
Bailey, N. P., 8H
Bailey, William H., 7
Baillie, James S., 10
Baillie, William, 2, 8H
Baillieu, F., 2
Bailliu, Pieter de, 2
Bailly, Nicolas, 2
Baily, Edward Hodges (after), 2
Baini, Antonio, 2
Baird, Miss, 8H
Bairnsfather, Bruce, 8H
Baizerman, Eugenie, 4
Bak, C., 2
Baker, David C., 7
Baker, Ernest Hamlin, 7, 10
Baker, Horace, 8H
Baker, Joseph E., 8H, 10
Baker, Martha S., 7
Baker, Robert P., 7
Baker, Thomas, 7
Bakst, Leon, 2
Bal, Jos, 8H
Balbou, Louis Michel, 8H
Balch, V., 8H
Bald, Ken, 8H
Baldi, Antonio, 2
Baldo, Giuseppe (att.), 2

Baldovinetti, 8H
Baldridge, Cyrus LeRoy, 2, 7
Baldung-Grien, Hans, 8H
Baldwin & Gleason, 8H
Baldwin, A. H., 8H
Baldwin, Frances, 7
Baldwin, John, 7
Baldwin, M. W., 8H
Balechou, Jean-Joseph, 2, 8H
Balestra, Antonio, 2
Balin, Bernard, 8H
Ballarini, Giovanni, 2
Ballauf, D., 8H
Balleau, Pieter de (after), 8H
Ballin, A., 8H
Balsham, Leah, 7
Baltard, Louis-Pierre, 2
Balthus, 4
Bance, Charles (publisher), 10
Banck, Jan van der, 2
Banck, Pieter van der, 2
Bandeira, Antonio, 2
Bandinelli, Baccio, 2
Bandini, (Tommaso?), 2
Banesi, A. W., 8H
Bang, George, 2
Bang, Theodor, 2
Bann, James, 8H
Bannerman, A., 8H
Bannick, J. van (after), 2
Bannister, Edward M., 5
Baptiste, Jean, 2
Baquoy, Jean-Charles, 2
Baquoy, Maurice, 2
Baquoy, Pierre-Charles, 2
Barabas, Miklos, 8H
Barabino, Carlo Francesco, 2
Baratta, Antonio, 2
Baratta, Francesco, 2
Barbash, Steven, 7, 8H
Barber, Charles E., 8H
Barber, John Warner, 8H
Barberi, Giuseppe, 2
Barbet, J., 2
Barbieri, Giovanni Francesco (called Guercino), 2
Barbotin, W., 8H
Barbour, Arthur J., 7
Barclay, G., 6
Barclay, McClelland, 8H
Barclay, Miss E. J., 8H

Barcons, Zulema, 8H
Bard, Philip, 7
Barigioni, Filippo, 2
Barker, Albert W., 7
Barker, Christopher
(printer), 8H
Barlach, Ernst, 2
Barlow, Edward, 10
Barlow, Francis *(after)*, 2
Barnard, George G., 7
Barnes, Bob, 8H
Barnes, Charles E., 7
Barnes, Elizabeth, 7
Barnes, Hiram Putnam
(after), 2
Barnet, Will, 2, 4, 7
Barnett, Thomas, 7
Barney, Alice Pike, 7
Barns, 2
Baron, Bernard, 2, 8H
Baron, H., 8H
Baron,
Henri-Charles-Antoine
(after), 2
Barone, Antonio, 7
Barozio, Giacomo (called
Vignola) *(after)*, 2
Barr, Stephen, 7
Barreau, 2
Barret, O'Connor, 2
Barrett, Charles Robert,
8H
Barrett, Thomas Weeks, 7
Barrie, George, 8H
Barriere, 2
Barron, Grace, 7
Barrows, Charles, 2
Barrows, Stanley, 2
Barry, Auguste, 2
Barry, Charles A. *(after)*, 2
Barry, Dan, 8H
Barry, G., 8H
Barry, Sy, 8H
Barrymore, John, 10
Barrymore, Lionel, 8H
Barse, George Randolph, 7
Bart, Charles, 8H
Barthelmess, N., 8H
Bartholomew, V., 8H
Bartholomew, William N.,
8H
Bartlett, Jennifer Losch, 7
Bartlett, William Henry, 7,
8H; *works after,* 2
Bartoli, Francesco, 2
Bartoli, Pietro Santi, 8H

Bartolommeo, Fra *(after)*,
2
Bartolozzi, Francesco, 2,
7, 8H, 10
Barton, Loren Roberta, 7,
8H
Barton, Ralph, 7
Bartsch, Adam von, 2, 8H
Barye, Antoine-Louis, 4,
8H; *works att.,* 2
Basan, F., 8H
Baschenis, Evaristo, 2
Bashenov, A., 8H
Basire, James, 2, 8H
Baskerville, Charles, 2, 7
Baskin, Harold, 2
Baskin, Leonard, 2, 4, 7,
8H
Basoli, Antonio, 2
Basoli, Luigi, 2
Bass, Saul, 2
Bassaget, Pierre Numa, 2
Bassan, J. *(after)*, 2
Bassano, Giacomo da
Ponte *(after)*, 2
Basset, (the elder), 2
Batchelder, Marjorie, 8H
Batchelor, Clarence D., 2
Bather, G., 8H
Battaglia, Aurelius, 7
Batten, John D., 8H
Baude, C. H., 8H
Baudouin, Paul-Albert, 7
Baudouin, Pierre Antoine
(after), 2
Baudran, Etienne Larose,
8H
Bauer, Joseph, 8H
Baugniet, Charles, 8H, 10
Baulieu, Mademoiselle, 2
Baum, Paul, 2
Baumann, Gustave, 2, 7,
8H
Baumeister, Willi, 8H;
works after, 2
Baumgartner, Johann
Wolfgang, 2
Baur & Hasslwander, 8H
Baur, A., 8H
Baur, Johann Wilhelm, 2
Baur, Wilhelm *(after)*, 2
Bautree, W., 2
Bauvais, 2
Baxbaum, Selina, 8H
Baxter, George, 2, 8H
Bayefsky, Aba, 8H
Bayer, Herbert, 7, 8H

Bayer, T., 8H
Bayot,
Adolphe-Jean-Baptiste,
2
Bazin, L., 8H
Baziotes, William, 4
Beach, Chester, 8H
Beal, Gifford, 7
Beal, Jack, 7
Beale, Richard, 7
Beall, C. C., 8H
Beaman, R. B., 7
Beard, Daniel Carter, 2
Beard, James Carter, 2
Beard, Rollin E., 7
Bearden, Romare Howard,
2, 4, 7
Beardsley, Aubrey
Vincent, 2
Beatty, John Wesley, 2
Beauain, de, 2
Beauchamp, Robert, 4
Beaugrand, A. C., 8H
Beaumont, Edouard de, 2
Beaumont, Jean-Georges,
2
Beaumont, Sir George
Howland *(after)*, 2
Beauquet (?), 2
Beaustre,
Jean-Baptiste-Augustin,
2
Beauvais, Jacques, 2
Beauvais,
Nicolas-Dauphin de, 2
Becchetti, E., 2
Bechtle, C. Ronald, 7
Beck Engraving Company,
8H
Beck, G. K., 8H
Beck, Leonhard, 2
Beck, Walter, 7, 10
Becker, Fred G., 7, 8H
Becker, Joseph *(after)*, 2
Becker, Paul (I) *(after)*, 2
Beckett, Isaac, 2, 8H
Beckmann, Max, 2, 8H
Beckwith, H. S., 7
Beckwith, James Carroll, 2
Beebe, Bessie, 2
Beecher, Charles, 8H
Beecher, William J., 7
Beechey, Sir William
(after), 2
Beecq, Jan Karel van
(after), 2

Beerstraten, Anthonie *(after)*, 2
Bega, Cornelis-Pieter *(after)*, 2
Beger, Lorenz, 2
"Beggarstaffs," 2
Beggs, Thomas M., 7
Beham, Hans Sebald, 2, 8H
Beich, Joachim Franz *(after)*, 2
Bekker, David, 7
Belanger, Francois-Joseph, 2
Belanger, Louis *(after)*, 2
Belfiore, Gerardo, 8H
Belkin, A., 2
Belkin, Arnold, 7
Bell Brothers lithography company, 10
Bell, Cecil C., 2, 8H
Bell, Corydon, 7
Bell, E., 8H
Bell, Larry, 4
Bell, R. C., 8H
Bella, Stefano della, 2, 8H
Bellandi, Antonio, 2
Bellange, Eugene, 8H
Bellay, 2
Bellenger, Albert, 8H
Bellenger, Clement, 8H
Belleroche, Albert Gustave de, 2
Belli, Giovacchino, 2
Belli, Pietro, 2
Belli, Vincenzo (I), 2
Belliard, Zephirin-Felix-Jean-Marius, 2
Bellin, 2
Bellin, Samuel, 7
Belloni, Antonio *(att.)*, 2
Bellotto, Bernardo, 8H
Bellow, Frank Henry Temple *(after)*, 2
Bellows, Albert Fitch, 8H; *works after*, 2
Bellows, George Wesley, 2, 4, 7, 8H, 10
Belluschi, Pietro, 2
Belmont, Jean-Antoine, 2
Belorge, *(att.)*, 2
Beltcher, George, 7
Beltran, Alberto, 2
Belville, M. A., 8H
Bemmel, Willem von *(after)*, 2
Ben-Zion, 7

Benaerd, Theodore *(after)*, 2
Benard, 2
Benard, Jacques Francois, 2
Benard, Robert, 2
Benata, Giovanni *(att.)*, 2
Benazech, Peter Paul, 2
Bencke & Scott, 8H
Bendann, 10
Bendiner, Alfred, 10
Benedictus (Benedetti), Elpidius *(after)*, 2
Beneke Lithography Company, 8H
Beneworth, 2
Benforado, I., 7
Bengough, R., 2
Benjamin, Marcus, 8H
Benneci, Vincenzio, 8H
Bennett, John L., 7
Bennett, William James, 7
Benney, Robert, 8H
Bennington, R., 6
Benoist, Antoine, 2
Benoist, Felix *(after)*, 2
Benoist, Marie, 8H
Benson, Frank Weston, 2, 7, 8H
Benson, Patricia, 7
Benson, W., 7
Bentley, Charles, 7
Bentley, J. C., 8H
Benton, Thomas Hart, 2, 4, 7
Benucci, Tommaso, 2
Benzing, J. C., 8H
Berain, Claude, 2
Berain, Jean (the elder), 2
Berat, E., 2
Beraud, Jean, 8H
Berchem, Nicolaes, 2, 7, 8H
Berchmans, Emile, 2
Berdanier, Paul Frederick, 7
Berdick, Vera, 7
Berend-Corinth, Charlotte, 7
Beretta, Giuseppe, 2
Berg, Robert V., 4
Berge, Pieter van den, 2
Berger, Daniel, 2, 8H
Berger, Oscar, 10
Bergeron, Suzanne, 4
Berghaus, A., 10

Berghem, Claes. *See* Berchem, Nicolaes
Bergler, Joseph (the younger), 2
Bergmann, J., 8H
Bergmuller, Johann Georg, 2
Berington, Simon, 2
Berjon, Antoine *(att.)*, 2
Berkman, Bernice, 7
Berkowitz, Leon, 7
Berlin Photographic Company, 8H
Berman, Eugene, 2, 4
Berman, Saul, 7
Bernard, Jeanne, 2
Bernardi, Paolo, 2
Berndt, J. O., 2
Berndt, Johann Christian, 8H
Berndt, Walter, 8H
Bernigeroth Family, 8H
Bernigeroth, Johann Martin, 2
Berninghaus, Oscar E., 7
Bernini, Giovanni Lorenzo *(att.)*, 2
Bernollin, Denk (?), 2
Berns, Ben, 7
Bernstrom, Victor, 8H
Beroth, Leon A., 7
Berranier (?), 2
Berrettini, Pietro (da Cortona) *(after)*, 2
Berrien, Martha, 8H
Berrill, 8H
Berry, Jim, 8H
Berryman, Clifford K., 7, 8H
Berstein, Theresa F., 8H
Bersy, P. J. de *(after)*, 2
Bertano, Giovanni Battista *(after)*, 2
Bertaux, 2
Bertaux & Reville, 8H
Bertaux, H. G., 6
Berte, Jean, Inc.
Berthaud, 8H
Berthault, 6
Berthault, Nicolas, 2
Berthault, Pierre Gabriel, 2
Berthelot *(after)*, 2
Bertinazzi, 6
Bertini, Angelo, 8H
Bertinot, Gustave, 8H
Bertrand, Antoine Valerie, 8H

Brody, Jerome, 2
Broekhusius, Janus, 8H
Bromley, William, 8H
Broner, Robert, 8H
Brook, Alexander, 4, 7
Brooke, J., 2
Brooke, Richard Norris, 7
Brooks, Edwin, W., 2
Brooks, H. Jamyn, 2
Brooks, Leonard, 7
Brooks, Mildred Bryant, 2, 7, 8H
Brooks, Romaine, 7
Brooks, Wendell T., 7
Brookshaw, R., 8H
Bross, Robert S., 8H
Brouet, Auguste, 2
Brough, Richard, 7
Brouwer, Adrien *(after)*, 2
Brown, A., 8H
Brown, Barnes & Bell, 8H
Brown, Benjamin Chambers, 7, 8H
Brown, Bolton Coit, 7, 8H
Brown, Don, 6, 7
Brown, Douglas, 7
Brown, E. C., 10
Brown, Eliphalet, Jr., 10
Brown, George Loring, 7, 8H
Brown, H., 2
Brown, Henriette, 8H
Brown, Henry Kirke, 2
Brown, Howard, 7
Brown, Howell Chambers, 7, 8H
Brown, Joan, 4
Brown, John George, 7; *works after*, 2
Brown, Joseph, 8H
Brown, Lance Jay, 2
Brown, M. E. D., 10
Brown, Paul, 2
Brown, Reynold, 8H
Brown, Robert Delford, 2
Brown, Robertson Company, 8H
Brown, Samuel Joseph, 7
Brown, T., 8H
Brown, Walter Francis *(after)*, 2
Browne, Byron, 4, 7
Browne, Dik, 8H
Browne, George Elmer, 2, 7
Browne, Syd, 7

Browning, Robert Barrett, 2
Brownson, Mary Morison, 2
Brubans, Stephen V., 2
Bruchon, N., 2
Brucker, Heinrich, 8H
Brueblin, 8H
Brueghel, Jan (the elder)*(after)*, 2
Brueghel, Jan (the younger)*(after)*, 2
Brueghel, Peter, 8H
Brueghel, Peter (the elder)*(after)*, 2
Brugnot, 2
Brun, Giovanni, 7, 8H
Brun, Isaac, 2
Brunais, Augustin *(after)*, 2
Brunelleschi, L., 8H
Brunelleschi, Umberto, 2
Brunet, 2
Brunet-Debaines, Alfred, 2, 8H
Brunier, Gauchard, 8H
Brunner, Arnold William, 2
Brusco, Paolo-Girolamo, 2
Bruscoli, Andrea, *(att.)*, 2
Brush, Daniel, 7
Brussel-Smith, Bernard, 2, 6
Brustolon, Giovanni Battista, 2
Brutt, Ferdinand, 2
Bruyn, Abraham de, 2
Bruyn, Nicolaes de, 2
Bry, Theodor de, 2, 7, 8H
Bryer, Henry, 2
Buatta, Mario, 2
Bucarme, 8H
Bucheister, L., 10
Buchel, Arnold, 2
Buchman and Kahn, Architects, 2
Bucholzer, H., 10
Buck, 8H
Buckler, John F. S. A., 2
Buckton, Eveleen, 7
Budd, Robert, 7
Buddeus, Julius, 8H
Budko, Joseph, 7
Buek & Lindner lithography company, 8H, 10
Buell, Alice Standish, 2
Buff, Conrad, 8H
Buff, Sebastian, 2

Buffagnotti, Carlo Antonio, 2
Buffet, Bernard, 4, 7; *works after*, 2
Bufford, J. H., lithography company, 2, 8H, 10
Buhot, Felix, 2, 7, 8H
Buller, Cecil, 7
Bullet, Pierre, 2
Bullock Brothers, 8H
Bumbeck, David, 7
Bunbury, Henry William *(after)*, 2
Bunch, J. Alphege, 2
Buncho, Ippitsusai, 3
Bundasz, Rudolph E., 7
Bunn, William Edward Lewis, 7
Bunner, A. F., 8H
Buonaccorsi, Pietro. *See* Vaga, Pierino del
Buonarroti, Michelangelo. *See* Michelangelo
Buontalenti, . Bernardino *(after)*, 2
Burbank, E. A., 8H
Burchard, A. & W., 8H
Burchfield, Charles Ephraim, 4, 7
Burford, Thomas, 10
Burg, M., 2
Burger, J., 8H
Burgess, Lowry, 7
Burghers, Michel, 2
Burgkmair, Hans, 8H
Burgkmair, Hans (the elder), 2
Burgmann, Johann, 8H
Burke, David, 7
Burke, Jackson, 8H
Burkert, Robert, 7
Burkhard, Verona Lorraine, 7
Burkhardt, Hans Gustav, 4
Burkhardt, Jakob *(after)*, 2
Burliuk, David Davidovich, 4
Burnacini, Lodovico Ottavio *(after)*, 2
Burnard, Eugene, 7
Burne-Jones, Sir Edward Coley, 2
Burner, J., 8H
Burnet, John, 2, 8H
Burnett, James, 8H
Burney, Edward Francis, 2

Carlson, Wally, 8H
Carlu, Jean, 8H
Carmiencke, Johann
 Hermann, 7
Carmine, Josef, 2
Carmona, D. J. A., 8H
Carmona, Manuel
 Salvador, 2
Carmontelle. See Carrogis,
 Louis
Caro, Baldassare de, 2
Carolsfeld, Johann Veit
 Schnorr von (after), 2
Carolus-Duran, Charles
 Emile Auguste, 7; works
 after, 2
Caron, 8H
Caronni, Paolo, 2, 8H
Carpeaux, Jean-Baptiste, 4
Carpi, Girolamo da, 2
Carpi, Ugo da, 8H
Carpioni, Giulio, 2, 8H
Carqueville, William, 2
Carr, 2
Carracci, Agostino, 2;
 works after, 8H
Carracci, Annibale, 2, 8H
Carracci, Lodovico (after),
 2
Carrier-Belleuse, Pierre, 7
Carriera, Rosalba, 2
Carrogis, Louis (called de
 Carmontelle), 2
Carrol, 8H
Carrothers, Grace Neville,
 7
Cars, Jean Francois, 2
Cars, Laurent, 2
Carson, Sol, 7
Carte, Antoine, 6
Carter, C., 2, 8H
Carter, C. F., 8H
Carter, J., 8H
Carter, John, 2
Carter, John Randolph, 7
Carter, Susan N. (att.), 2
Cartin, Arthur, 8H
Caruso, Enrico, 2, 10
Cary, Francis Stephen
 (after), 2
Cary, Page, 7
Cary, William de la
 Montagne, 2
Caryl, Naomi, 4
Casa, Augusto dalla, 2
Casa, Giacomo, 2
Casarella, Edmond, 4, 7

Caselani, Alessandro di
 Agostino (after), 2
Casianeral, 8H
Casilear, John William, 8H,
 10
Casini, Bernardo (att.), 2
Caslon, H. W., &
 Company, 8H
Caso, Ralph, 2
Cassady, Cornelia S., 8H
Cassanova, A., 8H
Cassara, Frank, 7
Cassas, Louis-Francois
 (after), 2
Cassatt, Mary Stevenson,
 2, 4, 10
Cassini, Giovanni Maria, 2
Castaigne, Andre (after), 2
Castellani, Enrico, 4
Castelli, G., 2
Castellon, Federico, 2, 7
Castellotti, Lorenzo, 2
Castiglione, Giovanni
 Benedetto, 2, 8H
Castilhoni, Joseph, 8H
Catalano, Giuseppi, 7
Cately, George, 8H
Cathelin, Louis-Jacques, 2
Catlin, George, 7
Cattier lithography
 company, 10
Cattini, Joannes, 8H
Caukercken, Cornelius
 van, 2, 8H
Caulo, A., 8H
Cauvet, Gilles-Paul, 2
Cavalieri, Giovanni
 Battista de (Cavalleriis),
 2
Cavalletto, Giovanni
 Battista de, 8H
Cavalli, Dick, 8H
Cavalli, Nicolo, 2
Cavedone, Giacomo, 2
Cawein, Kathrin, 7
Caxenave (?), 2
Caylus, Anne Claude
 Philippe, comte de, 2, 8H
Cayron, Jules, 7
Cazes, Pierre-Jacques, 2
Cazin, Jean-Charles, 2
Cecchi, Francesco, 2
Cecchi, Giovanni Battista,
 8H
Ceileur, A., 8H
Celardo, John, 8H
Celestini, Celestino, 7

Centino, Giovanni
 Francesco Nagli. See
 Nagli, Giovanni
 Francesco
Central Lithograph
 Company, 8H
Century Company, 8H
Ceracchi, Giuseppe, 8H
Cermak, Jaroslav (after), 2
Cernel, Marie Jeanne
 Champion de, 2
Ceroni, Luigi, 2
Cesar, 4
Cesari, Giuseppe (called
 Cavaliere d'Arpino), 2
Cesi, Bartolommeo (att.), 2
Cesio, Carlo, 2, 8H
Ceulen, Cornelis Johnson
 van. See Johnson,
 Cornelis van Ceulen
Chabanian, Arsene, 7
Chabas, Paul, 7
Chadwick, Lynn, 4
Chadwick, William, 7
Chaffee, Ada Gilmore, 7
Chagall, Marc, 4
Chailleat, Leonard, 2
Chaillot A., 2
Chalfant, Jefferson David,
 7
Chaliapin, Boris, 10
Challamel, Jules Robert,
 8H
Challe, Charles
 Michel-Ange, 2
Chalon, Henry Bernard, 2
Chalon, John James (after),
 2
"Cham." See Noe,
 Amedee Charles de
Chamant, Giuseppe, 2
Chambans, T., 8H
Chamberlain, Samuel V.,
 2, 7, 8H
Chamberlin, Wesley, 7
Chambers, Thomas, 8H
Chambers, William, 2
Chamblain, Jean-Baptiste
 Bullet de, 2
Chamon (?), 2
Champagne, J. (after), 2
Champaigne, Jean Baptiste
 de (after), 2
Champaigne, Philippe de
 (after), 2
Champfleury, 8H

Christy, Howard Chandler, 2

Chryssa, Varda, 7; *works after*, 2

Ch'u Sui-liang, 3

Chu Ta, 3

Chun, Chen, 7

Chuntrey, 8H

Church, Frederic Edwin, 2, 10

Church, Frederick Stuart, 7, 8H; *works after*, 2

Ciamberlano, Luca, 2

Ciceri, Eugene, 7, 8H

Cignani, Felice, 2

Cigoli, Lodovico Cardi da, 2

Cikovksy, Nicolai, 4

Cimarolo, Giambattista, 2

Cimino, Harry, 7

Cincinnati Process Engraving Company, 8H

Cipolla, Antonio, 2

Cipriani, Galgano, 2

Cipriani, Giovanni Battista, 8H; *works after*, 2

Cirone, Carmella, 7

Citron, Minna Wright, 4, 7, 8H

Claessens, Lambertus Antonius, 7, 8H

Claghorn, Joseph Conover, 7, 8H

Clamp, R., 2

Clark Engraving Company, 8H

Clark, Cecil G., 7

Clark, G. W., 2

Clark, George, 8H

Clark, Isaac C., 2

Clark. J. H., 6

Clark, Michael, 7

Clark, Roland, 7

Clark, Walter Appleton, 2

Clarke, Gertrude M., 2

Clarke, John Clem, 7

Clarke, Thomas, 10

Clauber, I., 8H

Claudius, 8H

Claudius, H., 2

Claussin, J., 2

Clawson, Rex Martin, 4

Claxton, Wayne, 7

Clay, Edward Williams, 8H, 10

Cleaves, W. P., 8H

Clem, Adrian D., 7

Clemens, J. T., 7

Clemens, Johan Frederik, 10

Clemens, Paul Lewis, 7

Clement, Jayet, 2

Clements, Gabrielle de Veaux, 7, 8H

Clennell, Luke, 8H

Clerici, Francesco, 2

Clerisseau, Charles Louis, 2

Clermont, Jean Francois, 2

Clifford, Edward, 10

Clinedinst, Benjamin West, 2

Clint, George, 2

Closson, William Baxter Palmer, 2, 7, 8H

Clouwet, Albertus, 2, 8H

Clouwet, Petrus, 2

Clowes, Butler, 2

Coale, Griffith Baily, 2, 7

Cober, Alan, 6

Coburn, Alvin Langdon, 10

Cocchi, Francesco, 2

Cochin, Charles Nicolas (the elder), 2, 7

Cochin, Charles Nicolas (the younger), 2

Cochin, Nicolas, 2

Cochran, 8H

Cochran, J., 8H

Cock, Hieronymus, 2

Cock, Jan Claudius de, 2

Cockerell, Douglas, 2

Coelemans, Jacques, 8H

Coemart, B., 8H

Coeur d'Acier, Pierre (called L'Assurance), 2

Coget, Antoine, 8H

Coghetti, Francesco, 2

Cohen, Eleanore G., 2, 7

Colby, Homer Wayland, 2

Cole, Benjamin, 2

Cole, Joseph Foxcroft, 2, 7, 8H

Cole, Robert, 7

Cole, Thomas, 2

Cole, Timothy, 2, 7, 8H, 10

Coleman, Glenn O., 4, 7

Coles, John, Sr. *(att.)*, 10

Coles, M. Izabel, 2

Colescott, Warrington, 7, 8H

Colibert, Nicolas, 2

Colin, Alexander Mane (?), 2

Colin, Charles-Amedee, 2

Colinet, C., 2

Colker, Edward, 7

Collaert, Adrian, 8H

Collaert, Adrian (II), 2

Collaert, Hans (II), 2

Collaert, Hans, Le Pere, 2

Collaert, Jan Baptist (I), 2

Collas, A., 8H

Collet, 2

Collet, L., 2

Collette & Sanson, 8H

Collier, John, 8H, 10

Collignon, F. Jules, 8H

Collin, Dominique, 2

Collin, Louis-Joseph Raphael *(after)*, 2

Collins, Kreigh, 8H

Collins, R. C., 8H

Collins, Robert, 7

Collot, Pierre, 2

Collotype Company, 8H

Colman, Samuel, 2, 7, 8H

Colombini, Cosimo, 8H

Colonna, Angelo Michele, 2

Colorcraft Company, 8H

Coloritype Company, 8H

Colorplate Engraving Company, 8H

Colos, Francois, 10

Colson, W. E., & Company, 8H

Coltellini, C. *(after)*, 2

Columbia Planograph Company, 8H

Colwell, Elizabeth, 7

Combs, C. H., 8H

Comirato, Marco, 8H

Commercial Printers, Inc., 8H

Comparini, Luca, 8H

Compte-Calix, F. C. *(after)*, 2

Conca, Sebastiano, 2

Conca, Tommaso, 2

Conde, Jean, 2

Condouze, Anais, 2

Congio, Camille, 2

Conixloo, Gillis van (III) *(after)*, 2

Conover, Marilyn, 10

Conover, Robert, 2, 7

Conrad, Barnaby, 10

Conrad, Paul, 10

Consagra, Pietro, 4
Conslans, C., 8H
Consoni, Nicola, 2
Constant, Benjamin, 8H
Constant, George Z., 4, 7, 10
Constantini, 8H
Constanzi, Placido, 2
Contant, Pierre. See Ivry, Pierre Contant d'
Contencin, James, 8H
Contgen, Georg Joseph, 2
Conti, Metrodoro, 2
Continental Colortype Company, 8H
Contini, Giovanni B., 2
Converse, Lily S., 8H
Cooghen, Leendert van der (att.), 2
Cook, George, 8H
Cook, H. R., 2
Cook, Howard, 2
Cook, Howard Norton, 7
Cook, Lia, 7
Cook, Mary E. (after), 2
Cooke, Hereward Lester, 6
Cooke, Robert, 10
Cooper Union Engraving Class, 2
Cooper, E., 8H
Cooper, Mario, 6
Cooper, R., 8H, 10
Cooper, Richard (the younger), 2
Cooper, Robert, 2
Copeland, Lila, 7
Copello, J., 7
Coppola, Giovanni Andrea, 2
Coques, Gonzales (after), 2
Coquin, Louis, 2
Cor, P. L., 2
Corbett, Edward, 4
Corbino, Jon, 2, 7
Corbould, Henry (after), 2
Corday & Gross Company, 8H
Cordier, Robert, 2
Corenzio, Belisario (att.), 2
Corinth, Charlotte Berend, 7
Corinth, Lovis, 8H
Coriolano, Bartolomeo, 8H
Coriolano, Giovanni Battista, 2
Corita, Sister Mary, 7

Corlis, Macy, and Company, 2
Corneille, Guillaume Beverloo, 7
Cornelius, Peter von (after), 2
Cornell, Joseph, 7
Cornell, Robert, 7
Cornell, Thomas, 7
Cornille, F., 2
Corning, Merv, 6
Cornwell, Dean, 2, 6
Corot, Jean-Baptiste-Camille, 2, 8H
Corr, Erin, 2
Correggio. See Allegri, Antonio
Corss, C. W., 8H
Cort, Cornelis, 2, 8H
Cortazzo, Oreste (after), 2
Cortona, Pietro da. See Berrettini, Pietro
Corvi, Domenico, 2
Corvinus, Johann August, 2
Cosmi, Bernardo (att.), 2
Cosse, J. Laurence, 2
Cossinus, J., 8H
Coste, M. de, 2
Costigan, Constance, 4
Costigan, John Edward, 2, 7, 8H
Cosway, Richard, 6; works after, 2
Cotelle, Jean, 2
Cottet, Charles, 7
Cottingham, Robert, 7
Cotton, John Wesly, 7, 8H
Couadi, N., 10
Couche, J., 8H
Coudrain, 2, 7
Coughlin, Jack, 7
Coughlin, Mildred M., 7
Coulet, Anne Philiberte, 2
Coulter, Mary, 7
Coupe, Antoine-Jean-Baptiste, 2
Coupeau, Ch. G., 2
Courbain, Francois, 8H
Courbet, Gustave, 8H
Courier lithography company, 10
Courlander, David, 7
Courson, C., 8H
Courteille, 2
Courtin, Pierre, 4

Courtry, Charles J. L., 2, 8H
Cousen and Bartlett, 7
Cousen, C., 8H
Cousen, J., 8H
Cousinet, C. E., 8H
Cousins, Samuel, 7, 8H
Coutil, Leon-Marie, 2
Coutterand and Macaux, 2
Covarrubias, Miguel, 7, 10
Cove, 8H
Covert, Herbert B., 2
Covey, Authur Sinclair, 2
Cowan, Jack, 7
Cowfer, Linda, 7
Cowtan and Sons, 2
Cox, Allyn, 2
Cox, Gardner, 10
Cox, J. Halley, 7
Cox, Joseph, 7
Cox, Kenyon, 2, 7
Cox, Louise Howland, 2
Cox, Nostrand, and Gunnison, Inc., 2
Cox, Palmer, 2
Coxe, Reginald Cleveland, 8H
Coypel, Antoine (after), 2
Coypel, Charles (after), 2
Cozzadi, 10
Craaz, Gottfried (after), 2
Crace, Frederick, 2
Crace, John, & Son, 2
Craffonaria, G., 8H
Craig, Frank, 2
Cramer, Konrad, 7
Cranach, Lucas, 8H
Cranach, Lucas (the elder), 2
Crane Lithography Company, 8H
Crane, Abbie, 2
Crane, Alan Horton, 7, 8H
Crane, Roy, 8H
Crane-Howard Company, 8H
Cranmer, Thomas, 7, 8H
Crapster, Katherine N., 7
Crawford, Earl Stetson, 7
Crawford, Jay, 2
Crawford, Ralston, 7
Crawford, Will, 2
Crecelius, Henry R., 2
Creekmore, Raymond L., 7
Crehen, Charles G., 10
Crehen, Ernest, 10
Crenice, de, 2

Daumier, Honore, 2, 6, 7,
8H
Daumont, E., 8H
Dauphin, Claude, 2
Dautel, P., 2
Dauthage, Adolph, 8H
Davenport, Bob, 8H
Davenport, Carson J., 7
Davenport, Nancy, 2
Davenport, S., 7
Davenport, William H.
(after), 2
Davey, Randall, 2, 4, 8H
David, 6
David, Antonio (after), 2
David, Giovanni, 2
David, Jacques-Louis
(after), 2
David, Jerome, 2
David, Jules, 2
Davidson, Frank, 2
Davidson, Harry, 2
Davies, Arthur Bowen, 2,
4, 7, 8H
D'Avignon, Francis, 8H,
10
Davis, Alexander Jackson,
2
Davis, Gene, 4, 7
Davis, Georgiana, 2
Davis, Hubert, 7
Davis, J. P., 2, 8H
Davis, Jack, 10
Davis, John D., 8H
Davis, John Parker, 2, 8H
Davis, Lew, 7
Davis, Noel Rockmore, 2, 4
Davis, Ronald, 4
Davis, Stuart, 4, 7, 8H
Davis, Theodore R., 2
Davis, Warren, 8H
Davis, Wayne, 6
Dawe, George (after), 2
Dawson, A. & W., 8H
Day & Haghe lithography
company, 8H, 10
Day, Martha S., 2
Day, Worden, 7
Dayes, Edward (after), 2
Dean, George A., 8H
Dean, Hilliard, 7
Dean, James D., 6
Dean, Mallette, 7
Dean, T. A., 8H
Deblois, C. A., 8H
Debonneval (after), 2
De Boissieu, J. J., 8H

Debrie, Gabriel Francois
Louis, 2
De Brun, Elsa, 4
Debucourt,
Louis-Philibert, 2, 8H, 10
De Camp, Joseph, 7
Dechesne, 2
Decisy, E., 8H
Decker, Cornelis (after), 2
Decker, Gabriel, 8H
Decker, Paul (the elder), 2
Decreuse, Auguste (after),
2
De Diego, Julio, 7
Deeble, T., 6
Defehrt, A. J., 2
Deferneville, P., 2
Degen, 6
De Genlir, 7
Degotardi, J., 8H
Dehn, Adolf Arthur, 2, 4, 7
Deigendesch, H., 8H
Deines, Hubert E., 8H
Deis, Carl August, 2
Deis, H., 8H
De Kooning, Elaine, 10
De Kooning, Willem, 4, 7
De Kruif, Henri, 7
Delacour, William (after), 2
Delacroix, Ferdinand
Victor Eugene, 2, 7, 8H
Delafosse, F., 2
Delafosse, Jean-Charles, 2
Delagardette, Pierre
Claude, 2
Delaistre, Louis Jean
Desire, 8H
De La Marcade, 2
De Lacollombe, 2
Delamonce, Ferdinard, 2
De Lamonica, Roberto, 4, 7
Delannoy, Ferdinand, 2
Delany, Mary (Granville), 2
Delaroche, Paul, 2
Delasalle, Angele, 7
Delatre, Auguste, 8H
Delattre, Jean Marie, 2
Delaunay, Nicolas, 2, 8H
Delaunay,
Robert-Victor-Felix, 4,
8H
Delaune, 8H
Delaune, Charles-Etienne,
2
Delff, Willem Jacobsz, 2,
8H

Delignon, Jean-Louis, 2,
8H
Delisle, Guillaume, 2
Delleker, George, 10
Delobel, Nicolas (after), 2
Delorme, 2
Delpech,
Francois-Seraphin, 2, 8H
Delsenbach, Johann Adolf,
2
Delteil, Loys, 7
Delvaux, Remi-Henri
Joseph, 2
Demachy, Pierre A. (after),
2
De Maine, Harry, 7
Demarais, Joseph, 7
Demare, H., 8H
Demare, J., 8H
Demarteau, 8H
Demarteau, Gilles, 2
Demarteau, Gilles Antoine
(the younger), 2
De Martini, Joseph, 7
De Matties, Nick, 7
Demetrios, George, 7
De Milhau, Zella, 7
Deming, Edwin Millard, 7
De Miskey, Julian, 7
Demoulin, Vignerol, 8H
Demuth, Charles Henry, 4,
7
Denby, F., 7
Denby, Peter Rex, 7
Denes, Agnes, 7
De Niro, Robert, 4
Denis, Maurice, 2, 7, 8H
Denison, Harold, 2
Denner, Balthasar, 2
Denning and Fourcade, 2
Denon, Dominique Vivant,
2, 8H
Denroche, S. B. (after), 2
Dente, Marco Da Ravenna,
2, 8H
Denton, E. S., 8H
Deny, Jeanne, 2
De Pauw, Victor, 7, 8H
De Prangey, Girault, 7
Dequevauvilier, Francois
Jacques, 2, 8H, 10
Derain, Andre, 2
De Ram, I., 8H
Deraniygala, Ranil, 8H
Derderian, Ara, 2
Derfet, T. L., 8H
Derille, H., 2

Dermott, Leonard, 6
Deroy, 7
De Saavedra, Ruben, 2
De Sauty, Alfred, 7
Desboeufs de
 Saint-Laurent, 2
Desboutin, Marcellin
 Gilbert, 2, 8H
Desbrulins, F., 2
Descamps, Jean-Baptiste
 (after), 2
Descares, Victor Lucien, 6
Deschamps, E., 8H
Desclaux, V., 8H
Descourtis, Charles
 Melchior, 2, 8H
Desfontaines, Swebach,
 8H
Desgots, Claude (after), 2
Deshaies, Arthur, 2, 7
Deshayes, Eugene (att.), 2
Deshayes, T., 7
Desire-Lucas, 7
Deskey, Donald, 2
Desmaisons, Emile, 8H
Desmarchais, 2
Desnoyers,
 Auguste-Gaspard-Louis,
 10
Desnoyers, B., 8H
Desow-Fishbein, Lillian, 7
Despiau, Charles, 4
Desplaces, Louis, 2, 8H
Desprez, Jean-Louis, 2
Desrais, 6
Desrais, Claude Louis, 2
Desrochers, Etienne, 2, 8H
Dessain, Emile Francois, 3
Desvachez, D. I., 8H
Detaille, Edouard, 2, 8H
Detroy, Jean-Francois, 2
Detroy, Laurent, 2
Detwiller, Frederick
 Knecht, 7, 8H
Deutsch, Boris, 7
Deutsch, Hilda, 7
Deutsch, Nikolaus Manuel,
 2
Devachez, D., 8H
Devambez, 2
De Varene (after), 2
Deveaux, James, 2
Deveria, Achille, 2, 8H
Devey, George, 8H
Deville, 8H
Deville, Henry, 2
Devos, M., 8H

Dewey, Elizabeth R., 7
Dewing, Thomas Wilmer,
 3, 7
Dey, Mukul Chandra, 7
Deye, 2
Deyrolle, Jean, 2
Diaz, Juan, 2
Dick, A. L., 8H
Dick, Robert, 6
Dickenson, Fred, 8H
Dickes, William, 8H
Dickinson & Watson, 10
Dickinson, Edwin Walter,
 4
Dickinson, Eleanor
 Creekmore, 7
Dickinson, Geoffrey, 10
Dickinson, Lowes Cato, 2
Dickinson, Preston, 4, 7
Dickinson, William, 2
Dicksee, Herbert, 8H
Dickson, Jennifer, 8H
Didier, Adrien, 8H
Didot, Firmin, 8H
Diebenkorn, Richard, 4, 7
Dielman, Frederick, 2
Dielmann, Jakob
 Furchtegott (after), 2
Diepenbeeck, Abraham
 van (after), 2
Dies, Albert Christoph, 2
Dies, Carl, 2
Diest, Adriaen van (after),
 2
Dieterich, 8H
Dietrich, Christian
 Wilhelm Ernst, 2, 8H
Dietrich, Friedrich
 Christophe, 2
Dietterlin, Wendel (the
 elder), 2
Dietterlin, Wendel (the
 younger), 2
Dieuaide, E., 6
Diez, Wilhelm von, 2
Di Gemma, Joseph P., 8H
Dighton, Denis, 2
Dighton, Richard, 2
Dighton, Robert D., 2, 10
Di Gioia, Frank, 4
Di Mari, Valere, 7
Dine, Jim, 4, 7
Dinglinger, Sebastian
 Henry (after), 2
Di Preta, Tony, 8H
Dirk, Nathaniel, 7
Dirks, R., 8H

Disney, Walt, 8H
Divita, Robert J., 6
Dix, Harry, 7
Dix, Otto, 2
Dixon, Artie Markatos, 7
Dixon, Charles, 8H
Dixon, John, 8H; works
 after, 2
Dixon, Maynard, 2
Dizambourg, 2
Dmitri, Ivan, 8H
Dobie, James, 8H
Dobkin, Alexander, 4
Dobson, John, 8H
Doctoroff, John, 10
Dodd, Ed, 8H
Dodd, Francis, 7
Dodd, Irene, 6
Dodd, Lamar, 6, 7
Dodd, Lois, 2
Dodge, Frances Farrand, 7
Dodge, Ozias, 7
Dodge, William de
 Leftwich, 7
Dodson, R. W., 8H
Does, Anton van der, 8H
Dohanos, Stevan, 6, 7
Dohm, William H., 2
Doi, Isami, 7
Dolbin, B. F., 10
Dole, William, 4
Dolice, L., 6
Dolivar, Jean, 2
Dollman, John Charles
 (after), 2
Dolph, John Henry (after),
 2
Dolwick, William
 Adelbert, 7
Domberger, P., 2
Domeni, 2
Domenichi, Cesare, 2
Dominici, Antonio de, 2
Domjan, 7
Domjan, Joseph, 8H
Donahey, William, 8H
Donald, D., 2
Donaldson Art Sign
 Company, 8H
Donaldson Brothers, 8H
Donaldson, Joseph, Jr., 7
Dondorf, B., 2
Doney, Thomas, 8H, 10
Dongen, Kees Van, 8H
Donnelley, R. R., & Sons,
 8H
Donnelly, Thomas, 7

Donneson, S., 7
Donoho, Thomas, 8H
Donovan, Ellen, 7
Donovan, Samuel (Don
 Swan), 2
Doo, G. T., 8H
Doolittle, Amos, 2, 7, 10
Doolittle, Harold L., 7
Dorazio, Piero, 2, 7
Dore, Gustave, 8H; works
 after, 2
Dore, Louis, 2
Dorfman, Bruce, 7
Dorgeloh, Marguerite
 Redman, 7
Dorgez, 6
Dorigny, Louis (after), 2
Dorigny, Michel, 2, 8H
Dorigny, Nicolaus, 2
Dorman, John, 7
Dorner, J., 8H
Dossi, Dosso (after), 2
Dossier, Michel, 2
Dou, Gerard (after), 2
Doudelet, Charles, 8H
Doudyrs, Willem (after), 2
Dougal, W. H., 8H
Dougherty, Bertha
 Hurlbut, 2
Doughty, Thomas, 2, 7
Doughty, William, 8H
Douglas, Morgan, 7
Douglas, W. (after), 2
Douglass, Lucille Sinclair,
 2
Doux, Harold, 8H
Dove, Arthur, 7
Dow, Arthur Wesley, 2, 7
Dow, Flora M., 2
Dow, Jane M., 7
Dowden, Raymond Baxter,
 2
Dowell, John E., Jr., 7
Downey, Juan, 7
Downey, W. & D., 8H
Downing, Joseph Dudley,
 8H
Doyle, Hugh, 8H
Drake, Stan, 8H
Draper, Dorothy, 2
Drayton, J., 8H
Dreier, Katherine, 7
Dreisler, B., Jr., 7
Drentwet, Abraham
 (after), 2
Dresely, Johann Baptist,
 8H

Drevet, Claude, 2
Drevet, Pierre, 2, 8H, 10
Drevet, Pierre Imbert, 2
Drewes, Werner, 7, 8H
Drexler, Sherman, 4
Driendl, Thomas, 8H
Dripps, M., 8H
Driskel, David, 8H
Drosd, Nancy, 7
Drouais, Francois-Hubert
 (after), 2
Drucker, Mort, 10
Drumlevitch, Seymour, 4
Drummond, A. J., 8H
Drummond, J. C., &
 Company, 8H
Drummond, Samuel, 2
Drummond, William
 (after), 2
Drury, William H., 8H
Duane, William, 8H
DuBois, Guy Pene, 4, 7
Dubois, Jean, 2
Dubois, Jean Joseph
 (after), 2
Dubois, Louis-Albert, 2
Dubordier, Pieter (after), 2
Dubosc, Claude, 2
Dubourg, Louis Fabritius
 (att.), 2
Dubourg, M., 2, 6
Dubreulie, 2
Dubroeucq, Jacques
 (after), 2
Dubufe, Edouard (after), 2
Dubuffet, Jean, 2, 4
Ducarme, 8H
Ducerceau, Jacques
 Androuet, 2
Ducerceau, Paul Androuet,
 2
Duchage, G., 8H
Duck, Jacob, 2
Duclange, G., 7
Duclos, Antoine-Jean, 2,
 8H
Ducq, Jan le (after), 2
Dudensing, Richard, 8H
Duer, Douglas, 2
Duez, Ernest (after), 2
Duff, John Robert Keitley,
 7
Duflos, Claude Augustin,
 2, 8H
Duflot, Victor, 2
Dufourmantell, Felix, 8H
Duftius, C. L., 8H

Dufy, Raoul, 2
Dughet, Gaspard (called
 Poussin,
 Gaspard)(after), 2
Dughet, Joannis, 8H
Duglos, 8H
Dugourc, Jean
 Demosthene, 2
Dugourc, Jean Denis, 2
Duhamel, A. B., 2
Dujardin, Karel, 2, 8H
Dujardin, P., 8H
Dulac, Edmund, 2
Dumas, F. G., 8H
Dumond, Frank Vincent, 2
Dumont, Gabriel Martin
 (after), 2
Dumont, Jacques (le
 Romain), 2
Duncan, Anne Laddon, 6
Dunkarton, Robert, 2, 8H
Dunker,
 Balthasar-Antoine, 2, 6
Dunlap, William, 8H
Dunn, Alfred, 7
Dunn, Bob, 8H
Duperac, Etienne, 2
DuPeyron, F. H., 7
Dupin (le jeune), 7
Dupin, N. (after), 2
Dupin, Pierre, 2
Duplat, Pierre Louis, 2
Duplessi-Bertreaux, Jean,
 2, 7, 8H
Duplessis, Jean Claude
 Thomas, 2
Dupont, Charles Carle
 Henri, 2
Dupont, Louis Pierre
 Henriquet, 2, 8H
Dupont, Paul, 8H
Dupre, Francois, 2
Dupre, Jules, 2, 8H
Dupree, J., 2
Dupuis, Charles, 2, 8H
Dupuy, Nicholas, 8H
Dupuy, Paul-Michel, 7
Durand, Amand, 8H
Durand, Andre, 8H
Durand, Asher Brown, 7,
 8H, 10
Durand, Godefroy (after), 2
Durand, J(ean Francois?),
 2
Durant, Jean-Louis, 2
Duranti, Fortunato
 (Agricola, Filippo), 2

Ferrero, Giovanni Francesco, 2, 8H
Ferri, Ciro, 2
Ferri, Gaetano, 2
Ferris, John Leon Gerome, 7, 8H
Ferris, Stephen James, 7, 8H
Ferriss, Hugh, 2
Fertig, I., 8H
Fessard, Claude-Mathieu, 2
Fessard, Etienne, 2
Fett, George, 8H
Feure, Georges de, 2
Feyen-Perin, 8H
Fichot, Charles, 2
Fichter, Herb, 2
Field, Elisabeth C., 2
Field, Gueliema, 2
Field, Robert, 8H, 10
Fielder, Harold, 2
Fielding, Theodore Henry Alolphus, 2
Fiene, Ernest, 2, 7
Fiesinger, Gabriel, 10
Figueroa, Jose Manuel, 2
Figura, 8H
Filipart, J. J., 8H
Fillebrown, F. E., 8H
Filloeul, Pierre, 2, 8H
Filmer, J., 8H
Filmer, John, 2
Finch, Dan O., 7
Finch, Eleanor, 2
Finden, Edward F., 8H
Finden, G. C., 8H
Finden, W., 8H
Fine, Lois, 8H
Fine, Pearl, 7
Finelli, Carlo, 2
Finguerlin (?), 2
Finiguerra, Maso (att.), 2
Finlayson, John, 2
Fiore, Nicola, 2
Fioroni, Adamo, 2
Fiquet, F. C., 7
Fischel, Adler, and Schwartz, 2
Fischer, Anton Otto, 8H
Fischer, Fritz, 2
Fischer, L., 2
Fischer, Paul, 2
Fischer, Ulrich, 2
Fischer, Vincenz, 2
Fischetti, Fedele, 2
Fischetti, John, 8H

Fisher (?) (after), 2
Fisher, Albert, 8H
Fisher, Alfred Hugh, 7, 8H
Fisher, Alvan, 7
Fisher, Bud, 8H
Fisher, Edward, 8H, 10
Fisher, Harrison, 2, 10
Fisher, Joseph, 8H
Fisher, M., 8H
Fisher, Orr, 7
Fisher, S., 7
Fitch, Gladys Kelley, 7
Fite, Eugene J., 8H
Fitsch, Eugene, 7
Fittler, James, 8H
Fitton, Hedley, 2, 7
Fitzer, Arthur, 2
Fitzgerald, James, 10
Fitzgerald, James Herbert, 7
Fitzgerald, John Cook, 8H
Fitzgibbons, John, 2
Fizeau, Hippolyte Louis, 8H
Fjelde, Paul, 6
Flachenecker, W., 8H
Flackman, David, 6
Flagg, Ernest, 2
Flagg, James Montgomery, 8H, 10
Flagg, Montague, 2
Flaizik, John, 2
Flamen, Albert, 2
Flameng, Francois, 7
Flameng, Leopold, 2, 7, 8H
Flanagan, Albert Edward, 7
Flanders, Charles, 8H
Flannagan, John, 7
Flavell, Thomas, 7
Flegel, Johann Gottfried, 2, 8H
Flessel, Creig, 8H
Fletcher, F. Morley, 8H
Fletcher, Frank, 8H
Fleury, Robert, 8H
Flint, LeRoy, 7, 8H
Flipart, Jean Charles, 8H
Flipart, Jean Jacques, 2, 8H
Flora, Paul, 2
Flori, 5
Florian, Frederic, 8H
Floris, Cornelis (after), 2
Floris, Giovanni, 2
Floris, Jacob (after), 2
Florsheim, Richard A., 7, 8H

Floury, H., 8H
Flower, Forrest, 7
Flowers, Don, 8H
Focillon, Victor-Louis, 2
Foin, Augustin, 2
Fokke, Simon, 2
Folkema, Jacob, 7
Folo, G., 8H
Folo, Pietro, 8H
Foltz, Lloyd Chester, 7
Fonbonne, Anne, 2
Fontaine, Jacques Valentin, 2
Fontaine, Pierre Francois Leon, 2
Fontana, Domenico, 2
Fontana, Francesco, 2
Fontana, Girolamo, 2
Fontana, M., 2
Fontana, Pietro, 2
Fontebasso, Francesco, 2
Foo, Skat Holman, 8H
Foote & Davies, 8H
Foote, Marion (att.), 10
Foote, Mary A. Hallock, 2
Foote, Will Howe, 7
Forain, Jean-Louis, 2, 8H
Forberg, Ernst Carl, 2, 8H
Forbes Lithographic Mfg. Company, 8H
Forbes, Edwin, 7; works after, 2
Forbes, James, 7
Ford, Lauren, 2
Fordrin, Louis, 2
Foresso, S. W., 8H
Forjohn, Horatio C., 7
Forma, Franco, 8H
Forman, Helen, 7
Formhals, Henry, 8H
Formstecher, H., 8H
Formster, 8H
Fornance, Mary, 7
Fornasari, Giovanni, 2
Forrest, J. B., 8H
Forrester, Patricia Tobacco, 7
Forster, 7
Fortess, Karl E., 7
Fortier, H., 7
Fortuny y Carbo, Mariano, 2, 7, 8H
Forty, Jean-Francois, 2
Foschini, Antonio, 2
Foshko, Joseph, 4
Fosset, 6
Fossick, Michael R., 6, 7

Gest, Margaret, 7
Getchell, Edith Loring, 7,
8H
Getterman, 8H
Getz-Johansen, Aage, 7
Geyn, G. D., 8H
Geyser, Christian Gottlieb,
2
Ghaffar, Muzaffar A., 7
Ghandini, Alex, 8H
Gheeraerts, Marcus (I), 2
Ghelli, Giuseppe, 2
Ghent, Emanuel de, 2
Gherardi, Antonio, 2
Gherardi, Guiseppi, 8H
Gheyn, Jacob de, 2, 8H
Ghezzi, Pier Leone, 2
Ghigi, P., 8H
Ghisi, Diana, 2
Ghisi, Giorgio, 2
Ghisi, Giovanni Battista
(called Mantuanus), 2
Ghitti, Pompeo, 2
Giacometti, Alberto, 4
Giampiccoli, Guiliano, 8H
Giancarli, Polifilo, 2
Giani, Felice, 2
Giaquinto, Bruno, 7
Giaquinto, Corrado, 2
Giardini, Giovanni, 2
Giardoni, Alessio, 2
Giardoni, Francesco, 2
Gibbings, Robert Jomn, 2,
7
Gibbons, Percival, 8H
Gibson, Charles Dana, 2,
10
Gibson, G., 2
Gibson, William Hamilton
(after), 2
Giddens, Philip H., 7
Giffart, Pierre, 2
Gifford, E. S., 2
Gifford, Robert Swain, 7,
8H
Gihaut Freres, 2
Gikow, Ruth, 2, 7, 8H
Gilbert, 8H
Gilbert, A., 8H
Gilbert, Cass, 7
Gilbert, Sir John (after), 2
Gilbert, R., 6
Gilbert, R. S., 8H
Gilchrist, (Jonathan ?), 6
Gilder, Comfort Tiffany, 2
Giles, J. L., 10
Gilkey, Gordon, 8H

Gill and Register, 2
Gill, Delancey W., 7
Gill, James, 7
Gillam, Bernhard, 2
Gillam, Frederick Victor,
10
Gillespie, Gregory, 2
Gilliam, Sam, Jr., 5, 7
Gillot, 8H
Gillot, Charles, 3
Gillot, Claude, 2
Gillray, James, 8H; works
after, 2
Gilman, G. E., 8H
Gimbrede, J. N., 7, 8H
Gimbrede, Thomas, 8H, 10
Gini, Conte Cesare
Massimiliano, 2
Ginrack Press, 2
Giordano, Luca, 2
Giorgetti, Giacomo, 2
Giorgetti, Giuseppe, 2
Giorgi, 7
Giovanni, Antonio, 8H
Giraldon, A., 8H
Girard, Andre, 8H
Girard, M., 8H
Girard, Romain, 2
Girardet, E., 8H
Girardet, P. Jean, 2
Girardet, Paul, 8II
Girardey, A., 8H
Girardin, 2
Girop, A., 2
Giroux, Charles, 8H
Girsch, F., 8H
Gittiker, C. See
Saint-Germain
Gittleman, Len, 6
Giudici, Carlo Maria de, 2
Giusti, George, 10
Givler, William Hubert, 7
Glackens, Louis M., 2
Glackens, William James,
7, 8H, 10
Glaesser, Alexander, 2
Glaman, Eugenie, 7
Glanzman, Louis, 10
Glarner, Fritz, 4, 8H
Glasco, Joseph, 4
Glaser, Milton, 2, 10
Gleason, F., 8H
Gleeson, Charles K., 7
Glenn, Isa Urquhart, 8H
Glicenstein, Enrico, 7 ⸜
Glines, David, 7
Glintenkamp, Hendrik, 7

Glover, Townsend, 7, 8H
Glume, Johann Gottlieb, 2
Gobin, 2
Gobrecht, Christian, 8H
Godard, A., 8H
Godby & Merke, 8H
Goddard, Robert H., 6
Godfrey, J., 8H
Goebel, Carl, 8H
Goeneutte, Norbert, 2, 8H
Goers, William, 7
Goethe, Johann Wolfgang,
8H
Goetsch, Gustav F., 7
Goetz (or Goz), Gottfried
Bernhard, 2
Goetze, H., 2
Goff, Seymour R., 8H
Gogh, Vincent Van, 2
Goines, David Lance, 2
Gold, Albert, 7
Goldar, I., 8H
Goldbeck, Walter D., 7
Goldberg, Chaim, 2, 7, 8H
Goldberg, Frederick, 7
Goldberg, Reuben (Rube),
2, 6, 7, 8H
Goldensky, 8H
Goldsmith, M., 8H
Goldstein, Marvin, 2
Goldstein, Milton, 8H
Goldthwaite, Anne, 2, 7,
8H
Gole, J., 2
Golihew, Elizabeth, 8H
Golinkin, Joseph Webster,
2
Goltzius, Hendrick, 2, 7
Goltzius, Hubert, 8H
Gomier, Aloisio, 2
Gomier, Louis, 2
Gommersall, Lucy, 8H
Goncourt, Jules de, 2
Gonzalez, Julio, 4
Gonzalez, Xavier, 7
Good, Minnetta, 7, 8H
Goodacre, R., 2
Goodall, Edward, 8H
Goodbear, Paul Flying
Eagle, 7
Goode, Joe, 7
Goodeve, C., 8H
Goodman & Piggott, 10
Goodman, Bertram, 2
Goodman, C., 8H
Goodman, Jeremiah, 2
Goodman, Sidney, 4, 7

Goodnough, Robert, 7, 8H
Goodrich, Gertrude, 7
Goodyear, Joseph, 8H
Gorbaty, Norman, 10
Gordon, J. G., 8H
Gordon, Lawrence, 2
Gordon, Russell, 7
Gordy, Robert, 7
Gorelick, Boris, 7
Gorky, Arshile, 4, 7
Gorny, Anthony, 7
Gorsline, Douglas, M., 2, 8H
Goryaev, 8H
Gosselin, Edward, 10
Gotcliffe, Sid, 8H
Gothein, Werner, 2
Gottlieb, Adolph, 4, 7
Gottlieb, Harry, 7
Gouaz, Yves Marie, 2
Goudt, Hendrick, 2, 8H
Gould, Chester, 8H
Gould, J. J. (?), 2
Goupil & Cie., 2, 8H
Gourdon *(after)*, 2
Goussier (?), 2
Gouwen, Gilliam van der, 2
Gowland, J., 2
Goya y Lucientes, Francisco Jose de, 2, 6, 8H
Goyen, Jan Josefuz van *(after)*, 2
Gozzoli, Benozzo *(att.)*, 2
Graf, Urs, 2, 8H
Grafiani, Ercole *(att.)*, 2
Graham, A. W., 8H
Graham, Alex, 8H
Graham, Charles, 2
Graham, F. Wynn, 2, 7
Graham, George, 7, 10
Graham, John, 7
Graham, John (II)*(after)*, 2
Graham, John D., 7
Grain, Peter *(after)*, 2
Grainger, William, 2, 10
Gramberg, Liliana, 7
Grambs, Blanche, 7
Grand'homme, C. A. *See* Grossmann, Karl August
Grandi, Francesco, 2
Grandville, J. A. *See* Gerard, Jean-Isidore
Granello, L., 8H
Granet, Francois Marius, 2
Gransire, Eugene, 8H
Grant, Douglas, 7

Grant, Gordon, 2, 7, 8H
Grant, S. A., 2
Graphic Company, 10
Grassby, Percy, 7
Grasset de Saint-Sauveur, Jacques, 2
Grasset, Eugene Samuel, 2
Grassi, Ranieri, 8H
Gravelot, Hubert Francois, 2
Graves, Michael, 2
Graves, Morris, 4, 7
Graves, Nancy, 4, 7
Graves, R., 8H
Gravesande, Charles Storm van, 2
Gray, Abbie, 8H
Gray, Cleve, 2, 7
Gray, Frances, 2, 7
Gray, Harold, 8H
Gray, Joseph, 2
Gray, N. *(after)*, 2
Gray, Nancy, 7
Gray-Parker, 2
Graziani, Ercole, 2
Grazier, John H., 7
Greatbach, G., 8H
Greatback, William, 2
Greatorex, Elizabeth Eleanor, 7
Greaver, Hanne Nielsen, 7
Grecgy, Mrs. E. M., 8H
Greco, Frank, 8H
Green, Antoinette, 7
Green, C., 8H
Green, Elizabeth Shippen, 2
Green, Samuel M., 7
Green, Valentine, 8H, 10
Greenberger, Isabelle, 7
Greene, Stephen, 2, 7
Greenleaf, Richard Cranch, 2
Greenly, Colin, 7
Greenwald, Bernard, 7
Greenwood, Jane, 2
Greenwood, John, 10
Greenwood, Marion, 4
Gregoire, 8H
Gregori, Carlo, 2, 8H
Gregori, Ferdinando, 2
Gregorini, Domenico, 2
Gregorio, Melchiorre de, 2
Gregory, John Worthington, 7
Greiffenhagen, Maurice, 8H

Greischer, Matthias, 2
Greitzer, Jack J., 7
Greuter, Johann Friedrich, 2
Greuter, Matthaus, 2
Greux, G, 8H
Greve, Wilhelm, 8H
Grevedon, Henri, 2, 8H
Grevedon, Pierre Louis, 8H
Greven, H., 7
Gribayedoff, Valerian Michaelovich, 10
Gribelin, Simon, 2
Gridley, Enoch G., 7
Grien, Hans Baldung. *See* Baldung-Grien Hans
Grieshaber, Helmut Andreas Peter (HAP), 2, 8H
Griessmann, C. W., 2
Grifalconi, Ann M., 2
Griffier, Jan, 2
Griffith, Louis Oscar, 7
Griggs, W., 8H
Grignard-Lithographic Company, 8H
Grignion, Charles I., 2, 8H
Grimaldi, 8H
Grimaldi, Giovanni Francesco *(after)*, 2
Grips, Philip, 2
Gris, Juan, 4
Griset, Ernest, 7
Grive, (Abbe) Jean de la *(after)*, 2
Groeger, Friedrich Carl, 2
Groningen, Jan Swart van, 8H
Grooms, Red, 4, 7
Gropius, Walter Adolf, 2
Gropper, William, 4, 7
Grosch, Laura, 7
Grosch. Oscar, 7, 8H
Gross, Anthony, 2, 8H
Gross, Chaim, 4, 5, 7
Grosser, Maurice, 7
Grossman, Christian Gotthelf, 2
Grossman, Elias Mandel, 7
Grossman, Karl August, 2
Grossman, Nancy, 4
Grossman, Robert, 10
Grosz, George, 2, 4, 7
Groth, John, 7, 8H, 10
Grozelier, Leopold, 2, 8H, 10

Hankey, Lee, 8H
Hanks, Jarvis, 10
Hannotiau, Alexandre, 2
Hansen, Heinrich, 2
Hansen, Pete, 8H
Hansen, Robert, 7
Haque, Mahmud, 7
Harari, Hananiah, 2
Hardie, Martin, 7
Harding, Edward, 2
Harding, G. P., 6
Harding, J. D., 8H
Harding, Sylvester (after), 2
Hardy, Dewitt, 7
Hardy, Dudley, 2
Hardy, Heywood, 2, 8H
Hardy, John, 7
Hardy, T. M., 8H
Harer, Frederick W., 7
Harley, J. J. (or J. S.)(after), 2
Harley, Joseph S., 2
Harlow, George Henry (after), 2
Harmon, Lily, 4, 7
Harnett, William, 8H
Harper, Charles, 7
Harper, William St. John, 8H; works after, 2
Harpignies, Henri, 2, 7
Harral, H., 2
Harris, E. Landseer, 7
Harris, J., 8H
Harrison, Alexander (after), 2
Harrison, H., 6
Harrison, William, Jr., 10
Harroun & Bierstadt, 8H
Harrowyn, 8H
Hart, George Overbury ("Pop"), 4, 7, 8H
Hart, Johnny, 8H
Hart, Milton, 2
Hartigan, Grace, 4, 7, 8H
Hartl, Leon, 4
Hartley, Marsden, 4, 7, 8H
Hartman, Ludwig, 8H
Hartmann et Fils, 2
Hartung, Hans, 4
Hartwagner, Michael, 2
Harunobu, Suzuki, 2, 3, 8H
Harvey, William, 8H
Haseltine, William Stanley, 2
Hasen, Irwin, 8H
Haskell, Ernest, 7, 8H, 10

Hassall, John, 2
Hassam, Childe, 2, 4, 7, 8H, 10
Haste, Michel, 2
Hastings, Lynn Courtlandt, 7
Hasui (Bunjiro Kawase), 2
Hatch and Company, 2, 10
Hatch and Smillie, 2
Hatch, George W., 2
Hatch, Lorenzo James, 7, 8H
Hatcher, Keith, 7
Hatfield, Richard, 7
Hauer, Johann Thomas, 2
Haughey, James M., 7
Haussard, Elisabeth, 2
Haussard, Marie Catherine, 2
Havell, Robert, Jr., 2, 7, 8H
Havens, Leonard, 7
Hawkins, W., 8H
Hawley, Elisabeth King, 2
Hawley, Gene, 7
Hawley, Hughson, 2
Haworth, Miriam, 7
Hay, Walter, 8H
Hayes, David V., 7
Hayes, E. D., 8H
Haymes, John, 2
Haymson, John, 7
Haynes, F. Jay, and Brothers, 2
Hayter, Stanley William, 2, 7, 8H
Hayward, George, 7, 8H
Hayward, H. G., 7
Hazen, Grace, 2
Heale, 8H
Healy, Arthur K. D., 7
Heap, G. H., 8H
Heard, Thomas, 8H
Hearne, Thomas (after), 2
Heaslip, Lillian or Lucian, 6
Heath, Charles, 2, 8H
Heath, Fred, 8H
Heath, H., 8H
Heath, James, 2, 8H, 10
Heaton, Edward, 7
Hecht, W., 8H
Hechter, Charles, 7
Heckel, Erich, 2, 8H
Heckenauer, Leon, 8H
Heckman, Albert William, 2, 7
Hedonin, Edward, 8H

Heed, Ture, 8H
Heemskerk, Martin van, 8H; works after, 2
Heese, Edna W., 2
Hegi, 2
Heidenreich, Carl, 7
Heil, Charles E., 7, 8H
Heilmann, Jean Gaspard (after), 2
Heim, Henry, 8H
Heimdahl, Ralph, 8H
Heince, Zacharie (after), 2
Heindel, Robert, 10
Heindricx, Gillis, 10
Heinemann, Ernest, 2, 8H
Heinemann, Peter, 2
Heinig, Paul, 7
Heins and La Farge, 2
Heintzelman, Arthur William, 2, 7, 8H
Heinzmann, Carl Friedrich (after), 2
Held, Al, 4, 7
Held, Edward S., 2
Held, John, Jr., 7
Helder, Zama Vanessa Paterson, 7
Helier, Claude, 7
Heliker, John Edward, 2, 7
Heliotype Company, 8H
Heliotype Printing Company, 8H
Helle, Ray, 8H
Heller, Helen West, 7, 8H
Helleu, Paul Cesar, 2, 3, 7
Hellich, Joseph, 8H
Helman, 6
Helman, I. S., 7
Hemery, 2
Hemery, Antoine Francois, 2, 8H
Heming, Arthur, 2
Hemm, J. P., 2
Hempel, H. A., 8H
Henderson Lithography Company, 8H
Henderson, Harold G., 8H
Henderson, Leslie, 8H
Henderson, William Penhallow, 7
Henkels, Stanley V., 8H
Hennequin, Phillippe, 2
Henner, Jean Jacques (after), 2
Hennessy, Richard, 7
Hennessy, William John, 10; works after, 2

Henon, Antoine, 2
Henri, Robert, 4, 7, 8H, 10
Henrique, Antonio, 7
Henriquel, D., 8H
Henriquez, B. L., 8H
Henry & Sandmeyer, 8H
Henry, Charles, 8H
Henry, George, 8H
Henry, John, 7
Henshaw, Glen Cooper, 10
Hentschel, W. E., 8H
Hentzi, Rudolf (after), 2
Herbert, Isaac, 2
Herbin, Auguste, 4
Herblock. See Block,
 Herbert Lawrence
Herbsthoffer, K., 8H
Here de Corny, Emmanuel,
 2
Herford, Oliver, 2, 7, 8H
Hergenroeder, Georg
 Heinrich, 8H
Heriot, George, 2
Herisset, Antoine, 2
Herkomer, Hubert von, 2,
 8H
Herline, Edward,
 lithography company, 10
Hermann, I. M., 8H
Hermes, William, 8H
Hernandez-Ouevedo,
 Manuel, 2
Herndon, Claude, 2
Herrick, Henry, 2
Herricks (after), 2
Herring, Frank Stanley, 7
Herrle, Karl (?) (after), 2
Herron, Carl, 2
Herstein, A. E., 7
Hertel, Georg Leopold, 2,
 8H
Hertel, Johann George (the
 younger), 2
Hervier, Adolphe, 8H
Hervier,
 Louis-Jules-Adolphe, 2
Herview, Auguste, 10
Hery, 8H
Herz, Johann Daniel (the
 younger)(after), 2
Herzberg, 2
Herzbrun, Helene, 7
Hess, Erwin L., 8H
Hess, Johann Heinrich, 2
Hess, Peter von (att.), 10
Hesse, Eva, 2
Heudelot, J., 8H

Heuer & Kirmse, 8H
Heun, Alice, 7
Heusch, Jacob de, 2
Heusch, Willem de (after),
 2
Hewitt, Edward S., 7
Heydeker, Richard, 2
Heyden, Jacob van der, 2,
 8H
Heyden, Pieter van der,
 (called Petrus A Merica),
 2
Heyer, William, 7
Heywood, Thomas, 8H
Hibon, Auguste, 2, 8H
Hicken, Philip, 2
Hicks, Thomas, 2
Hicks, William, 7, 8H
Higgins, Eugene, 2, 4, 7,
 8H
Higgs, Robert, 7
Higham, T., 8H
Highmore, T., 8H
Higmer (?), 2
Hiler, Hilaire, 2, 7
Hill, I. (J), 2
Hill, J. Henry, 7
Hill, James Jerome, 7
Hill, John, 7
Hill, John Henry, 8H
Hill, Leaven (?), 2
Hill, Mabel Betsy, 2
Hill, Polly Knipp, 7
Hill, Raven, 7
Hill, Samuel, 10
Hill, Thomas (after), 8H
Hillemacher, Frederic, 2
Hiller, Joseph, Jr., 10
Hillmann, Hans, 2
Hills, Robert, 8H
Himely, Sigismond, 8H
Himmelfarb, John, 7
Hindley, William, 2
Hinge, Mike, 10
Hinman, Charles, 7
Hinschelwood, Robert, 7,
 8H
Hios, Theodore, 7
Hiratsuka, Unichi, 7, 8H
Hirons, Frederic C., 2
Hiroshige (II), 2
Hiroshige (III), 10
Hiroshige, Ando, 2, 3, 8H
Hirsch, Joseph, 7
Hirsch, Stefan, 7
Hirschfeld, Al, 4

Hirschmann, Johann
 Baptist, 7
Hirschmann, Johann
 Leonhard (after), 2
Hirschvogel, Augustin, 2
Hitchcock, George, 2
Hitchcock, Mrs., 7
Hitchings, H., 8H; works
 att., 2
Hittorff, Jacques Ignace, 2
Hiv, Elsie, 8H
Hixon, Alfred W., 8H
Hnizdovsky, Jacques, 7
Hoag, Peter, 7
Hoagland, Clayton, 2
Hobbema, Meindart,
 (after), 2
Hobbs, Morris Henry, 2, 7
Hoch, Georg Friedrich, 2
Hochfeld, Joseph, 7
Hockner, Johann Casper, 2
Hockney, David, 2, 4
Hocquart, Edouard, 8H
Hodges, C. H., 8H
Hodgetts, T., 2
Hodgson, J. S., 2
Hodgson, Thomas, 8H
Hodick, Angelo, 7
Hoeckner, Carl, 7
Hoen Lithography
 Company, 8H
Hoen's Lithocaustic
 Process, 8H
Hoener, Arthur, 2
Hoertz, Fred J., 8H
Hofer, Karl, 2
Hoff, Margo, 7
Hoffer, A., 2
Hoffman & Shutz
 lithography company, 10
Hoffman, Abram J., 10
Hoffman, August 8H
Hoffman, Irwin D., 2, 7
Hoffman, Johan, 8H
Hoffman, Seth, 7
Hoffy, Alfred M., 10
Hofmann, Hans, 4
Hofmann, Ludwig von, 2
Hogam, Thomas, 2
Hogan (after), 2
Hogarth, William, 2
Hogue, Alexandre, 7
Hohe, Fr., 8H
Hohenstein, Anton, 8H, 10
Hoit, Albert Gallatin, 10
Hokinson, Helen Elna, 2
Hokkei, Totoya, 2, 3

Hokuba, Teisai, 2
Hokusai, Katsushika, 2, 3,
7, 8H
Holbein, Edward (after), 2
Holbein, Hans (the elder)
(after), 2
Holbein, Hans (the
younger) 2; works after,
8H
Holden, Joseph E., 7
Hole, H. F. P. W., 8H
Holeywell, Arnold, 7
Holihan, Michael Sean, 7
Holl, Francis, 10
Holl, W., 8H
Holland, Tom, 7
Hollar, Wenzel
(Wenceslaus), 2, 8H
Holley, Lee, 8H
Hollidge, W., 2
Holloway, Thomas, 2, 8H,
10
Hollyers, Samuel, 2, 7, 8H
Holman, Bill, 8H
Holman, Louis A., 8H
Holmes, Kate Clifton, 7
Holmes, Kenneth C., 7
Holmes, William Henry, 7,
8H
Holty, Carl Robert, 7
Holtzmann, Carl Friedrich,
8H
Holzer, Johann
Evangelista, 2
Homann, Johann Baptista,
2
Homar, Lorenzo, 2
Homer, Henrietta Benson,
2
Homer, Winslow, 2, 3, 4, 7,
8H; works after, 10
Hondecoeter, G. van
(after), 2
Hondius, Willem, 2
Honthorst, Willem van
(after), 2
Hooch, Pieter de (after), 2
Hood, (Thomas) Richard,
10
Hooghe, Cornelis de, 2
Hooghe, Romeyn de, 2
Hoogland, William, 10
Hoopes, Elisabeth, 2
Hoover, Ellison, 7
Hopf, Ernest, 2
Hopfer, C. B. (?), 8H
Hopfer, Daniel (I), 2, 8H

Hopfer, Hieronymus, 2
Hopkins, A., 8H
Hopkins, Eve, 8H
Hoppenhaupt, Johann
Michael (II), 2
Hopper, Edward, 2, 7, 8H,
10
Hoppin, Augustus (after), 2
Hopson, William Fowler, 7
Hopwood, Fanny, 8H
Hopwood, James (I), 2
Hopwood, James (the
younger), 2, 7
Hornby, Lester G., 7
Horner, Thomas, 7
Horning, R., 7
Hornung, Clarence P., 8H
Horsfall, B., 8H
Horstmeir, Albert, 7
Horte, Max (after), 8H
Horter, Earl, 2, 7
Hosbrook, M., 8H
Hosford, H. Lindley, 7, 8H
Hosiasson, Philippe, 4
Hoskin, Robert, 8H
Hottenroth, J., 8H
Houbrac, C. A., 2
Houbraken, Arnold (after),
2
Houbraken, Jacobus, 2, 7,
8H
Houdon, Jean-Antoine, 2
Houel,
Jean-Pierre-Louis-
Laurent, 2
Houghton, Arthur Boyd
(after), 2
Hourdain, C., 7
Houston, H. H., 10
Houston, Richard, 2, 7, 8H,
10
Hovenden, Thomas, 8H
Howard, Cecil de
Blaquiere, 7
Howes, E. Townsend, 7
Hsi Kang, 3
Hsia Ch'ang, 3
Hsiao Yun-ts'ung, 3
Hsu Hsuan, 3
Hsu Wei, 3
Hua Yen, 3
Huang Shen, 3
Huard, (Charles?), 2
Hubard, William James,
8H
Hubbard, E. Hesketh, 7
Huber, Jean, 8H

Hubert, 8H
Hubert, F., 8P
Hubert, Francois (att.), 2
Hubert, W., 8H
Huberti, Gaspar, 2
Huchtenburgh, Johann
van, 2
Hudson, Erlund, 7
Hudson, Muriel, 8H
Hudson, Thomas (after), 2
Hudson, William, Jr., 8H
Huehnergarth, John, 10
Huet, Christophe, 2
Huet, Francois (after), 2
Huet, Jean-Baptiste Marie,
2
Huet, Paul, 2
Huffaker, Sandy, 10
Huffman, Lelia, 2
Hugo, Ric, 8H
Huguenet, Jacques Joseph,
8H
Huhn, Rudolf von, 8H
Hulett, Ralph, 7
Hull & Sons, H. B., 8H
Hull, Albert Gregory, 7
Hullmandel, Charles
Joseph, 2, 8H
Hulmer, 7, 8H
Humphrey, H., 2
Humphrey, Ralph, 7
Humphrey, William, 2
Humphrys, W., 8H
Hunerfauth, Irma, 7
Hungerford, Cyrus Cotton,
8H
Hung-jen, 3
Hunnings, Richard, 2
Hunt, C., 7
Hunt, J. B., 8H
Hunt, Leigh Harrison, 2
Hunt, Richard Howard, 7
Hunt, Samuel Valentine, 7
Hunt, William Holman, 2
Hunt, William Morris, 7
Hunter, Dard, 8H
Hunter, Warren, 7
Huntington, Daniel, 2
Huntington, Wilford H., 7
Huntley, Victoria Hutson,
7
Hunzinger, M., 2
Huot, A., 8H
Huquier, Gabriel, 2
Huquier, Jacques Gabriel
(the younger), 2
Hurd, Jud, 8H

LaFarge, Bancel (Studio
 LaFarge), 2
LaFarge, John, 2, 7
LaFarge, Mabel, 7
LaFarge, Thomas
 Sergeant, 7
LaFaye, Christopher, 7
Lafitte, Louis (after), 2
Lafon, D. (?), 2
Lafort, Henri, 2
Lafosse, (Jean-Baptiste)
 Adolphe, 10
Lafosse, Lionnet, et
 Medard Cie., 2
Lafrery, Antoine, 2
LaFresnaye, Roger de, 4
Lagardette (Delagardette),
 10
Lagerstrom, Gertrude, 2
Lagrenee, Jean-Jacques
 (the younger) (att.), 2
Laguerre, Louis, 2
La Guillermie,
 Frederic-Auguste, 2, 8H
Lahey, George, 2
Lahey, Richard, 7
Laidman, Hugh, 6, 7
Lainee, Thomas, 2
Laing, Frank, 2
Laing, Gerald, 7
Lairesse, Gerard de, 2, 8H
Laisne, Pierre, 2
Lajoue, Jacques de, 2
Lalanne, Maxime, 2, 7, 8H
Lalauze, Adolphe, 2, 7, 8H
La Live de Jully,
 Ange-Laurent de, 2
Lallemand, Georges
 (after), 2
Lallemand, Jean-Baptiste,
 2
Lalonde, Richard de, 2
Lam, Wilfredo, 5
Lamagure, E., 8H
LaMarcade, J. de, 2
LaMare-Richart, Florent
 de (after), 2
Lamario, 2
Lambart, 10
Lambert, 8H
Lambertenghi, 2
Lameyer, F., 8H
Lamfyeld, J., 8H
Lami, Eugene-Louis, 2
Lammers-Schilling
 Company, 8H
LaMore, Chet Harmon, 7

Lamour, Charles Jean, 2
Lamy, Pierre Auguste, 8H
Lamy, Pierre Franc, 7
Lancaster Photogravure
 Company, 8H
Lanceck, Armin, 8H
Lanci, Apelles, 2
Lancon, A., 8H
Landacre, Paul H., 2, 7
Landau, Jacob, 4, 7
Landeck, Armin, 7
Landels, E., 8H
Landerer, Ferdinand, 8H
Landini, Domenico, 2
Landis, John, 10
Landon, Edward, 2, 7, 8H
Landry, Pierre, 2
Landsar, John, 2
Landseer, Edwin Henry
 (after), 2, 7
Landseer, Thomas, 8H
Lane, Bond, 8H
Lane, Marian, 8H
Lane, Richard James, 8H,
 10
Lanfranco, Giovanni di
 Stefano (att.), 2
Lanfranco (?), B., 2
Lang, Hans Kaspar, 2
Lang, Maurit, 8H
Lange, (after), 2
Langendyk, Dirk (att.), 2
Langer, T., 8H
Langerman, Elaine
 Marcus, 7
Langier, Jean N., 2
Langlois, Jerome Markin, 2
Langlois, Nicolas, 2
Langlume, 8H
Langridge, J. L., 8H
Lankes, Julius J., 2, 7, 8H
Lanretti, Cczarc, 8H
Lansky, Bernard, 8H
Lanyon, Ellen, 7
Lapi, Emilio, 8H
Lapi, Pompeo, 2
Lapinski, Tadeusz, 7
LaPlanche, 2
Laporte-Blairsy, Leo, 7
Lardy,
 Francois-Guillaume, 2
Larez, Francisco, 8H
Largilliere, Nicolas de
 (after), 2
Larkin, Eugene, 7
Larkin, Peter, 2
Larkin, William, 7

L'Armessin, Nicolas de, 2,
 8H, 10
LaRose, Jean-Baptiste de,
 2
Larsen, Charles Peter, 7
Larson, Kenneth A., 7
LaRue, Louis-Felix de, 2
Lasalle, Emile, 8H
Lasansky, Mauricio, 7, 8H
Lasinio, Carlo, 2, 6, 8H
Lasne, Michel, 2
Lassaw, Ibram, 7
L'Assurance, Pierre. See
 Coeur d'Acier, Pierre
Lassus, Jean-Baptiste
 Antoine (after), 2
Lasswell, Fred, 8H
Lasteyrie du Saillant,
 Charles Philibert de, 8H
Latam Lithograph and
 Printing Company, 8H
Lathrop, Francis L., 2
Lathrop, W. L., 8H
LaTouche, Jacques Ignace
 de, 2
Latour (La Tour),
 Maurice-Quentin de
 (after), 2
Lattre, Jean, 2
Lattre, Marie F. Verard, 2
Laufberger, Ferdinand
 (after), 2
Laugier, Jean Nicholas, 8H
Lauray, Robert de, 8H
Laurens, Henri, 4
Laurens, Jean Paul, 7
Laurens, Jules, 8H
Laurens, Paul-Albert, 7
Laurent, P., 8H
Laurent, Pierre, 2
Laurent, Pierre Francois, 7
Laurent, Robert, 7
Laurentio, Cesare, 8H
Laureolli, 2
Lautensack, Hans Sebald,
 2, 8H
Lauterbach, Paul, 7
La Vallee Poussin, Etienne
 de, 2
Lavau, 6
Lavigne, Marin, 8H
Law, David, 2
Law, Margaret M., 7
Lawless, Benjamin, 6
Lawrence, Clark J., 7
Lawrence, Jacob, 4, 7, 10

Liu Kung-ch'uan, 3
Liu Yung, 3
Liverani, Antonio, 2
Liverani, Romolo, 2
Livingston, Guida, 8H
Livingston, R. Crawford, 7
Lizars, William Home, 2, 8H
Lizer, Anna, 8H
Lo P'ing, 3
Lobdell, Frank, 7
Lobeck, Tobias, 8H
Lobmeyr, J. and L. (after), 2
Lobre, Maurice, 7
Locatelli, Antonio, 2
Lochmann, Johann, 2
Lochner, Stephen (after), 2
Lochom, M. van, 8H
Locke, A. S., 8H
Locke, Charles Wheeler, 2, 7, 8H
Locke, Vance, 7
Locke, Walter Ronald, 2
Locker, Edward Hawke, 6
Lockhardt, A., 8H
Lockwood, Ward, 7
Lodge, I., 8H
Loecher, Albert, 2
Loewy, Raymond, 2
Loffler, 8H
Logan, Robert F., 7
Logari, Prospero (called Clemente) (att.), 2
Loggan, David, 8H; works after, 2
Loir, Alexis, 2, 8H
Loir, Luigi (after), 2
Loir, Marianne (after), 2
Loir, Nicolas, 2
Loli, Lorenzo, 2
Lombard, Pierre, 2, 8H
Lommelin, Adriaen, 2, 8H
Londerseel, Jan van, 2
Londonio, Francesco, 2
Long, M. H., 7
Longacre, James Barton, 2, 7, 8H, 10
Longhi, Giuseppe, 2
Longhi, L., 8H
Longo, Vincent, 7
Longstaff, W. Francis, 8H
Longueil, Joseph de, 2, 7
Lonihior, 2
Lonsdale, James (after), 2
Lonsing, Francois Joseph, 8H

Loo, Jean-Baptiste van, 2
Loomis, Chester R., 7
Looney, Ben Earl, 7
Loos, Friedrich, 8H
Lopez y Portana, Vicente, 2
Loran, Erle, 7
Lorck, Melchior, 2
Lord, Gordon H., 8H
Lorentz, Alcide (after), 2
Lorrain, Claude. See Gelee, Claude, 2
Lorreau, Jules, 8H
Lorsay, Louis Alexandre Eustache, 2
Los Rios, Ricardo de, 2, 8H
Lossi, Carolus, 8H
Lossi, Giovanni Domenico, 8H
Lottes, Christophe Friedrich, 2
Louis, Aristide, 8H
Low, Howard, 2
Low, Will Hicok, 2
Lowe, Marvin, 7
Lowell, Nat, 2
Lowenstein, Loretta, 8H
Lowrie, Robert, 2
Lowry, Wilson, 2
Loye, Charles Auguste (called Montbard), 2
Loyer, Michel, 2
Lozowick, Louis, 2, 4, 7, 8H
Lu Chih, 3
Lu Yuan, 3
Lubarow, Renee, 8H
Lubbers, Adrian, 7
Lubbers, Bob, 8H
Lubin, Jacques, 2, 8H
Lublinsky, Martin Anton, 2
Lucas, B., 2
Lucas, Claude, 2
Lucas, David, 7, 8H
Lucas, John, 8H; works after, 2
Lucas, Louis, 8H
Luce, 2
Lucianus, 8H
Lucioni, Luigi, 2, 7, 8H
Lucotte, J. P., 2
Lucotte, J. R., 2
Ludovici, Albert, 2
Ludovisi, Bernardino (att.), 2
Ludy, Friedrich, 8Y
Luhn, Joachim (after), 2

Luigini, Ferdinand Jean, 7
Lukas, Joan, 2
Luks, George Benjamin, 4, 7, 8H
Lum, Bertha, 8H
Lum, Catherine, 8H
Lum, Peter, 8H
Lumley, Arthur (after), 2
Lunak, Al, 7
Lundeberg, Helen, 7
Lupo, Dom, 7
Lupton, Thomas, 2
Luquiens, Huc-Mazelet, 7, 8H
Lurat, A., 8H
Lurat, M., 8H
Lurcat, Jean, 2, 7
Lurie, Nan, 7
Lusy, Marino, 7
Luthmann, Hans, 7
Lutma, Jan, 8H
Lutzelburger, 8H
Lux Engraving Company, 8H
Luyken, Jan, 2
Lynch, Albert, 2
Lynde, Stan, 8H
Lyon, Rowland, 7, 8H
Lyouns, H. F. W., 8H

McAdams, Alfred, 6, 7
MacArdell, James, 2, 8H, 10
MacBeth, Donald, 8H
MacBeth, Robert W., 8H
MacBeth-Raeburn, H., 8H
McBey, James, 2
McBurney, Harriet, 8H
McCaffrey, Maxine, 6
McCain, Bill, 2, 7
McCall, Robert, 6
McCauley, 2
McCauley, Bill, 7
McCay, Winsor Zenic, 2
McClure, Frank, 7
McCombs, Bruce C., 7
McConnell, J. C., 8H
McCosh, David John, 7
MacCoy, Guy, 7
McCoy, John T., 6
McCoy, John W., 6
McCracken, 2
McCready, John, 2
McCullough, John, 8H
McCullow & Wood, 8H
McCutcheon, John Tinney, 2, 8H

McDaniel, Henry, 7
MacDermott, Diane, 8H
MacDonald, Diane Hillier,
2
McDonald, Mary C.
(after), 2
McDonald, W. P., 8H
McEwen, Alfred, 8H
McEwen, Walter, 2
McFarlane & Erskine, 8H
McFeatters, Dale, 8H
McFee, R. J., and
Company, 2
McGarrell, James, 2, 4, 7
McGee, Winston, 7
McGowin, Edward, 7
McGraw-Phillips Printing
Company, 8H
McHarty, Jack, 7
McIan, Robert Ronald
(after), 2
McIntyre, Nancy, 7
Mac Ivor, Loren, 4, 7
McKendrick, Lillian, 4
McKenzie, J. R. D., 8H
McKinnie, 7
MacKinnon, Esther B., 7
McLarty, Jack, 7
MacLaughlin, Donald
Shaw, 2, 7, 8H
McLaughlin, M. Louise,
8H
McLean, Wilson, 10
McLeary, Kindred, 7
McLees, Frank, &
Brothers, 8H
MacLeish, Norman
Hilliard, 7
McMahon, Franklin, 6
McMillan, Mildred, 7
McMillen, Inc., 2
McMullan, James, 10
McMurray, Daniel L. D., 2
MacNelly, Jeff, 8H
McNeil, Hermon, 8H
McNeill, Lloyd, 7
McPherson, 8H
MacPherson, Duncan, 10
McPherson, John, 10
McRae, John C., 7, 8H, 10
MacRitchie, Lewis, 7
MacTear, Andrew, 8H
McVeigh, Blanche, 7
McWilliams, A., 8H

Ma Shou-Chen, 3
Maag, Johan Nepomuk, 2

Mabieu, Abel V., 2
Mac, F., 8H
Macauley, David, 2
Macchietti, Girolamo
(after), 2
Maccio, Romulo, 4
Mace, W., 2
Machiavelli, G., 8H
Mack, Stan, 10
Macke, August, 2
Mackie, Lisa, 7
Mackler, Tina, 7, 8H
Macouillard, Louis, 7
Macret,
Charles-Francois-
Adrien, 2, 8H
Mactarian, Ludwig, 7
Madeleine (Giuseppe
Tiberio), 6
Maderno, Carlo, 2
Madiona, Tonnaso, 8H
Madison, Dolley, 10
Madsen, Loren, 4
Maedel, E. A., 8H
Maerz, 10
Maes, Nicolas (after), 2
Maestri, Michelangelo, 2
Maffei, Niccolo Francesco,
2
Maggi, Giovanni, 2
Maggi, Pietro, 2
Maggiotto, Francesco
(after), 2
Magill-Weinsheimer
Company, 8H
Magliar, Guiseppe, 2
Magnelli, Alberto, 2, 8H
Magnus, Charles, 10
Magnus, Marco Antonio, 2
Mahoney, James, Jr., 6
Maile, George, 8H
Maillard, Claude, 2
Maillardet, Henri, 2
Maillefer, 8H
Maillet, Joseph C., 2
Maillol,
Aristide-Joseph-
Bonaventure, 4
Maina, Hyacinth, 2
Mainardi, Lattanzio (att.),
2
Major & Knapp
lithography company, 10
Major, Thomas, 2
Makart, Hans (after), 2
Malapeau, C., 8H

Malapeau, Charles Louis
(after), 2
Malbeste, Georges, 8H
Maldarelli, Oronzio, 7
Maleuvre, Pierre, 2
Malicoat, Philip, 4
Malitz, Arlene, 2
Mallett, Margaret Isabella,
2
Mallia, Giovanni Carlo, 2
Mallory, R. P., 8H
Malman, Christine, 2
Malone, Robert, 7
Malta, Helen, 2
Malton, James, 2
Malvaux, Jean, 8H
Mandel, Eduard, 8H
Mandel, Philippe, 8H
Mandelman, Beatrice, 7
Mander, Karel van (after),
2
Mandrot de Freudenreich,
O. de, 2
Mane-Katz 4
Manet, Edouard, 2, 8H
Manfredi, Emilio (after), 2
Manget, J. A., lithography
company, 10
Manglard, Adrien, 2
Mangravite, Peppino, 7
Mann, Karl, 2
Mannfeld, Bernhard, 2, 8H
Manni, 2
Mannini, Giacomo Antonio
(Magnini), 2
Mannius, Victor, 7
Manolo, 4
Man Ray, 4, 6, 7
Mansart, Francois, 2
Mansart, Jean (att.), 2
Mansart, Jules Hardouin
(after), 2
Mansfield, J. E., 10
Manship, John P., 7
Manship, Paul, 2, 7
Mansion, L., 8H
Mantegna, Andrea, 2;
works after, 8H
Mantiroli, 2
Mante, 8H
Mantuanus, Georgius, 8H
Manuel, Margaret, 2, 8H
Manutius, Aldus, 2
Manz Engraving Company,
8H
Manzu, Giacomo, 4
Maranze, Julius, 7

Merrill, Hirma Campbell, 2, 8H
Merrill, Katherine, 7, 8H
Merritt, Anna Lea, 8H
Merrymount Press, 2, 8H
Merrythought Press, 2
Merson, Luc Oliver (after), 2
Mertle, J. S., 2
Meryon, Charles, 2, 7, 8H
Merz, Henrich, 8H
Mesches, Arnold, 4
Mesibov, Hubert, 7
Mess, George Jo, 7
Messer, Edmund Clarence, 7
Messick, Ben, 8H
Messick, Dale, 8H
Messmore and Damon, 7
Mestler, Ludwig, 4
Metallography Company, 8H
Metam, Ovid, 8H
Metivet, Lucien-Marie-Francois, 2
Mettais, Charles, 8H
Mette, C., 8H
Metthey, Andre, 7
Metz, C., 8H
Metzeroth, R., 8H
Metzger, Robert, 2
Metzmacher, Pierre Guillaume, 10
Meulen, Adam-Frans van der (after), 2
Meunier, Georges, 2
Meunier, Henri, 2
Meussens, D., 8H
Mey, M., 2
Meyandi, Giovanni Sebastiano, 2
Meyer, C., 2
Meyer, F. A., 2
Meyer, Hans, 2
Meyer, Henry Hoppner, 2, 8H, 10
Meyer, Herrmann J., 7, 8H
Meyer, Hubert, 8H
Meyer, Johann Wilhelm, 2
Meyer, Victorien M., 2
Meyerowitz, William, 2, 7
Meyers, Dale, 6
Meyrowitz, William, 8H
Meyssens, Joannes, 2, 8H
Mezger, George, 2
Mezian, 8H

Michalov, Ann, 7
Michel, Jean Baptiste, 2, 8H
Michel, Louis, 8H
Michelangelo (after), 2
Michelin, Jules, 8H
Michelinotte (att.), 2
Michigan Lithography Company, 8H
Micossi, Mario, 2, 8H
Middiman, Samuel, 2
Middleton, Charles H., 8H
Middleton, R. Hunter, 2
Miedzielsky, Paulin, 10
Miel, Jan, 2
Mielatz, Karl Friedrich Wilheim, 2, 7
Mielziner, Leo, 10
Mieris, Willem van (after), 2
Mierisch, Dorothea, 7
Miers, 8H
Miger, S. C., 6
Mignard, Nicolas (after), 2
Mignot, Victor, 2
Mik, 8H
Milbert, J. 8H
Miles, Walter, 7
Milheusser, J. Julius, 2
Milius, F., 8H
Millar, Addison Thomas, 2
Millatz, 6
Miller, Charles H., 7, 8H
Miller, Elis F., 7
Miller, Hugh, 7
Miller, John B., 2
Miller, Kenneth Hayes, 2, 7
Miller, Lilian, 8H
Miller, W., 8H
Miller, Willliam, 8H
Miller, William Rickarby, 7
Miller, Willy, 7, 8H
Millet, Francis Davis, 7
Millet, Jean Francois, 2, 7, 8H
Millier, Arthur, 7
Milliken, Henry O., 2
Millman, Edward, 7
Mills, Charles E., 8H
Mills, Lew, 2
Mills, Robert, 8H
Milton, Peter W., 7
Milus, Guglielmus (after), 2
Mimaux, Andre, 2
Minardi, Tommaso, 2
Mind, Gottfried, 2
Minguzzi, Luciano, 4

Miniera, Biagio, 2
Minot, R., 7
Minoux, 7
Minozzi, Flaminio, 2
Mintz, Joyce L., 2
Miranda (after), 2
Mirandol, J. F., 2
Miro, Joan, 2, 4, 7; works after, 8H
Mirza Bashir, 7
Misnensis, Caspar, 2
Missola (?), Giovanni, 2
Misti, 2
Mitan, James, 8H
Mitan, S., 2
Mitchell, Bruce, 4, 7
Mitchell, Charles Davis, 10
Mitchell, H., 2
Mitchell, T., 7
Mitelderg, Louis (Tim), 10
Mitelli, Agostino, 2
Mitelli, Giuseppe Maria, 2
Mittermayr, Michael, 2
Mixter, Samuel J., 8H
Miyasaki, George Joji, 7
Miyata, Shoji, 2
Mizufune, Rokushu, 7
Mocetto, Girolamo, 8H
Mochetti, Giuseppe, 8H
Modersohn-Becker, Paula, 2
Modigliani, Amedeo, 2
Modjeska, Marylka, 7
Modrakowska, Eleanor, 7
Mogford, H. 8H
Moholy-Nagy, Laszlo, 4
Mohr, Alfred Vincent, 2
Moir, Robert, 7
Moithey, P. (the elder), 2
Moitte, Pierre Etienne, 7
Molin, Brita, 8H
Molitor, Edward, 8H
Moller, Hans, 2, 4
Mollet, Armand-Claude, 2
Mollison, James, 8H
Molyn, Pieter (the elder) (after), 2
Momberger, W., 8H
Monaco, Pietro, 8H
Monchelet, A., 2
Monchy, Martin de, 2
Moncornet, Baltazar, 2, 8H
Moncy. See Monchy, Martin de
Mond, J., 8H
Mondet, Clairon, 8H
Mondhare, 2

Mondo, Domenico, 2
Mondon, Jean, 2
Mondragone, Domenico, 2
Mongin, Augustin, 2, 8H
Mongin, Pierre, 8H
Monhoff, Frederick, 7
Monk, William, 7
Monnet, Charles *(after)*, 2
Monnier, Henri
 Bonaventure, 2
Monnoyer, Jean Baptiste, 2
Monograms and
 initials:A.D.H.; A.E.;
 A.F.; A.G.; ATA;
 B.G.J.; B.N.; C.A.M.;
 C.B.; C.C.; C.D.M.;
 C.H.; C.I.; C.I.F.; C.R.;
 C.S.R.; D; F.A.; F.C.;
 F.G.; F.G.S.; F.R.F.;
 G.B.C.; G.F. *(after)*;
 G.H.; G.J.; G.L.D.;
 G.P.F.; H.G.; H.M.;
 H.S.; H.W.; I.C.H.;
 I.C.W.; I.E.W.; I.M.L.
 (McLenan?) *(after)*; I.P.;
 I.S.P.; I.W.; J.A.B.;
 J.B.; J.H.; J.S.; L.C.;
 L.M.; L.V.; M.B.;
 M.B.M. (Thomas Sidney
 Moran); M.C.; M.G.F.;
 M.R.; M.W.T.; N.;
 N.B.; N.J.; O.C.W.;
 P.B.; P.C.; P.M.; P.P.;
 P.S.; R.L. *(after)*; R.N.
 (after); RRVH; R.S.;
 S.F.; Sq.W.R.; T.H.;
 T.L.; T.T.; V.C.F.;
 V.P.; V.R.; W.D.T.;
 W.I.; W.J.A. *(after)*, 2
Monroe, William, 2
Montague, C., 8h
Montalent, Mademoiselle,
 2
Montana, Bob, 8H
Montana, Pietro, 2
Montano, Giovanni
 Battista *(after)*, 2
Montaut, S., 6
Montefiore, E. B. Stanley,
 8H
Monteith, Caroline, 8H
Monti, Claudio, 2
Monti, Francesco, 2
Monzies, Louis, 2, 8H
Moon, Jay, 7
Mooney, John, 10
Moore, Benson Bond, 7,
 8H

Moore, Bruce, 7
Moore, Henry, 4
Moore, James, 10
Moore, Ned T., 7
Moore, Robin, 8H
Moorepark, Carton, 7, 8H
Moores, 8H
Moosbrugger, Caspar, 2
Moose, Philip, 7
Mora, Francis Luis, 7;
 works after, 2
Moraine, M., 8H
Moran, Emily Kelley, 7,
 8H
Moran, Leon, 7
Moran, Mary Nimmo, 2, 7,
 8H
Moran, Paul, 8H
Moran, Percy (Edward), 7,
 8H
Moran, Peter, 7, 8H
Moran, Thomas Sidney, 2,
 7, 8H
Morand, Pierre, 10
Mordant, D., 8H
Moreau,
 Jean-Charles-Alexandre,
 2
Moreau, Luc-Albert, 2
Moreau, P., 2
Moreau-Despreux, Pierre
 Louis, 2
Moreau Le Jeune, Jean
 Michel, 2
Moreelse, P., 8H
Morel, 8H
Morelli, Carlo, 2
Morelli, Cosimo, 2
Moretti, Giovanni *(after)* 2
Morgan & Company, W. J.,
 8H
Morgan, Charles L., 7
Morgan, Matthew S., 10
Morgan, Norma, 5
Morgan, Wallace, 2
Morgan, William Evans
 Charles, 7
Morghen, Filippo, 2
Morghen, G., 8H
Morghen, Rafaello, 2, 8H
Morghen, Ralph, 7
Morin, Jean, 2, 8H
Morisson, Friedrich Jacob,
 2
Moritz, Karl Philipp, 2
Morland, G., 8H

Morland, George *(after)*, 2
Morley, Eugene, 7
Morley, Hubert, 7
Moro, M., 2
Morris, Edward A., 7
Morris, John Floyd, 2
Morris, William, 8H
Morse, Breton, 7
Morse, Samuel Finley
 Breese, 2
Morse, W. H., 2
Mortensen, Gordon, 7
Mortier, Pieter, 8H
Morton, Edward, 7
Morton, Henry, 2
Morvan, A. G., 8H
Mosca, August, 7
Mosca, Francesco (called
 Moschino), 2
Moscheles, Felix Stone, 2
Moschetti, A., 2
Moser, James Henry, 2, 7
Moses, Edward, 4
Moses, Henry, 2, 8H
Mosher, Terry, 10
Moskowitz, Ira, 7
Mosler, Henry, 8H
Mosley, Zack, 8H
Moss Engraving Company,
 8H
Moss, Bill, 7
Mostaert, Gilles *(after)*, 2
Motay, C. M. Tessie du, 8H
Mote, W. H., 8H, 10
Motherwell, Robert Burns,
 4, 7, 8H
Motta, Raffaello, 2
Motte, Jean Guillaume, 2
Mottram, Charles, 2, 8H
Moucelot, 6
Moucheron, Isaac de
 (after), 2
Mougel, Max, 7
Mougeot, Jean Joseph, 8H
Mouilleron, 7
Mouilleron, Adolphe, 2, 8H
Moulton, E., 4
Mouton, Michel P., 2
Mouton, Paul, 2
Moy, Seong, 4, 7, 8H
Moyreau, Jean, 2
Moyremus, J., 8H
Mozert, Zoe, 8H
Mozin, C., 8H
Muccio, Giovanni
 Francesco, 2
Mucha, Alphonse, 2

Muelbacher, 2
Mueller, 7
Mueller, George, 4
Mueller, Hans Alexander, 2
Mueller, Henri Charles, 2
Mueller, Henri Frederich, 2
Mueller, Jan Harmensz, 2
Mueller, Johann Sebastian, 2
Mueller, Otto, 2
Muir, Emily Lansing, 7
Mulet, M. (after), 2
Mulinari, A., 8H
Mulinari, Stefano, 2
Mullen, Albert, 2
Muller, Charles, 2
Muller, Enzing, 8H
Muller, Franz Xaver, 10
Muller, G., 8H
Muller, G. T., 7
Muller, Harman, 8H
Muller, J. G., 8H
Muller, Jan, 4, 8H
Muller, Paul Adolphe, 8H
Muller, R. A., 8H
Muller-Ury, Adolph (Adolfo), 10
Mullins, Al, 7
Mulready, William, 2
Mumler, W. H., 8H
Munch, Edvard, 8H
Munchen, Gabriel Max, 8H
Munder & Company, Norman, 8H
Munford, Robert, 4
Munkacsy, Michael (after), 2
Munoz Lee, Luis, 2
Munoz, Oscar, 4
Mura, Francesco di, 2
Murao, Ayako, 7
Murphy, Arthur, 8H
Murphy, Catherine, 7
Murphy, H. D., 8H
Murphy, J. J., 4
Murphy, John Cullen, 8H
Murphy, John J. A., 7
Murphy, John O., 8H
Murphy, M. Lois, 7
Murray, Charles Oliver, 2
Murray, Joseph Sherburne, 7
Murray, Samuel Aloysius, 4
Musi, Agostino dei (called Veneziano), 2

Musial, Joe, 8H
Music, Antonio, 8H
Mussoff, Jody, 4
Mustafa, Ghulam, 7
Mutel (?), 2
Mutzel, G., 8H
Muyden, Ewert Louis Van, 8H
Myers, Frances, 7
Myers, Jerome, 2, 4, 7, 8H
Myers, W. B. (after), 2
Mylne, Robert (II), 2
Mynde, J., 2
Myre, Herman O., 7

Nabholz, Johann Christoph, 2
Nadelman, Elie, 2, 4, 7
Nadler, Harry, 7
Naegele, Charles Frederich, 2
Nagel & Weingaertner lithography company, 10
Nagli, Giovanni Francesco (called Centino) (after), 2
Nahl, Johann-August, 2
Nakamizo, Fugi, 7
Nakamura, Yoshio C., 4
Nakian, Reuben, 4
Nama, George A., 7, 8H
Nani, Antonio, 8H
Nankivell, Frank A., 8H
Nanteuil, Celestin, 2, 8H
Nanteuil, Robert, 2, 8H
Naoko, 2
Naot, J. K., 7
Narciza, Manuel, 8H
Narducci, Pietro, 2
Nash, John, 2, 7
Nash, John Henry, 8H
Nash, Joseph, 8H
Nash, Paul, 8H
Nash, Tom, 7
Nash, Willard, 8H
Nason, Thomas Willoughby, 2, 7, 8H
Nast, Thomas, 2, 7, 8H, 10
Nastasia, James, 4
Natali, Giovanni Battista (III), 2
Natalis, Michel, 2
National Bank Note Company, 8H
National Chemigraph Company, 8H
National Colortype Company, 8H

National Engraving Company, 8H
, National Lithography Company, 10
Natkin, Robert, 4
Nattier, I. M., 8H
Nattier, J. B., 10
Nattier, L. B., 8H
Naudin, Bernard, 2
Nay, Ernst Wilhelm, 4
Naya, C. Venice, 8H
Naylor, Bob, 8H
Nazari, Jacopo (after), 2
Neagle, John, 2
Neagle, John B., 8H
Neal, Reginald, 2
Neas, Richard Lowell, 2
Nedved, Rudolph J., 7
Nee, Francois Denis, 2, 7, 10
Neeffs, Jacob, 2
Neele. See Stalker
Neeson, Remick, 7
Negker, Jost de, 8H
Negre, Charles, 8H
Negulesco, Jean, 7
Neher, Fred, 8H
Nehlig, Victor, 8H
Nehr, Bernard (after), 2
Neilson, L. W., 7
Nelson, Bill, 10
Nelson, Roger, 7
Nepote, Alexander, 7
Nervi, Pier Luigi, 2
Nervi, Pietro Martire (after), 2
Nesbit, Charlton, 8H
Nesbitt, Alexander, 2
Nesbitt, Esta, 7
Nesbitt, Jackson Lee, 2
Nesbitt, Lowell, 4, 6, 7
Nesbitt, Phil, 7
Nesch, Rolf, 8H
Neubert, M. P., 2
Neufforge, Jean-Francois de, 2
Neumann, Adolf, 8H
Neumann, Robert V., 7
Neurdein, 8H
Neureuther, Eugen Napoleon, 2
Neuville, Alphonse Marie de, 2
Nevelson, Louise, 7, 8H
Nevinson, Christopher Richard Wayne, 2, 8H

Raemaekers, Louis, 2
Raffael, Joseph, 4
Raffaelli, Jean-Francois, 7, 8H
Raffe, W. G., 8H
Raffet, Auguste, 8H
Raffet, Denis Auguste Marie, 2
Ragghiante, Constantino, 2
Raiguel, Marjorie, 7
Raimisch, Waldemar, 2
Raimondi, Marc Antonio, 2, 8H
Raina, Giuseppe, 2
Rainaldi, Francesco, 2
Rainaldi, Girolamo, 2
Rajon, Paul Adolphe, 2, 7, 8H
Raleigh, Henry Patrick, 2, 7
Ralier, V. de, 8H
Ralph, W., 2
Ramage, James, 8H
Ramberg, Johann Heinrich (after), 2
Ramos, Mel, 7
Ramos-Poque, Guillermo, 2
Ramsay, Allan (after), 2
Ramsay, James (after), 2
Ramus, Edward, 8H
Randolph, Lee F., 7
Randonini, Carlo, 7
Ranger, Henry Ward, 7
Ranson, Pierre, 2
Ransonnette, Charles, 2
Ransonnette, N., 8H
Ransonnette, Pierre-Nicolas, 2
Raphael, 8H; works after, 2
Rasmusson, David, 2
Rassenfosse, Andre Louis Armand, 2
Rasul, Ghulam, 7
Rattner, Abraham, 7
Raum, Walter, 7
Raupp, Karl, 2
Rauschenberg, Robert, 2, 4, 6, 7, 8H, 10
Rauscher, Charles, 2
Rauscher, Rad. V., 8H
Rauschmayr, Joseph Peter Paul, 10
Ravenet, 8H
Ravenet, Simon F., 2
Rawden, Wright & Co., 2
Rawdon, Wright, & Hatch, 8H

Rawdon, Wright, Hatch & Smillie, 8H
Rawlins, Mary B., 8H
Ray, Man. See Man Ray
Raye, Sallie, 8H
Raymond, Frank Willoughby, 7
Raymond, Jean, 2
Raymund, Paul, 2
Rayo, Omar, 4, 8H
Read, Richard, 8H
Reading, B., 8H
Reading, Burnet, 10
Rebay, Hella, 7
Reboul-Vien, Marie Therese, 2
Reboux, Paul, 2
Recanatini, Cesare, 2
Rechberger, Franz, 2
Recorder Printing & Publishing Company, 8H
Redaway, J., 8H
Redding, 2
Reddy, N. Krishna, 8H
Redein, Alex S., 7
Redell, Ray, 7
Redell, Robert, 7
Reder, Bernard, 4, 7
Redfern, Larry, 2
Redkovsky, A., 2
Redmond, Patrick M., 7
Redon, Odilon, 4, 7, 8H
Redoute, Pierre Joseph, 8H; works after, 2
Redwood, Allan Carter, 2
Reece, Maynard, 7
Reed, Charlotte, 8H
Reed, Doel, 7, 8H
Reed, Earl H., 7
Reed, Ed, 8H
Reed, Ethel, 7, 8H
Reed, Frederick, 8H
Reed, Paul, 7
Reehling, Laurence, 2
Reep, Edward, 7
Reese, David M., 7
Reeves, Ruth, 2
Refregier, Anton, 4, 7
Regamey, Felix (?), 8H
Regan, John, 2
Regnier, Claude, 8H
Regnier, Henri de, 8H
Rehn & Company, Isaac, 8H
Reich, Jacques, 7, 8H, 10
Reich, Murray, 7
Reichman, Frank, 7

Reiff, Mohann Konrad, 2
Rein, Harry, 7
Reindel, Albert, 8H
Reindel, Wilhelm Georg, 7
Reingold, Alan, 10
Reinhardt, Ad, 7
Reinhart, Charles Stanley, 2
Reinhart, J. C., 8H
Reinike, Charles Henry, 7
Reisman, Philip, 4, 7
Reiss, C., 7
Reiss, Lionel S., 10
Reiss, Wilhelm, 2
Reiss, Winold, 10
Reitmann, Johann Jakob, 2
Rektorzik, Franz Xaver, 8H
Rembrandt Harmenszoon Van Rijn, 2, 7, 8H
Rembrandt Intaglio Printing Company, 8H
Remington, Fredrick, 8H
Remmey, Paul, 7
Remond, Jean Pierre, 6
Remondini, 2
Renard, 7
Renard du Bos, Marie-Jeanne, 2
Renard, Jan Benedykt Baron, 2
Renard, Jean, 8H
Renards, B., 8H
Renault, Malo, 8H
Renbage, Hinrich (after), 2
Reni, Guido, 2, 8H
Renier, Joseph E., 7
Renner, Georg Nikolaus, 2
Renoir, Pierre Auguste, 8H
Renouard, C., 8H
Renouard, Paul, 7
Renson Atelier, 2
Repton, Humphrey (after), 2
Resler, George Earl, 7
Rethi, Lili, 8H
Reubin, L. Camille, 2
Revel, Alfred, 2
Revere, Paul, 7, 10
Rexroth, Andree, 7
Reynard, Grant, 7
Reynolds, Alan, 4
Reynolds, Frederick, 8H
Reynolds, George, 2
Reynolds, Sir Joshua (after), 2

Santos, 7
Santoyo, 2
Sanzari, Elmer F., 2
Sanzi, Raffaello. *See* Raphael
Sanzone *(att.)*, 2
Saperstein, Henry G., 8H
Saporetti, 2
Saraceni, Carlo *(after)*, 2
Sarazin, 8H
Sarazin, Jean Baptist *(after)*, 2
Sarch, 8H
Sarg, Anthony Frederick (Tony), 2
Sargent, John Singer, 2, 4, 7
Sargent, Richard, 7
Sario, Anton, 7
Sarka, Charles, 10
Sarokins, S., 2
Sarony & Company, 8H
Sarony & Major lithography company, 10
Sarony lithography company, 10
Sarony, Major & Knapp, 2, 7, 8H
Sarony, Napoleon, 2, 8H, 10
Sarrazin, Jaques, 2
Sartain, Henry, 8H, 10
Sartain, James, 8H
Sartain, John, 2, 7, 8H, 10
Sartain, Samuel, 7, 8H
Sartain, William, 7, 8H, 10
Sarti, Antonio, 2
Sarti, P., 2
Sarto, Andrea del, 8H; *works attributed*, 2
Sarton, Mabel Elwes, 2
Sasso, 6
Sassoferrato. *See* Salvi, Giovanni Battista
Saubes, Leon-Daniel, 7
Saude, J., 8H
Sauer, LeRoy D., 7
Sauer, Walter, 7
Saul, 7
Saunders, Allen, 8H
Sauvage, Piat Joseph, 2
Sauvan, Philippe, 2
Savage, Charles R., 10
Savage, Edward, 7, 8H, 10
Savage, Lee, 4
Savage, Thomas Michael, 7
Savart, M. R., 7
Savart, Pierre, 2

Savelli, Angelo, 7
Savery, Roelandt, *(after)*, 2
Savery, Salomon, 2
Savini, Pompeo, 2
Savorelli, Pietro, 8H
Sawyer, Phillippe Ayer, 7
Sawyer, W. M., 8H
Saxton, Charles, 10
Saxton, Joseph, 8H
Sayen, Henry Lyman, 7
Sayer, Robert, 2, 8H
Scacciati, Andre, 8H
Scacki, Francisco, 10
Scadron, 7
Scaduto, Al, 8H
Scaglia, Leonardo, 2
Scalzi, Lodovico, 2
Scaminossi, Raphael, 8H
Scammon, C. M., 8H
Scamozzi, Vincenzo, 2
Scapicchi, Erminio, 7
Scarbo, George, 8H
Scarborough, R. A., 8H
Scarfe, Gerald, 10
Scarron, Paul *(att.)*, 2
Scarselli, Girolamo, 2
Schaarwachter, J. S., 2
Schaettle, Louis, 2, 7
Schaeuffelein, Hans Leonard, 2, 8H
Schalcken, Godfried *(after)*, 2
Schallenberg, Johannes Jakob, 2
Schamer, L., 10
Schanker, Louis, 2, 7
Schardt, Bernard, 7
Scharf, G., 8H
Scharl, Josef, 10
Scharvogel-Fybel. *See* Fybel, Julia Scharvogel
Schary, Emanuel, 7
Schatzberger, Michael, 2
Schaub, F., 2
Schedel, Martin, 2
Schedoni, Bartholomeo *(after)*, 2
Scheffer, Arny *(after)*, 2
Scheiner, James M., 2
Schell, Francis H., 2
Schellenberg, Johann Rudolph, 2, 8H
Schenau, Johann Eleazer (called Zeissig), 2
Schenk, Jan, 2
Schenk, Pieter, 2, 8H
Scher, Robert, 2

Scheuren, Caspar *(after)*, 2
Scheurenburg, Josef *(after)*, 2
Schey, Rodolphe, 2
Schiavonetti, Luigi, 2, 7, 8H
Schiavonetti, Nicolo, 2
Schidone, Bartolommeo, 2
Schiffer, Richard, 2
Schiffleger, Carol, 6
Schifflen, George Heinrich, 2
Schiller, Albert, 8H
Schillinger, Joseph, 2, 7
Schilt, Louis Pierre *(after)*, 2
Schinkel, Karl Friedrich, 2
Schlegel, Fridolin *(after)*, 2
Schlegel, G., lithography company, 10
Schleich, C. *(after)*, 2
Schleich, Johann Karl, 2
Schlemmer, Fredinand Louis, 7
Schlesinger, Joyce T., 2
Schleuen, Johann David, 2
Schleuen, Johann Friedrich, 2
Schley, Jakob van der, 2
Schlie, Peter, 2
Schloemann, Margaret, 7
Schlump, John O., 7
Schmahl, Matilda E., 7
Schmidt, 8H
Schmidt Lithographic Company, 8H
Schmidt, Arnold, 2
Schmidt, C. Y., 4
Schmidt, Carl, 2
Schmidt, Charles, 6
Schmidt, Erich, 8H
Schmidt, Friedrich Freiherr von, 2
Schmidt, Georg Friedrich, 2, 8H
Schmidt, Julius, 4
Schmidt, Katherine, 7
Schmidt, Martin, 8H
Schmidt, Mathias *(after)*, 2
Schmidt, Mott B., 2
Schmidt, W., 8H
Schmidt, Wilhelm, 2
Schmidt-Rottluff, Karl, 2, 8H
Schmitt, Carl, 2
Schmolze, Karl Hermann (or Henrich), 2

Wallis, Henry, 2
Wallis, O., 8H
Wallis, R., 8H
Wallis, T., 8H
Wallis, W., 8H
Wallman, Ted, 2
Walser, Ursula, 2
Walt, 8H
Walter, 8H
Walter Freres, 2
Walter, Adam B., 8H, 10
Walterlow & Sons, 8H
Walther (Wattier?), 8H
Waltner, Charles-Albert, 2, 7, 8H
Waltney, Armand, 2
Walton & Spencer Company, 8H
Walton, W., 6
Walton, W. L., 8H
Walton, William, 2
Waltrip, Mildred, 7
Wand, A. R., 2
Wandlaincourt (?), 2
Wang Chien, 3
Wang Ch'ung, 3
Wang Fu, 3
Wang Hsien-chih, 3
Wang Hui, 3
Wang Liang-ch'en, 3
Wang, Ming, 7
Wang, Shih-min, 3
Wang Yuan-chi, 3
Wangboje, 5
Wangner, Jakob, 2
Wappers, Gustave (after), 2
Ward, Franklin T., 10
Ward, George M., 8H
Ward, Lynd, 7, 8H
Ward, Sir Leslie ("Spy"), 2, 10
Ward, W., 8H
Ward, William, 2
Warder, William, 7
Warhol, Andy, 2, 4, 7, 10
Warner, Doug, 7
Warner, William, Jr., 10
Warren, A. C., 8H
Warren, A. W., 6
Warren, Alexander, 2
Warren, Charles Turner, 8H
Warren, Ferdinand, 6
Warren, Lloyd, 2
Warren, Whitney, 2
Warsager, Hyman, 7

Warshaw, Howard, 4
Warthen, Ferol Sibley, 7
Washburn, Cadwallader, 2, 8H
Wasley, Frank, 8H
Watanabe, Sadao, 7
Watelet, Claude Henri, 2
Waterloo, Antoni, 2, 8H
Waterston, Harry, 7
Watkins, Franklin C., 4
Watkins, John (after), 2
Watson, Caroline, 10
Watson, Ernest W., 7
Watson, Eva Auld, 7
Watson, James, 8H, 10
Watson, Nan, 7
Watson, Thomas, 2
Watt, W. H., 8H
Watteau, Antoine, 2
Watteau, Louis Joseph, 2
Wattier, Emile, 2
Watts, George Frederick, 2, 10
Watts, Simon, 8H
Watts, W., 8H
Watts, William, 2
Waud & Jenkins, 8H
Waud, Alfred R., 2, 10
Waugh, Frederick, 8H
Waumans, Conrad, 2
Way, Thomas Robert, 3, 8H
Wayne, June, 2, 7, 8H
Weaver, David A., 2
Webb, Albert, 7, 8H
Webb, Alonzo C., 2, 7
Webb, Sir Aston, 7
Webb, James, 8H
Webb, Samuel W., 2
Weber, 8H
Weber, Bob, 8H
Weber, Carl, 7
Weber, Edward, & Company, 8H
Weber, Frederick T., 7, 8H
Weber, Hugo, 7
Weber, Max, 4, 7, 8H
Weber, Otto, 8H
Weber, Sybilla Mittell, 8H
Weber, Walter A., 7, 8H
Webster, Herman Armour, 7, 8H
Webster, M. A., 8H
Webster, Moune G. H., 7
Webster, R. B., 7
Wechsler, Beverly, 2
Wechter, Hans, 8H

Wechtlin, Hans, 8H
Weddige, Emil, 7
Wedgewood, Geoffrey H., 7
Wedgwood, I. T., 8H
Weege, William, 7
Weeks Photo-Engraving Company, 8H
Weeks, E. L., 8H
Weenix, Jan, 2
Wegener, Hans J., 2
Weger, August, 10
Wegner, Helmuth G., 7
Weguelin, John Reinhard, 2
Wehener, Gerda, 2
Wehmer, John, 7
Wehrhan, O., 2
Wehrlin, Johann Matthias, 2
Weidel, Anton, 8H
Weidenaar, Reynold Henry, 2, 7, 8H
Weidl, Seff, 2
Weidner, Roswell, 7
Weigand, F., 8H
Weighell, Minnie, 8H
Weinbaum, Jean, 7
Weiner, Isador, 7
Weingaertner, Adam, 10
Weinstock, Carol, 2
Weir, Harrison William (after), 2
Weir, John Ferguson, 7
Weir, Julian Alden, 2, 7, 8H, 10
Weir, Robert W., 7
Weirotter, Franz Edmund, 2, 8H
Weis, Bartholomous Ignaz, 2
Weis, Jean Martin, 2
Weisbrod, Carl Wilhelm, 2
Weishar, Joseph, 2
Weiss, Gustav, 2
Weiss, Jean Bijur, 7
Weiss, Lee, 6, 7
Weissbuch, Oscar, 7
Weissener & Buch, 8H
Weissenhahn, Georg Michael, 2
Weixlgartner-Neutra, Pepi, 7
Welch, T. B., 8H, 10
Welch & Walter Engraving Company, 10
Welcke & Brother, 8H
Welcke, Robert A., 8H

Index

Arabic numerals and alphanumerics refer to collection descriptions. The Index is a single alphabetical list that includes the following information drawn from the collection descriptions:

all personal names that occur in the descriptive essays;

all personal names, including authors', that occur in bibliographic entries;

geographic and corporate names that occur in the descriptive essays;

titles of works of art cited in the descriptive essays;

titles of publications cited in the descriptive essays;

selected format terms (e.g., maps, posters, scientific illustrations) that occur in the descriptive essays;

subjects specifically mentioned in the descriptive essays (e.g., aeronautics, mathematics).

The Index does not include titles of publications listed in the bibliographic citations. Media and techniques (e.g., charcoal, watercolor, woodcut, engraving) have not been indexed unless they appear as subject specialties of a custodial unit; for example, lithography is included as a subject interest of the Peters Collection in the Division of Domestic Life (**8E1**).